CONTENTS

HAUNTED LONDON

PETER UNDERWOOD

WITH PHOTOGRAPHS BY CHRIS UNDERWOOD

AMBERLEY

For Chris and Maggie with love.

First published 1973
This revised edition published 2010

Amberley Publishing
Cirencester Road, Chalford,
Stroud, Gloucestershire, GL6 8PE

www.amberley-books.com

British Library Cataloguing in Publication Data.
A catalogue record for this book is available from the British Library.

ISBN 978 1 84868 262 7

Typesetting and origination by Amberley Publishing
Printed in Great Britain

LIST OF ILLUSTRATIONS

ACKNOWLEDGEMENTS

The author wishes to acknowledge the generous help and co-operation he has received from the following, during the years that he has been compiling material for this book:

Robert Aickman, Mrs Trixie Allingham, Mrs Margaret Ashford, Arthur Askey, Dennis Bardens, Geoffrey Bernerd, Miss Gwyneth Bickford, Mrs Cicely Botley, Miss Yvonne Burgess, Miss Adele M. L. Butler, Commander A. B. Campbell, Fred Cavell, Sir Francis Chichester, Miss Geraldine Cummins, Eric Davey, Charles Dawson, James Wentworth Day, Alan Dent, Pamela and Crispin Derby, I. E. S. Edwards (Keeper of Egyptian antiquities at the British Museum), Charles Fishburn, the Revd Kingsley R. Fleming, the Revd H. J. Fynes-Clinton, Roy Grigg, the Revd R. W. Hardy, Jack Hayden, Lady Seymour Hicks (Ellaline Terriss), Dr Peter Hilton-Rowe, R. Thurston Hopkins, Miss Rosaline Howe, Edward C. Hull, Barry Jones, Guy Lambert, CB, Richard McGhee, W. J. Macqueen Pope, Mrs Margery Macqueen, Eric Maple, Brian Matthew, Prebendary Clarence J. May, Commander W. E. May, Dr Edward J. Moody, Mrs Munton, Miss Margaret Murray, Henry Oscar, Joseph Pearcey, W. G. T. Perrott, Billy Quest, the Revd John Robbins, C. H. Rock, Eric Rosenthal, Donald Ross, Miss Margaret Rutherford, Miss Dorothea St Hill Bourne, Dr Sidney Scott, Dr Mervyn Stockwood, Graham Stringer, John Sundell and J. M. Dent & Sons Ltd, Mrs Beryl Sweet-Escott, Reg Taylor, Dylan Thomas, Mrs Jerrard Tickell, Geoffrey Bourne-Taylor, Mrs G. C. Watson, Mrs Stuart Watson, Dr Donald West, and also various officers and authorities at New Scotland Yard, Tower of London, Hammersmith Public Library, Westminster Reference Library, British Museum, the British Library, the Post Office, the Society for Psychical Research, the Unitarian Society for Psychical Studies and The Ghost Club.

INTRODUCTION

Is London haunted? The answer depends on whether you are prepared to believe in ghosts in the first place. Personally, in thirty years' investigation, I have never seen anything that was indisputably a spontaneous ghost, but accounts of ghosts and haunted houses have interested me for as long as I can remember and there is no doubt that legion upon legion of people believe that they have seen ghosts. It is with the stories they tell that this book is concerned.

London is a very special city, it is always changing: presenting a new facet now and then even to the most native and long-established Londoner. London has more reputed ghosts and ghostly phenomena than any other place on earth. It is no exaggeration to say that practically every street in London has, at some time or another, been the scene of some kind of psychic happening, and my problem in writing this book has been to decide what I must leave out rather than what I will put in.

It seemed to me that I must include the famous ghost stories of London — the Cock Lane affair, the Man in Grey at Drury Lane, the haunted house in Berkeley Square, and the ghosts at the Tower of London — but I hope I have something new to add to these important cases. I have included also a sprinkling of poltergeist infestations, those strange happenings that take place in all kinds of properties for a limited period, and also some of the lesser-known ghost stories and psychic experiences that it has been my good fortune to come across. Much of the material has never been published before and I am very grateful to friends and correspondents who have been most helpful with information over the years, enabling me to present for the first time a representative picture of haunted London.

If the place of death can sometimes be haunted by the person who died there, it is probable that some hospitals should be haunted, and as there are authentic cases of hauntings associated with hospitals throughout Britain, so London hospitals also have their ghosts. Curiously enough, however, there are few recorded instances of apparitions of patients returning to the wards or rooms in hospitals where they died, and the more convincing accounts of hospital hauntings involve nurses or hospital staff.

A hospital ward at night can be an eerie place, especially in an old hospital; a place of laboured breathing and uneasy slumber, a place of anxiety and pain, of light and shadow — the kind of atmosphere in which imagination can play strange tricks. Yet most nurses and doctors are practical, realistic people and many of them have odd and unexplained happenings to relate.

There must be as many haunted theatres as there are haunted churches and it is interesting to consider the possibility that concentrated thought and preoccupation with death (and what may lie beyond) provide the requisite atmosphere for ghostly happenings in churches and theatres. In the artificial frame of the theatre, all the happiness and sadness, the evil and the good that mankind can experience is expressed by actors who often themselves have tragic lives. It may be that concentrated thought, whatever its direction and aim, can in certain circumstances and under certain conditions produce an atmosphere conducive to ghosts and apparitions, just as

tragic and violent happenings may, in special circumstances, give rise to hauntings. There are hundreds of haunted theatres around the world and London has more than its fair share. Inns have been described as the perfect microcosm of humanity, and certainly hostelries harbour, if only for a little while, the young and the old, the good and the bad, the rich and the poor, the happy and the sad. If (as some people believe) nothing is ever really lost, and every word, deed and thought is preserved for ever, it seems likely that occasionally something of that past, either a happy moment or one of tragedy, might return in some mysterious way and be visible or audible to present-day frequenters of the hundreds of historic inns and pubs of London.

To the sceptic I would say that no logical man could resist the weight of evidence of apparitions having formed a part of human experience through the centuries: similar and even identical reports are available from every part of the world from earliest times to the present day. There is simply too much evidence for it to be ignored. There can be no doubt that even in this prosaic age of rush and bustle, men and women with sound minds and sound bodies do sometimes see ghosts of dead persons in circumstances that rule out illusion or deception.

In 1971, a Hampstead mother of six, who believed that she was haunted by the ghost of her grandmother, killed herself by taking a drugs overdose. In 1969, actor Richard Harris filled a room in his London house with toys — not for the children to play with but to lay a ghost. He discovered that a child had once died in the room from which he heard the sounds of knocking and bell-ringing. 'I thought the toys would help the ghost to be happy,' he said at the time, 'and it seems to have done the trick.' The parents of Derek Bentley, executed in 1953 for his part in the shooting of P.C. Miles, have left his room untouched and they have heard his footsteps, his dog has howled and seemed to recognize its dead master, and bedclothes have been disturbed by no visible hand — years after the youth was hanged. Dr Sidney Scott, the eminent authority on Joan of Arc, told me, in February 1973, about the ghost of an unidentified Frenchwoman accompanied by her ghost dog that used to haunt the old houses behind St Peter's church in Cranley Gardens. A huddled form, thought to be the ghost of Catherine Eddowes, a Jack the Ripper victim in 1888, has been seen in a corner of Mitre Square during recent years, a spot long known as Ripper's Corner. Writer Robert Aickman has told me of a haunted hotel at Little Venice where the ghost of a dead man has been seen near a mysteriously opened window — the window from which the man 'fell' to his death.

Such snippets represent the rich tapestry of paranormal happenings in London, generally but not always the result of tragic or violent occurrences. Small wonder that I once met a lady who insisted that one morning she looked out of her window overlooking Marble Arch and saw the re-enactment of an execution with hundreds of people milling around dressed in the manner of two centuries ago. Is it unlikely that a power that many people sense and a few see with that inner eye pervades the site of Tyburn Tree where something like fifty thousand people met their deaths? It may be that all happenings are preserved and spin round in time and space, to be glimpsed again occasionally. A London bookseller once told me that he thought half the people one saw on the streets of London were ghosts, which is food for thought indeed! Whatever the explanation, London is full of ghosts and I hope that any reader who has knowledge of strange happenings in London — or anywhere else for that matter — will let me know, for it is important that permanent records of such experiences are preserved. I am very grateful to my son Chris for all the time and patience he has expounded on the excellent photographs that add so much to the book, and as always I am immensely indebted to my wife for her continuing interest, practical help and sincere understanding of the many problems involved. I hope that this book will give readers as much pleasure as it has given me to write it.

Peter Underwood
Savage Club, 1 Whitehall Place, London, SW1A 2HD

GHOSTS OF THE CITY AND EAST LONDON

AMEN COURT, ST PAUL'S

At the east end of Paternoster Row and just east of St Paul's Cathedral, this delightful little place, guarded by black iron gates, is always so quiet that it might almost be another world. Here, in the reign of Henry IV, lived the turners of beads who were called Pater Noster Makers; the name of the court may well be explained by the nearness to Old St Paul's. It was here that Richard Harris Barham lived between 1839 and 1845 whilst he was a minor canon of St Paul's, and wrote the *Ingoldsby Legends*.

At the far end of the court a piece of the old City wall on Roman foundations divides the gardens of the court from the Old Bailey, formerly the infamous Newgate Prison and immediately on the other side of the wall there was a narrow passage which was, in fact, the Newgate Prison graveyard, for here the criminals were buried in quicklime, after walking along the passage to attend and return from their trials. The whole area was covered with a massive iron grating in those days and was known officially as Birdcage Walk, but to the warders and to the prisoners it was Dead Man's Walk. Many walked over ground that was to become their graves, and the wall, black with the dirt of ages, formed the perimeter of the prison graveyard.

For many years, there have been reports of a mysterious and unexplained dark shape crawling along the top of this wall at night-time, an eerie scraping noise of heavy boots and the occasional rattle of chains breaking the dark silence that surrounds this sad place.

In 1948, a minor canon of St Paul's Cathedral who lived in Amen Court (where, a century earlier, Richard Barham said his windows gave him 'a fine view of a hanging wood!') maintained that he saw the ghost of Jack Sheppard, not once but several times. Sheppard, the most famous cat-burglar in the annals of crime, was born in the East End of London in 1702. He was caught in April 1724, and he escaped three times before being finally executed at Tyburn in the November of the same year.

One of these escapes was from Newgate, and according to official records Sheppard was lodged in one of the deep dungeons reserved for the worst criminals, and loaded with some hundred and fifty kilogrammes of iron fetters; yet, with the help of a file passed to him by a girl friend, Jack soon loosened his chain from the dungeon floor, slipped his small hands through the handcuffs and tied his fetters as high up as he could with his garters. By means of a chimney he was soon on the roof of Newgate where he made his way to the wall at the end of Dead Man's Walk and there dropped into Amen Court and freedom. Recaptured in due course, Newgate became Sheppard's last prison and this time he was watched day and night until he left for Tyburn.

It would seem that occasionally the ghost of Jack Sheppard returns to re-enact his daring escape from Newgate. He must find Amen Court little changed.

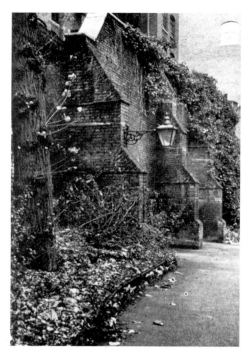

Amen Court near St Paul's Cathedral where a dark figure occasionally crawls along the top of the old City wall. This is possibly the cat-burglar Jack Sheppard re-enacting his daring escape from Newgate Prison.

THE BANK OF ENGLAND

One of the least-known ghost stories of the City concerns a charming garden deep within the precincts of the mammoth Bank of England building (nearly four acres) with its fortress-like and windowless walls. The bank is sometimes referred to as 'The Old Lady of Threadneedle Street' — a name that may have its origin in a ghost... The Bank of England, founded in 1694, carried on business at the old Grocers' Hall, where the City entertained Cromwell in 1649, until the bank was established in a building on the present site in 1734. This area of the City is historically important as being one of the busiest parts of Roman London. Here in Roman times stood the wharfs and offices of firms trading upon the then navigable Wall Brook, one of no fewer than seven rivers and streams now channelled in iron conduits beneath the present Bank. Two of the tessellated pavements of those Roman Londinium offices are still to be seen, not far from the position in which they were found, while preserved in the bank's own museum are the sandals, shoes and hob-nailed boots of men and women who must have trodden those pavements.

New wings and extensions were added in 1781 and 1788-1833 (when Sir John Soane was architect to the bank) and rebuilding continued until 1940. From 1780, when the bank was attacked during the Gordon Riots, a military detachment guarded the building each night until 1973. Now the island site is guarded by electronic surveillance.

The old Bank of England was haunted by the apparition of a man nearly eight feet high, a bank cashier in the days when bodies were often dug up and used for dissection. This cashier's one great fear was that, after he was dead, resurrectionists would get hold of his enormous body, and he persuaded the bank governor of the time to agree to his being buried inside the bank premises.

This was duly done and the burial of the 'giant' is included in the bank records. The gigantic and frightening ghost used to flit along the bank corridors after the bank guard had been posted, and it sometimes rattled the sentries' rifles. During the course of some excavations, the 'giant's' coffin was unearthed. It was found to consist of eighteenth-century lead, was seven feet eight inches long and bound with an iron chain.

The huge central block of the bank rises to a height of over a hundred feet and encloses a garden court, flanked by open vaulted colonnades, and it is here that the apparition known as the Black Nun has been seen on many occasions.

I heard the story first-hand from a Bank official some years ago. He told me that the so-called Black Nun was in fact the sister of Philip Whitehead, an apprentice cashier at the Bank in 1811. An ambitious but thoroughly unscrupulous young man, he used his good appearance and plausible tongue to establish himself and his nineteen-year-old sister, Sarah, in a splendid London mansion. There he entertained tricksters and adventurers until the bank heard of his dubious activities and he was asked to resign. His gambling losses mounted and he became more and more in debt, until finally some of his 'friends' suggested that he forge a few cheques to see him over the difficult patch. He did so and was discovered, arrested and, on 2 November 1811, condemned to death at the Old Bailey.

Sarah lived on in a fool's paradise, for her friends could not bear to tell her what had happened; they even arranged for her to move to new lodgings so that she would not hear the tolling of St Sepulchre's bell when her brother was led from the debtors' prison to the scaffold. Puzzled by his long absence, she journeyed one day to the bank to inquire about her brother and there the whole story was blurted out to her. She left the bank in a dream — quite unable to accept what had happened — and for the rest of her life she lived in a world apart, travelling each day to the bank where she would loiter outside and then suddenly slip inside and ask whether her brother was in that day. Always the answer would be, 'Not today, madam.' Often she would murmur, 'Tell him when he comes that I have called,' and she would depart, only to linger outside until the bank closed. All the bank employees came to know her and to feel compassion for the sad figure, dressed from head-to-foot in black, and her crudely-painted face earned for her the nickname of Rouge et Noir or the Black Nun (for her head was invariably covered with black material, like a nun). She was never in want, for the bank officials often gave her money as they passed; a room was provided for her and a small annuity ensured that she did not starve.

Some people even think that she gave the Bank the name of the Old Lady of Threadneedle Street, for whatever the weather she made her pilgrimage every working day for nearly forty years, until her death, which occurred suddenly when she was about sixty. She was buried in the old churchyard of St Christopher-le-Stocks that afterwards became the bank's garden, where her form has been seen wandering aimlessly along a stone pathway.

One witness told me that he was in the gallery of the bank that looks down on the bank garden when a friend pointed out to him the figure of a woman in a black dress walking with curious uncertainty along a path in the garden. 'It's the Black Nun!' my informant was told and he watched the odd figure walking in a groping, hesitant fashion, almost like a blind person, moving seemingly without purpose along the stone pathway composed of old gravestone slabs, her hollow and sad face glimpsed for a moment, crudely made-up with powder and rouge. Suddenly the figure dropped to its knees and seemed to beat a stone slab frantically with clenched fists, sobbing and shaking its head from side to side in an agony of grief. The next moment the figure had disappeared but the Bank garden, silent and still, an oasis in a busy world, continues to harbour its ghostly Black Nun.

COCK LANE, CITY

This is probably the best-known ghost of the City of London. In January 1762, the London newspapers were full of the popular mystery, and the sensation attracted the attention of many notables of the day. Oliver Goldsmith is credited with writing a treatise on the subject, whilst Dr Samuel Johnson concluded that the child concerned was consciously responsible. Horace Walpole changed his clothes before visiting the little terraced house, and even the Duke of York, accompanied by Lady Northumberland, Lady Mary Coke and Lord Hartford, made the journey to Smithfield; the latter writing afterwards about the 'wretchedly small and miserable' house in which fifty people were crowded by the light of one candle about the bed of the child 'to whom the ghost comes'.

The story revolves around a stockbroker named Kent who, following the death of his wife in 1757, took rooms with his wife's sister, Fanny, at the house of a man named Thomas Parsons, a clerk of St Sepulchre's church, in Cock Lane in 1759. Kent loaned some money to his landlord, and when all efforts for its return failed he sued Parsons. This resulted in considerable animosity between the two men, especially on the part of Parsons. Meanwhile, Fanny was taken ill, and when Parsons' twelve-year-old daughter, Elizabeth, shared Fanny's bed during the time that Kent was away attending a wedding in the country, they were disturbed by strange scratching noises and apparently inexplicable knocks and rappings. Fanny was very alarmed and believed that the noises were warnings of her impending death but Parsons attributed the disturbances to a neighbouring cobbler — until it was discovered that the noises were heard on a Sunday when the cobbler was not working. It was then suggested that the mysterious sounds were caused by the spirit of Fanny's dead sister, admonishing her for cohabiting with Kent. Parsons became interested and invited neighbours into the house to hear the strange noises, much to the distress of the ailing Fanny.

When Kent returned, he and Fanny made wills in each other's favour and secured new lodgings in Bartlet Court, Camberwell, where Fanny died in 1760; the litigation between Kent and Parsons was still unresolved. Fanny was buried in the vault beneath St John's church, Clerkenwell, and after her departure from Cock Lane until her death eighteen months later all was quiet and peaceful.

With the death of Fanny (from smallpox, according to the death certificate) the noises returned to the house in Cock Lane, seemingly centring on any bed occupied by little Elizabeth Parsons, who trembled and shivered uncontrollably at the loud sound of whirring wings, taps and scratching noises. Her father is reported to have tried in vain to discover a normal explanation, even removing floorboards and wainscotting.

Eventually, a nurse, Mary Frazer, suggested that the raps might be messages in code, and by accepting one rap for 'yes' and two for 'no' Parsons questioned the entity and deduced that the disturbances were caused by Fanny, who claimed that her death had been the result of poisoning with red arsenic in a draught of hot ale administered by William Kent — and she wanted to see him hanged! Questions on matters of fact produced answers that were sometimes right, sometimes wrong, as, for example, when she said that her father's Christian name was John instead of Thomas. It was stated that Elizabeth saw a shrouded figure standing by the bed, without hands. Other witnesses said that they saw a 'luminous apparition' with hands, and the noises apparently followed Elizabeth, even when she visited other houses.

Now Cock Lane became the street with the 'house of wonder' and crowds of neighbours and sightseers thronged the narrow lane between Newgate Street and West Smithfield night and day. The house, Number 33, has long since been demolished; it figures in Hogarth's plate, 'Credulity, Superstition and Fanaticism'.

At one stage, the communicating 'ghost' promised to rap on its own coffin in the vault of Clerkenwell Church, but when the assembly (including Samuel Johnson) hastened there they were rewarded by complete silence and murmurings of disbelief began to be heard.

Cock Lane became thronged with sightseers and Kent's reputation was maligned throughout the city, although many people, including Oliver Goldsmith, assumed that Parsons was at the bottom of the matter in revenge for having been sued by Kent. Finally the authorities decided to investigate the affair.

The investigating party discovered that when they held the hands of Elizabeth Parsons all the noises stopped. It was not until they threatened the child with Newgate Prison that a few scratching noises were heard as she wriggled and squirmed. Examination disclosed a small board concealed between her stays and it seemed that the secret was out.

Kent then indicted Parsons, his wife, his daughter, the servant Mary Frazer, the clergyman and several tradesmen who were all convicted of conspiring against his life and character. Thomas Parsons was sentenced to be placed three times in the pillory at the corner of Cock Lane, and to be confined for two years in prison. His wife was to be imprisoned for a year and Mary Frazer for six months. The sentence on the clergymen and tradesmen was postponed so that they could make good their misconduct by paying several hundred pounds to Kent.

Miss Elizabeth Parsons subsequently married twice and died at Chiswick in 1806. In 1845 the coffin of 'Scratching Fanny' is said to have been opened and it was found that there was no discolouration or mouldering of the body, which could suggest that arsenic had in fact been the cause of death. In 1893, when three hundred and twenty-five coffins were removed from the crypt of St John's, Clerkenwell, it was reported that one coffin was found to be stained with arsenic, but the coffin was not identified since it had no plate. In 1941, the church was reduced to a ruin by German bombs, and when the vaults were cleared there was no sign of Fanny's coffin. Now the whole truth about the Cock Lane affair will never be known.

THE CONNAUGHT ARMS, E16

Hard by the dock gates in Connaught Road, E16, The Connaught Arms has the ghost of a mad woman who committed suicide. Her room could never be slept in and no matter how many times the room was tidied and put to rights, next day everything was thrown about the room just as it must have been during the woman's last days. Once, a member of the staff went into the room and found it in chaos, and as he came out of the room he saw, facing him, a strange old woman with a wild look in her eyes. He had two dog with him and all three scampered down the stairs together as fast as they could to get away from the apparition!

GREYFRIARS CHURCHYARD

A quiet haunted spot in the City, one of those welcome patches of peaceful green among the multitude of buildings, is to be found in Newgate Street, by the ruined Christ Church: Greyfriars Churchyard. Christ Church was founded by the Grey Friars, formed by St Francis in Italy in 1209, who were known by three names. They were called Franciscans after their founder, Grey Friars from their clothing and Minor Friars because of their humility. Nine of the friars landed at Dover in 1223; five of them settled at Canterbury and the other four established themselves in London in 1228 and founded the great house of Grey Friars with its chapter house, dormitory, refectory,

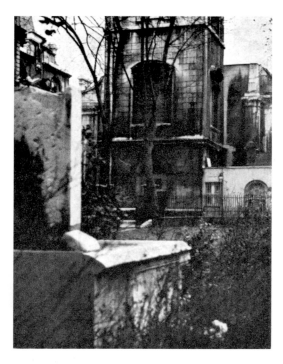

Greyfriars Churchyard, Newgate Street, harbours the ghosts of Isabella, the 'she-wolf of France' and the restless Elizabeth Barton, the 'Holy Maid of Kent'.

infirmary and church. The area came to be known as Greyfriars and afterwards as Christ Church or Christ's Hospital — famous for its Bluecoat Boys. The church received rich patronage from Queen Margaret, second wife of King Edward I, and from Isabella, wife of Edward II, and Queen Philippa, consort of Edward III. John of Brittany, Earl of Richmond, gave jewels; Gilbert de Clare, Earl of Gloucester, great trees from his forests; Dick Whittington, a library. Two hundred years ago, a writer (Thomas Pennant) stated: 'No order of monks seems to have had the powers of persuasion equal to these poor friars... and there are few of their admirers, when they came to die, who did not console themselves with the thoughts of lying within these expiating walls; and if they were particularly wicked, thought themselves secure against the assaults of the devil, providing their corpse was wrapped in the habit and cowl of a friar.'

Such a one was Isabella, daughter of Philip IV of France and wife of Edward II. When Edward neglected her for his favourite, Piers Gaveston, she returned to France and there collected an army, led by her lover, Roger Mortimer, and other barons.

Returning to England in 1326, she attacked and defeated the king, who was deposed, imprisoned and murdered. She and Mortimer ruled for a time, but in 1330, Edward III had Mortimer hanged and Isabella spent the rest of her life in retirement. The 'she-wolf of France' was buried in Greyfriars Churchyard, and, with audacious hypocrisy, had the heart of her murdered husband placed on her breast.

She is just one of the ghosts that haunt this historic spot, the burial place of three other queens and over six hundred people of nobility. Here also was buried Elizabeth Barton, the crazy 'Holy Maid of Kent', executed at Tyburn in 1534 for high treason. She hysterically and unsuccessfully opposed Henry VIII's intention to divorce Catherine of Aragon, and inaccurately predicted that he would die within a few months if his marriage to Anne Boleyn took place. Her figure, wild and

restless in the restricting habit of the Grey Friars, is said to be seen from time to time about the deserted churchyard.

When the Franciscan Friars first came to England they wore russet-brown habits with a cowl, girded with cords and walked barefoot; later they reverted to the original grey dress of their founder. In the early hours of misty autumn mornings the form of a monk has been seen, walking placidly about the Greyfriars Churchyard, dressed in russet-brown; a figure that disappears when the sun is fully risen or when human beings approach too closely.

Yet another ghost at Greyfriars is that of Lady Alice Hungerford who poisoned her husband. It is recorded that she was led from the Tower to Holborn and there 'put into a cart with one of her -servants, and thence to Tyburn' and execution. Her form has been recognized because of her great beauty and natural dignity. She walked one summer evening, haughty and arrogant, and so frightened a night watchman who recognized her that he fled in terror and gave up his job next day. He had seen enough of the ghosts of Greyfriars Churchyard and he saw only one.

The Nag's Head, Hackney

The Nag's Head, Hackney, was probably known to Jack the Ripper and it has certainly witnessed murder and suicide; at one time it had the dubious reputation of being the eeriest pub in London. Landlord Terry Hollingsworth, an ex-commando and amateur boxer, was sceptical of the haunting until he found taps turning on by themselves, furniture falling to pieces beneath him and other strange but inconclusive manifestations.

The ghost was finally seen by the barman, Tom Foord, when he went to the cellar one morning to fetch some crates. 'She was a very old woman,' he said, 'with a grey shawl and a long, Victorian-like dress.' Following a number of séances things seemed quieter, and the shawled woman has not been seen recently.

Odessa Road, Forest Gate

The occupants of Number III, Odessa Road, Forest Gate, saw no ghost at their house but said they 'lived in terror for twelve years'. I was consulted in February 1969, and learned that Robert Chilvers and his second wife, Doris, were almost at the end of their tether. The retired railwayman, then aged sixty-seven, had moved to the house in 1946 with his first wife Maude, who had died ten years later. Three weeks after they married in 1957 Doris Chilvers was quietly listening to the radio when suddenly there was a loud bang and blue flames flashed up around the set. When they heard similar banging noises, which they were at a total loss to explain, and saw more frightening blue flashes near the television set, they promptly got rid of both the radio and television, but still, they told me, 'It seemed the house was haunted.' 'Once our cat, Blackie, asleep on a chair, was suddenly whisked across the room in front of my eyes,' said Doris. 'It was as if some unseen hands had picked up the animal and taken it across the room.' The cat, it seems, was terrified and ran out of the house. (Perhaps it had received an electric shock, I thought to myself!) Sometimes Doris felt something invisible push violently against her and she has found bruises where she has been 'touched by unseen hands'.

Robert Chilvers thought that the disturbances, strange and eerie noises that echoed through the house at night, might be connected in some way with his first wife. He showed me holy pictures that he had found covered with scratches after a night of unrest.

Cats are very fond of sharpening their claws and although Robert and Doris thought that the blue flashes might be warnings, I suggested that they get the Electricity Board to carry out a thorough investigation. I heard no more about strange blue flashes and mysterious banging noises at Odessa Road.

OLD NEWGATE PRISON

Several ghosts were reported to haunt Newgate. One prison officer stated in a prison report in December 1891, that he was working late in his office situated near Dead Man's Walk when he heard limping footsteps from the direction of the Walk. As he listened they became louder and clearer. At first the officer thought it must be the chief warder making his rounds, but the chief's step was firm and military, whereas these footsteps were stealthy, uneven, occasionally with a drag to them: the shuffle of a limping man. The prison officer opened the grille in the doors that led to Dead Man's Walk and was horrified to see, pressed close to the other side of the grille, the dead-white face of a man. As it swayed back from the grille the officer saw bruised skin around the mottled green throat, and his immediate thought was that the man had been hanged. As the face disappeared the officer opened the gate, but outside there was no trace of anyone or anything. Subsequently, this officer and others heard limping footsteps, but they were never able to discover any cause for the noises, which invariably ceased as soon as they set out to investigate. Sometime afterwards, the officer who had seen the face learned that the last man to be buried in Dead Man's Walk was lame.

Another reported ghost at Newgate was that of the evil Mrs Dyer who was seen by one chief warder in what had been called the women felons' yard. She was the notorious Reading baby farmer who was executed on 10 June 1896, for the murder of a number of babies whom she was paid to adopt. The babies were strangled and thrown into the Thames at Caversham, whilst she continued to draw the money for their keep. The oily and horrible old woman had actually smiled at her trial as witness after witness related stories of the most appalling cruelty. As she passed the chief warder on her way to the execution shed she had turned and looked into his face and said quietly, 'I'll meet you again one day, sir.'

During his last week at Newgate, before the old prison was closed, the chief warder happened to be in the vicinity of the women's yard when he thought he heard a movement out in the darkness. He looked through a glass observation window and, although the yard seemed to be deserted, the last words of Mrs Dyer suddenly came into his mind: 'I'll meet you again one day, sir.' The next moment he saw a form loom up out of the blackness, and he recognized the dark, glittering eyes and the thin, merciless lips of old Mrs Dyer. Subjective hallucination perhaps? It might have been had not other warders and visitors reported fluttering footsteps and the dark form of an old woman in the women's yard at dead of night at a time when there were no women convicts in the prison, female prisoners having been lodged in Pentonville for some years by that time.

I recall too Thurston Hopkins, a Sussex man and friend of Rudyard Kipling, who studied ghosts, telling me about something in the chapel, deep in the heart of Newgate. Hopkins often visited the prison and explored the massive buildings with their dark stone corridors, frightening galleries and deep dungeons. The gloomy chapel was reached by a flight of stone steps and footsteps echoed eerily as one walked down them; even the chapel floor seemed impregnated with evil. One night a prison chaplain was alone in the chapel when suddenly the black curtains of the condemned pew swished back to reveal the outline of a man in a black coat with powdered hair,

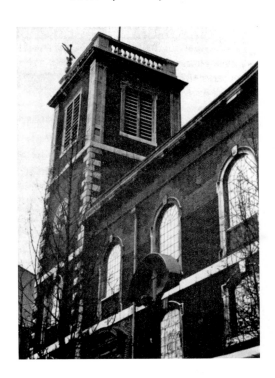

St Andrews-by-the-Wardrobe, Queen Victoria Street, has a haunted bell that used to toll of its own accord whenever a rector died.

his skull-like face gaunt and vivid in the dim light. Weeks later, Hopkins told me, the chaplain saw a portrait of Henry Fauntleroy, a banker and forger who had been executed at Newgate in 1824, and immediately the priest recognized the singular features he had seen in the chapel.

St Andrew-by-the-Wardrobe, City

St Andrew-by-the-Wardrobe in Queen Victoria Street has, or had, a haunted bell. The name of the church is derived from the king's wardrobe (i.e. storehouse), which stood close by until the Great Fire and is commemorated by Wardrobe Place entered from Carter Lane. It was here that the Master of the Wardrobe kept 'the ancient clothes of our English Kings,' says Thomas Fuller (1608-1661), 'which they wore on great festivals; so that this Wardrobe was in effect a Library for Antiquaries, therein to read the mode and fashions of garments in all ages.' In 1604, William Shakespeare purchased some scarlet cloth for a tunic to attend the state entry of King James I into London. After the destruction of the Wardrobe in the Great Fire, and the death of the then Master, the office was abolished, and the houses on the west side of the quiet little court probably date from the early eighteenth century. On the south side of Number I Wardrobe Place there is a stone shield on a rounded base and tapering stem, resembling an ancient battle-axe; the origin and history of this curiosity is unknown. In the tower of St Andrew-by-the-Wardrobe (rebuilt by Wren in 1692) stood the bell named Gabriel that was cast at Worcester some five hundred years ago, and a bell that was removed from the doomed belfry of Avenbury church in Herefordshire in 1937. Generations of Avenbury people held the belief that whenever a parson of Avenbury died, the bell would toll of its own accord, and several witnesses say that this happened when the last two vicars of the town died.

St Bartholomew's Hospital and Church, City

St Bartholomew's Hospital has a long and interesting history. In 1423, Dick Whittington's executors carried out repairs that preserved much of the old hospital for many years. A statue of Henry VIII is in the place of honour over the entrance gates, for when the ancient priory was dissolved he ordained that the hospital should be preserved for the sick and afflicted of London.

The hospital was founded in 1123 by Rahere, variously described as a courtier, minstrel and jester, at the court of Henry I. He was a canon of St Paul's and there is in the British Museum a *Life of Rahere* written by another canon within fifty years of the original founding of the hospital. The writer of Rahere's life says he was a frequenter of the palace and of noblemen's houses, and he made himself so agreeable with his suave manners, witty conversation, musical ability and flattering tongue that he came to be highly esteemed as a leader of 'tumultuous pleasures', though he was of humble origin. However, the atmosphere of the court changed after 1120 when the only legitimate son of King Henry I was drowned on a voyage from Normandy to England. It was said that the king never smiled again, and certainly the life at court became much more austere. Rahere made a pilgrimage to Rome where, near the spot reputed to be the site of the martyrdom of St Paul (some three miles from the city), he caught malaria. In his distress he vowed that if he was allowed to recover and return to England he would establish a hospital for the poor, as a thanks-offering. His prayers were answered and one night, during his convalescence, St Bartholomew appeared to Rahere in a vision and indicated Smithfield as the appointed spot for his hospital and church.

Back in London, Rahere found the authorities favourable to his projected scheme, for Smithfield was then an unpromising place, mostly marsh, with only one dry space, where the public gallows stood. Some idea of the size of the original priory building can be obtained by picturing the nave as stretching from the present church to the great gate in Smithfield, covering what is now the graveyard.

The first hospital for the sick had a master (Alfune, who had previously built the church of St Giles, Cripplegate), eight brethren and four sisters. Rahere's life as first prior to St Bartholomew's was not a peaceful one, for he had many enemies and at one point there was a plot against his life that only failed because a conspirator confessed. However, he governed the hospital for twenty-two years, and left the establishment well established and prosperous.

Rahere is represented on his majestic tomb clad in the black habit of the Augustinian canons. It seems that the tomb was opened for some reason in 1865 (his body lies just beneath the effigy) and some time after a pew-opener was taken ill and confessed that she had stolen one of the sandals from Rahere's coffin. Over the centuries, there have been many records of people who were supposedly healed by praying at Rahere's tomb and his sandal and a fragment of his coffin are preserved in the museum housed in the cloisters. A tiny window can be seen to the left of the thirteenth-century clerestory window; its reputed function is to drive away evil spirits that infested the north side of the church. The ghost of Rahere is said to have been seen here on many occasions, and footsteps, presumed to be his, have been reported many times in the ambulatories. A former rector saw the figure several times as did some of his church workers. Once, when a woman was helping to arrange the flowers in the church she complained that she could not arrange them satisfactorily; they kept falling over and they seemed to move whenever she 'turned her back'. The rector said, 'You know why? Rahere was standing behind you and you know how he dislikes women!'

Another rector stated that he noticed a strange man in the church one weekday evening when the church was in darkness except for a light in the sacristy. The cowled figure stood looking down the nave with the light behind him, and the rector walked towards the figure and asked whether he could be of any assistance. Without replying, the monk-like form turned and walked without

making any sound — as far as the rector could remember — towards the Lady Chapel. The rector followed and when he almost reached the dark-clothed figure, it suddenly and inexplicably disappeared. The same rector and his wife both report seeing the phantom monk standing beside the altar rail, and several members of the congregation have had similar experiences.

Elliott O'Donell, for sixty years one of Britain's most active ghost hunters, told me that he once saw the shadowy figure of a monk slip past him as he walked down the aisle towards the main entrance to the church, one summer afternoon. O'Donnell had the impression of stealth and he heard no sound. He also told me of a church official who was alone in the church one morning when he saw a luminous white form in the central aisle. As he watched it seemed to form into the shape of a woman and he thought that he recognized his daughter who had been in Australia for years. He was somewhat upset, thinking that perhaps she had died suddenly, but in a letter he received from her later he learnt that she had been seriously ill and that when she was sure she was about to die she had thought that she was standing in St Bartholomew's church looking at her father! It was subsequently established that both the date and the time of the two experiences corresponded.

Other visitors have reported seeing a strange white light or shape in the central aisle and a frightening dark shape gliding along one of the ambulatories. A former curate fainted when he saw the latter and was ill with the shock for some time afterwards.

More recently, two ladies visited St Bartholomew's one sunny July morning, happily looking forward to an interesting tour of the ancient church. Suddenly, as they walked down the central aisle, they had a curious feeling of being trapped and in some alarm they proceeded into the church, but then found themselves gripped with the fear that something dreadful was following them. After a moment they came to a halt, as they both experienced an appalling sense of horror and something so inexpressibly evil that one fled, half-sobbing, out through a side door into the sun-baked street where her companion joined her a few moments later. Both said that they would never again visit St Bartholomew's the Great.

Miss Dorothea St Hill Bourne of Farnham in Surrey tells me that she had three curious experiences at St Bartholomew's. On one occasion, she had arranged to sing some Bach at the church, but on arrival discovered that the organist did not have a copy of the piece she was to sing. However, she was fairly confident that she knew the piece and the organist used her copy, but it was arranged that they would try the piece over. As Dorothea sang to the deserted church, she had the distinct impression that the church was full with a silent, expectant crowd. As she finished her rehearsal the impression vanished and the great church was still and empty.

On another occasion, Dorothea was walking along one of the ambulatories towards the west end of the church when it seemed to her that the altar and high candles had been moved and were in a slightly different position to where she had been accustomed to seeing them. After a moment, everything was as it should have been, but, just for a second, it was as though she had stepped back to a previous age when the positions of some of the things in the church were a little different to their positions today.

The third experience that Dorothea St Hill Bourne had at St Bartholomew's was during the period that a pageant was being enacted. The church was packed and, just briefly, Dorothea distinctly saw the figure of a monk walk down the great aisle — a figure that took no part in the pageant and for which there seemed to be no rational explanation. It is interesting to recall that a former rector of St Bartholomew's the Great once went into the church with some visitors and saw a monk preaching in the pulpit, gesticulating energetically and apparently addressing an invisible congregation, although no sound accompanied the experience.

The same rector used to relate the experience of a church worker who knew St Bartholomew's for many years and, although familiar with the stories of ghostly forms and strange experiences,

had never personally encountered anything she could not explain until one evening, having finished arranging flowers in the church for a wedding next day, she sat down for a moment. As she took a last look round the church in the gloom of an autumn evening, she suddenly thought that she caught sight of something moving near the fifteenth-century font. A moment later, something caught her eye near Rahere's magnificent tomb and, 'just for a moment' (as she put it), she saw a smallish figure standing in the shadows, with his hat cocked at a rakish angle. The apparition, if apparition it was, soon disappeared, but the church worker always wondered whether it might have been the ghost of William Hogarth, the painter and engraver, who often wore 'his beaver cocked with careless air', according to a contemporary poet. Hogarth knew and loved St Bartholomew's the Great and he was baptized in the font there.

St James's Church, City

In Garlick Hill, off Queen Victoria Street, stands St James's Church, Garlickhithe, so-called, according to Stow's *Survey of London* (first published in 1598), because in old times garlic was sold here. There was a church here in 1259 when Peter del Gannok was rector. This was rebuilt in the fourteenth century and after destruction in the Great Fire the present building was opened in 1682, having been built to the design of the great Sir Christopher Wren (1632-1723). The church contains a mummified corpse that has been reported to 'walk' and there are other ghostly stories associated with this interesting church.

Inside a cupboard in the vestibule of the church there resided for many years the mummified body of a young man that was found during some excavations in 1839. The body was buried in a glass coffin near the altar of the fourteenth-century church, before it was destroyed in the Great Fire. Over the years, the corpse acquired the nickname of 'Old Jimmy Garlick', for nobody knows who the man was. It is possible that he was the first Lord Mayor of London (no less than six Lord Mayors were buried here); some people think he was a Roman general, for they were frequently embalmed, whilst others think he might be Belin, a legendary king of the ancient Britons. Experts seem satisfied that the relic is the calcified body of a medieval man but they are reluctant to date the remains. The man must have been important in his own time, for the coffin was elaborate and the body was almost certainly embalmed before burial and is still in perfect condition — the only known example of medieval embalming.

On occasions 'Jimmy Garlick', or a figure resembling him, has been seen in various parts of the church. One visitor was resting for a moment in one of the pews when something caught her eye and looking towards the altar she saw, on the north side, a figure in white, tall and silent, with arms folded and looking towards the tower end of the church where the projecting clock is surmounted by a figure of St James. At first the visitor took the figure to be someone connected with the choir or the church generally, but quickly became puzzled by the silence and stillness of the figure. It was gazing at a point behind her with such a fixed intensity that she turned to see what was there, and when she looked back again the white figure had vanished. She immediately went to the spot where the figure had appeared and made enquiries but could find no explanation for the silent form that she had seen.

A similar figure seems to have been encountered by the son of an American visitor to the church a few years ago. The visitor was accompanied by her two sons and while she and the younger boy were examining some of the memorials the older boy startled his mother by suddenly dragging her out of the church. He was in a terrified condition and had obviously seen something that had badly frightened him. He said that when he looked up one of the staircases to the balcony he saw the figure

of a man, clad in what could have been a winding sheet, standing erect with his hands crossed. The face and hands of the form resembled those of a dried-up corpse. The boy was very frightened, as he had just come down from the balcony, mounting one side and descending the other, and it had been quite deserted. Neither the boy nor his mother had seen 'Jimmy Garlick' or knew about the mummified corpse until later when they were relating the boy's experience.

Other reports of the occasional appearance of 'Old Jimmy's' ghost include the evidence of a visiting priest, who saw, just for a second, a figure dressed in white in the nave, and a fireman during the Second World War who shouted repeatedly at the white figure he saw inside the church during an air-raid to take shelter, a figure which melted into nothingness when he eventually approached the north-east corner of the church. He could discover no explanation.

During the Second World War, 'Jimmy Garlick' had several narrow escapes from damage and destruction. Once, in 1942, a bomb grazed his case and penetrated to the vaults below the church but did not explode. Afterwards 'Jimmy' was reported to be seen inside the church more frequently, usually glimpsed only for a moment, and new manifestations occurred, including unexplained movements of objects and the appearance and disappearance of a phantom cat.

St James's Church, Garlick Hill, boasts the mummified body of a young man, a ghost in a winding sheet and a phantom cat.

St Magnus the Martyr, City

By London Bridge (until 1750 the only bridge across the Thames), almost hidden among the tall buildings of Lower Thames Street, stands the church of St Magnus the Martyr. The church is of very ancient foundation and there is reference to it in confirmation of a grant of 1067, but even the origin of the dedication is uncertain. Some authorities maintain that the church was dedicated to a Christian who suffered martyrdom in Caesarea at the time of Aurelian, AD 273, while others agree with Professor Worsaae that the dedication is to a Norwegian jarl, killed in the twelfth century on one of the Orkney islands and buried in Kirkwall Cathedral, which is also dedicated to him. A previous rector of St Magnus brought to the church a stone from the apse of the ruined church of St Magnus on the island of Egilshay and a piece of a chest in which the saint's body was found.

The original St Magnus was the first church to be destroyed in the Great Fire, for the fire started nearby and the Monument, erected to commemorate the fire and containing 345 black marble steps, is but a stone's throwaway. Among the collection of relics in the church there is 'a piece of

the Holy Cross', 'duly authenticated', and the famed Falstaff cup, referred to in Henry IV Part 2 and probably used by Shakespeare.

In the south-east corner of the church lie the remains of Miles Coverdale, who produced the first complete English edition of the Bible, and it is here that some visitors have seen the unexplained figure of a cowled man, stooping in silent contemplation — a figure that disappears when it is approached. Other visitors have noticed a peculiar feeling of sadness and anticipation in the vicinity of the white marble inscription to the former rector of St Magnus; still others have remarked upon an indefinable impression that they are being watched.

A church worker saw this figure on three occasions. It appeared twice whilst she was sewing in the vestry, the first time walking around her and then disappearing through a solid wall, and on the second occasion it suddenly appeared beside her, so close that she could see the ribbing of the serge material of the cassock. As she looked up, she realized to her horror that the figure had no head, and becoming very frightened she left the room without looking back. The third occasion was during Mass early one Sunday morning. As the worker turned to put her money in the collection box, she saw the priest, wearing the same serge cassock, walk up the nave and into the row behind her. At first she thought it was a real priest, but then she remembered the figure she had seen in the vestry. She turned round quickly, but there was no one there, and when she questioned the verger he said that no one had come into the church during the service.

Some time later, a young electrician worked in the church for several days, making alterations and checking the wiring. Afterwards, as he was about to leave, he asked the rector about the priest who watched him so intently and who seemed to be there one moment and gone the next — a priest who wore a serge cassock. And one Easter time a man in the choir told the rector that he had passed a robed figure on the stairs and when he looked round afterwards he saw the figure disappear into one of the old walls of St Magnus. This man, a very practical and level-headed individual, was very frightened by the experience.

A former rector, the Revd H. J. Fynes-Ointon, told me that he had no doubt whatever but that the church was haunted by a robed figure and he thought it might be the ghost of a former priest at St Magnus. His verger, who had been a regular soldier, a reliable and unimaginative man, had seen the ghost one Sunday evening after service. Everyone had left and the verger had locked the doors but all the lights were still on. He was busy putting some things away in a cupboard behind a side altar when he saw the figure of a priest immediately in front of him. He was on the point of asking how the priest had entered the locked church when the figure, only a matter of four or five feet from him, suddenly stooped down and seemed to be searching the floor. The verger, puzzled, asked whether he could help —what had been lost? Whereupon the figure straightened up, looked at the verger and smiled, and then faded away to nothing in front of his eyes. The rector told me that a former verger's wife had twice seen a short, black-haired priest kneeling in the Lady Chapel. She particularly noticed that the figure wore an old-fashioned 'sort of cassock' and when she spoke the figure turned towards her and then disappeared. The same thing happened on both occasions. Several witnesses of the ghostly priest at St Magnus have described the figure as 'cowled' or 'wearing a hooded robe' and it is interesting to recall that Miles Coverdale, in the vicinity of whose grave such a figure has been seen, was a friar and one-time Bishop of Exeter.

St Paul's Cathedral, City

One of the little-known stories about St Paul's Cathedral (reputedly built on the site of a temple to Diana, a fertility goddess) concerns a secret stairway and the haunting of the Kitchener Memorial

Chapel, formerly All Souls' Chapel, at the extreme west end of the cathedral. In fact, the cathedral is honeycombed with secret passages and stairways and it is likely that many have yet to be discovered.

The Kitchener Memorial Chapel used to be haunted by a former official of the cathedral. He appeared in old-fashioned clerical clothes and had a fondness for whistling! Vergers and other members of the cathedral staff would find themselves being followed by the apparition, who, every now and then, would annoy and alarm them with a high-pitched but not unmusical whistle. After a time, it was noticed that the old parson whistled more often and more loudly in the vicinity of the Kitchener Chapel and at one particular spot in the chapel he would often disappear into the stonework.

When some structural repairs were being undertaken in the chapel a hidden doorway was discovered at the place where the whistling ghost often disappeared and when the little door was opened a winding stairway was disclosed that ascended through the heart of the cathedral to the dome.

When new stonework was incorporated in the renovations in the Kitchener Chapel, a secret stone doorway was fitted to the staircase that can be made to slide back by pressing a spring, but the stairway is one of a number of parts of the cathedral that is seldom shown to visitors. Special permission is required even to enter the Kitchener Memorial Chapel and it was hastily re-arranged when I entered, although as far as I know the ghost has not been seen for many years now.

St Paul's Cross, the open-air pulpit that has never been used for preaching, beyond the north-east corner of the cathedral, is built on the site of the old cross, the foundations of which were discovered six feet below ground level in 1879. The old St Paul's Cross, first mentioned in 1194, was called by Carlyle 'a kind of Times newspaper of the Middle Ages' since it was the official pulpit not only of London but of the whole country. Here, in 1441, Roger Bolingbroke, necromancer, was exposed with all his instruments during a sermon and he was afterwards 'drawn, hanged and quartered'. In 1538, a crucifix, the Rood of Grace from Boxley Abbey, which had eyes that opened and closed and lips that seemed to speak, was exposed as having ingenious secret springs and was thrown down amid derision.

Before the Protestant Reformation the cathedral possessed many relics including 'a piece of the true cross', stones from the Holy Sepulchre and the Mount of Ascension, some hair of Mary Magdalene and some blood of St Paul. Legend has it that the fire in the eleventh century destroyed everything but left unharmed the resting-place of St Erkenwald, Bishop of London, buried about AD 700, and for centuries pilgrims flocked to the tomb and lavished riches of all kinds upon it. During the reign of Richard II, one Richard de Preston, 'a citizen and grocer', presented a remarkable sapphire that was supposed to cure infirmities of the eyes. Sacrifices in the shape of a doe in winter and a fat buck in summer were offered at the high altar for some centuries during the Middle Ages.

WEST SMITHFIELD, CITY

A spot so full of historical associations as Smithfield is likely to be haunted by echoes from the past. St Bartholomew's Hospital is here, the oldest hospital in England where men were treated who suffered from wounds sustained at the Battle of Hastings and from later famous battles such as Crecy, Agincourt, Naseby, Blenheim, Waterloo, the Crimean war and, of course, two world wars. For centuries, traders in clothing and food have held markets at Smithfield and as far back as 1180 it was famous for its horse races and the 'show of fine horses for sale'. It stands on the site

of an ancient tournament and jousting ground, where Edward III held festivities that lasted for seven days in honour of his mistress Alice Pierce (or Perrers) in 1374; Richard II held tournaments in 1390 attended by sixty knights from all over Europe, and it was frequently used as a duelling ground, for Shakespeare mentions a duel in which a 'prentice fought his master whom he had accused of treason. St Bartholomew's Fair was instituted in the reign of Henry I and held annually for more than seven centuries. Ben Jonson used it as the subject of his play, written in 1614, and in 1668 Pepys met an extraordinary performing horse, a 'mare that tells money, and many other things to admiration; and among others, came to me when she was bid to go to him of the company that most loved a pretty wench in a corner. And this did cost me 12*d*. to the horse which I had flung him before, and did give me occasion to kiss a mighty belle fille.'

But, most of all, Smithfield (originally Smoothfield) is famous in history as a place where many executions were carried out, and where many religious offenders were burned at the stake. At a spot known as 'The Elms' (from a clump of trees that grew there) on St Bartholomew's Eve in 1305 William Wallace (*c*. 1272-1305), the Scottish patriot, was executed, together with his servant and two Scottish knights. In 1530, a cook named Roose (or Rose) was boiled alive for having put poison in the soup served to the Bishop of Rochester's household, resulting in seventeen cases of poisoning and two deaths. In 1538, a prior of the Observant Convent at Greenwich was suspended in a cage over fire and roasted to death for denying the supremacy of Henry VIII.

It has been calculated that during the reign of Mary 270 persons were burnt to death in England for heresy, the great majority at Smithfield. The usual place of burning was immediately opposite the entrance to the church of St Bartholomew the Great, with the victim facing the east so that the great gate of the church was in front of him. The prior was generally present. In 1849, the exact site of the burnings was discovered during some excavations whilst a sewer was being laid. Three feet below the surface were found un-hewn stones, covered with ashes and charred human bones. At the same spot, strong oak posts were discovered in a fire-blackened condition together with a staple and ring.

Small wonder then that even today ghostly groans and occasional blood curdling shrieks are said to be heard by people passing this way at night. There have been reports of people hearing the crackling noise of burning faggots and wood, and occasionally people have smelt the appalling stench of burning flesh.

CHAPTER TWO

GHOSTS OF COVENT GARDEN, BLOOMSBURY AND THE STRAND

THE ADELPHI THEATRE, STRAND

The late Ellaline Terriss (Lady Hicks) first told me about the Adelphi Theatre ghost, for she was the daughter of William Terriss, the actor-manager who was stabbed to death on December 16 1897 at the doorway in Maiden Lane; his ghost haunted the theatre and a nearby Underground station for years afterwards, and perhaps still does. William Terriss had been a sheep farmer in the Falkland Islands (where Ellaline was born) and he had been a horse-breeder, a gold-miner and a sailor before becoming an actor. He had great success on the stage and was scoring a considerable triumph as the vigorous lead in the thriller *Secret Service* in which an ambitious and jealous man named Richard Prince had a very small part. Prince really believed that he could play the lead better than the experienced and popular Terriss and furthermore he thought he would be given the part, if only Terriss was not in the way... That chill December evening William Terriss dined early with a friend and at seven o'clock he made his way into ill-lit Maiden Lane. He was just opening his private door at the back of the theatre when Richard Prince sprang at him from out of the shadows and without a word stabbed Terriss twice with a dagger he had bought that afternoon, and the forty-nine-year-old actor slumped to the ground, fatally wounded. He was carried into the theatre and died twenty minutes later, his head supported by his distraught leading lady, Jessie Milward. Those who were with him at the end say that just before he died he mumbled something that sounded like, 'I will come back.'

Ellaline's husband, Sir Seymour Hicks, went to Bow Street police station to identify Prince, who had been seized in Maiden Lane, and found the murderer screaming and cursing and foaming at the mouth. Back at the Adelphi, Sir Seymour knelt by the dead body of his father-in-law and said afterwards 'In utter silence I heard a voice say to me, "Are there men living such fools as to think there is no hereafter?" and I knew beyond doubt that I would meet William Terriss again.' At the subsequent trial Prince was found guilty of murder, but insane, and he spent the rest of his life in Broadmoor where he died in 1937 at the age of seventy-one. Soon after the murder, actors and actresses at the Adelphi were disturbed by strange tapping and rapping noises that seemed to emanate from the dressing rooms used by William Terriss and his leading lady, and this was just the beginning. Over the succeeding years, unexplained footsteps, the strange behaviour of mechanically sound lifts, odd noises, strange lights, the overwhelming impression of someone being present in the deserted theatre at night (especially in the vicinity of the two main dressing rooms) and the feeling of being watched, all these apparently inexplicable impressions and occurrences have been attributed to the ghost of William Terriss, and his ghost has been seen in Maiden Lane.

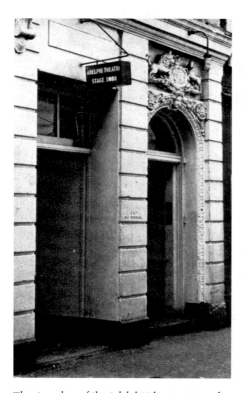

The stage door of the Adelphi Theatre in Maiden Lane where William Terriss was murdered and where his ghost has been seen in recent years.

One summer evening in 1957, a visitor to London who knew nothing of William Terriss or the ghost story, encountered a tall and handsome figure dressed in old-fashioned clothes, seemingly quite solid and normal in every way. A figure that passed close by but which disappeared completely at the doorway where Terriss had been struck down.

In March 1928, June, the well-known musical comedy actress, was occupying the large dressing room used by Jessie Milward at the time of Terriss's death. Terriss had been in the habit of tapping a couple of times with his stick on the door of his leading lady's dressing room as he passed — a little reminder that he was in the theatre. June usually refreshed herself with a light meal between matinee and evening performances, which she consumed in the very pleasant dressing room with its three windows and open fireplace; afterwards she often had a nap until about seven o'clock. On the day in question she had just settled on the chaise-longue for a rest when the couch began to vibrate and lurch, for all the world as though someone was kicking it from underneath, but a careful search revealed nobody under the chaise-longue and nothing that might account for the peculiar movements. No sooner did she lie down again than the movements recommenced and she felt a number of light blows on her arm and then she felt her arm gripped tightly by an invisible hand. Suddenly she noticed a greenish-coloured glow of light hovering in front of the dressing table mirror. Rising from the couch where she had been trying in vain to rest, she walked towards the dressing table, watching the luminous glow all the time. Arriving there and still observing the pale-green light flickering in front of the mirror, she put out her hand towards the light, whereupon it instantly vanished, but she saw raised weals on her arm where 'something' had gripped her forearm. After a moment she heard a couple of taps that seemed to come from behind the mirror and then there was silence.

When June's dresser, Ethel Rollin, arrived, June related her experiences and then heard for the first time about strange happenings at the theatre. Time after time, the dresser said, just after June had gone on stage, a couple of raps would sound at the door but when she opened it, there was never anyone there. During the course of a séance held in the dressing room, at which psychic investigator Harry Price was present, nothing of real interest happened, but no strange lights or tapping noises were reported for some months afterwards. Four years later, when people suggested that the whole affair was a publicity stunt, June reasserted that she had heard the noises, felt the blows on her arm and seen the strange light; she was still satisfied that her dresser had answered unexplained knocks at the dressing-room door. In 1962, two members of the theatre staff saw what might have been a similar light to that seen by June thirty-four years earlier. It was after everyone else had left the theatre and the dark stage was lit only by two pilot lights. Without warning, one of the stage-hands felt uncomfortably cold, although a moment earlier he had felt normally warm,

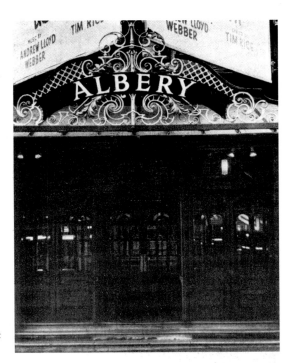

Albery Theatre (formerly the New) where the ghost of Sir Charles Wyndham has been seen backstage.

and in looking about him for some explanation for the sudden and extreme drop in temperature he saw a curious glowing light that seemed to be lit by some kind of inner radiance. Glancing at his companion, he saw that he too was staring at the strange form which seemed to float just above the stage and to be shaped something like a human body. The two men fled in terror and next day reported their experience to the manager, asking to be transferred to work away from the front of the stage, but on being told that they had probably seen the long-established and harmless ghost of the famous William Terriss, they agreed to continue working as before!

THE ALBERY THEATRE, ST MARTIN'S LANE

The Albery Theatre (formerly the New) in St Martin's Lane, was built by Sir Charles Wyndham, and his ghost, a handsome figure with wavy grey hair, has been seen backstage, crossing the otherwise deserted stage and disappearing in the direction of the dressing rooms. Film and stage actor Barry Jones told me that he was talking to an actress at the New, during a break in rehearsal, and they both moved aside to allow a grey-haired man to pass them. He nodded an acknowledgement as he went by and then crossed the stage and disappeared from view towards the dressing rooms. His distinguished appearance intrigued Jones and after a moment he too crossed the stage and asked an attendant who was standing beside a door (through which the man must have passed) which way the man had gone, but the attendant said no one had passed him for some time and he had never seen anyone answering Jones's description in the theatre. Suddenly Barry Jones realized that the figure he and his fellow-actor had seen was Sir Charles Wyndham who had also built the theatre that backs on to the Albery and which bears his name.

Aldine House, Bedford Street, Covent Garden, where a suicide returned in August 1972.

ALDINE HOUSE, BEDFORD STREET, WC2

One of the household staff told me in August 1972 that he had four times heard noises he could not account for in the vicinity of a small room on the first floor of Aldine House, Bedford Street, when it was occupied by Dents the publishers. The noises — the sounds of heavy breathing, coughing and footsteps — were heard over a period of three months, and my informant told me that on the last occasion (on Wednesday 16 August 1972) he was so certain, although he saw nothing, that 'something' was there that he ran away and left the light on in that particular room, fearing what he might encounter if he went inside.

The coughing on this occasion sounded very close at hand, almost over his shoulder. He always heard the noises during the early evening, about 6 p.m., when he was touring the building, putting out lights and closing windows. When the housekeeper reprimanded him for leaving a light on, the staff member immediately admitted that he had indeed left the area of the old building very quickly because he had become frightened, after hearing noises that he could not explain. The housekeeper replied that he was not surprised for other people had noticed mysterious noises on that particular landing and indeed his wife had, on one occasion, heard such odd sounds that she had become frightened and telephoned her husband on the internal telephone, from a nearby office, and he had come down at once with a torch and investigated, but nothing was found that might have caused the noises. That time the noises were heard much later at night.

The housekeeper also discovered that many years ago a man had committed suicide in the room where the noises seemed to originate. At the time of the disturbances the building was in process of changing hands — perhaps the ghost was worried about what might happen to its habitat!

I found it interesting to note that the 'phenomena' seemed to be mounting in intensity. At first slight noises suggesting someone in the room, then distinct footsteps and louder noises until on the last occasion they seemed to be outside the room and at the very elbow of the staff member doing his rounds. Furthermore, each person who experienced the noises was certain that someone or something was in the room as they reached the corridor leading to the room; on the occasions that the noises were heard they somehow 'sensed' that there was something there before they heard anything, although on scores of other occasions they found the area quite normal in every respect.

I tried to discover more about the suicide, whether it had taken place in the evening (which is most probable) and whether it had occurred during the summer months, when the noises were heard; but I was unsuccessful and now, since the building is likely to be completely altered, London has probably lost yet another of its ghosts.

THE BRITISH MUSEUM, BLOOMSBURY

One of the most interesting cases of haunting in London is or was associated with the mummy cases of a high priestess of the Temple of Amen-Ra. Perhaps the best way of presenting the story is to relate the somewhat differing accounts told to me by the various people concerned. It does seem indisputable that from the time the mummy case passed into the possession of an Englishman in Egypt about 1860 a strange series of fatalities followed its journey and even when it resided in the Mummy Room at the British Museum sudden death haunted those who handled the 3,500-year-old relic from Luxor.

Count Louis Hamon, 'Cheiro', the palmist and astrologer, used to relate that he once read the hands of a young man named Douglas Murray and that as soon as he took his visitor's right hand, he experienced a feeling of dread and terror. He felt that the arm would not long remain attached to its owner. In addition 'Cheiro' saw the hand draw a prize of some kind and said that from that moment a series of misfortunes would commence and soon afterwards Murray would lose his arm.

A few years later the same man revisited 'Cheiro' with the empty sleeve of his right arm fastened across the front of his coat. He said he had been in Egypt with two friends and while in Cairo an Arab showed him a finely-preserved mummy case, the hieroglyphics describing its ancient owner as a high priestess of Amen-Ra. The enigmatic features of the young princess were beautifully worked in enamel and gold on the outside of the case.

When his friends heard of the wonderful find they each wanted to buy the mummy case and eventually it was agreed that the three friends would draw lots for the opportunity of bargaining for it. Douglas Murray won, and the same evening he completed arrangements for the purchase of the mummy case and for its package and despatch to London.

A few days later, duck-shooting on the Nile, Murray's shotgun exploded and shattered his right arm. In an attempt to hurry back to Cairo he was hindered by tremendous headwinds and it was ten days before he obtained expert medical attention; by then gangrene had set in and the arm had to be amputated. On the return journey to England both Murray's companions died and were buried at sea. Back in London and feeling far from well himself, Murray found the mummy case unpacked and waiting for him in the hall of his home. There was something ominous about it. The face he had thought so young and beautiful now seemed old and full of malevolence, and when a reporter asked to borrow the mummy case in connection with an interview she was writing on Douglas Murray, he found that he was glad to know that the case was leaving his home.

Misfortune seems to have struck the unfortunate journalist as soon as the mummy case entered her home. Her mother fell downstairs and died as a result, her fiancé ended their engagement, her prize dogs went mad and she herself became ill. Her lawyer, with whom she had been preparing her will, decided that the mummy case was worrying her and he had it returned to Douglas Murray who decided to give it to the British Museum.

Still not feeling his old self, Murray obtained the services of a friend to make the necessary arrangements with the museum authorities and this man, himself an ardent Egyptologist, had the mummy case sent to his home where he studied the hieroglyphics. Within weeks the man was found dead. His servant said that his master had been unable to sleep ever since the mummy case had arrived at the house.

Eventually, the mummy case went to the British Museum and before long stories began to circulate that something unfortunate always happened to anyone who tried to photograph or sketch the mummy case. 'Cheiro' claimed that the British Museum authorities removed the mummy case from public exhibition and presented it to a museum in New York and that it disappeared when the 'unsinkable' Titanic sank on her maiden voyage across the Atlantic.

Stuart Martin, a novelist and journalist, studied the case and stated that in addition to the incidents recounted by 'Cheiro', Douglas Murray lost a large part of his fortune soon after the mummy case came into his possession, and that when the case was being photographed at a studio the photographer was puzzled and perplexed by an entirely different face that appeared on his photograph, a woman's face with hatred and spite in every line. The photographer died soon afterwards, said Martin.

When the mummy case was sent to the British Museum the carrier who transported the case died a week later, but Martin maintained that once the mummy case was at the British Museum, residing among other embalmed bodies and mummy cases of Egyptian nobility, no more disturbances occurred.

The ghost-hunter Thurston Hopkins told me that he was convinced that at least thirteen people who handled the haunted mummy case met with sudden death or disaster. He said that a press photographer had taken a photograph of the mummy case at the British Museum and had returned next day to Sir Ernest Wallis Budge, Keeper of Egyptian and Assyrian Antiquities in the British Museum for thirty years, with the photograph which showed another woman's face, so horrid and frightening that after leaving the museum, the photographer went home and shot himself. Hopkins always maintained that Wallis Budge, perhaps the most learned Egyptologist of modern times, was continually worried by reports from his staff about unexplained hammering noises and the sound of sobbing coming from the case containing the mummy. He said the case had an 'extremely lurid record' and wondering whether the priestess was not satisfied with her position and presentation, arranged for the mummy case to have a show-case to itself and a large ticket with a laudatory notice. Thereafter the mummy case was quiet.

Thurston Hopkins told me he had once interviewed a keeper in the Mummy Room who maintained that at dusk one evening he had seen a figure suddenly sit up in the empty bottom half of the mummy case of Amen-Ra and something with a horrible yellow face glided towards him with a sickeningly smooth movement, until he thought he was going to be pushed down a trapdoor. He sprang forward to protect himself only to find that his face and hands met nothing and the figure or form that he had seen had disappeared.

Kay Thomas, the daughter of a British Museum official, told Thurston Hopkins some of the many stories her father had related to her about curious happenings in the vicinity of the mummy case. Most of the museum cleaners seem to have been scared of some intangible influence and when one treated the case containing the relic disdainfully, his son died soon afterwards. Several

museum workers were injured when the mummy case was being set in position and most of the men firmly believed that 'she' exerted a harmful influence. Eventually, the case was relegated to the basement; during the removal one man suffered a sprained ankle and within a week one of the section chiefs died at his desk at the museum.

Wentworth Day told me that Budge believed that the Arab who found the mummy fell dead in the tomb as soon as his hand touched the folds of bandages that had covered the mummy for over three thousand years. He said that when the mummy case was photographed, one photographer died suddenly and the other smashed his thumb and his son was badly cut in an accident; even a photographer's assistant fell while adjusting the camera and cut his face. When a photograph was at length obtained it showed a livid and ominous woman's face, full of menace and evil. A later owner no sooner had it in his home than every piece of glass in the house shattered.

Fascinating as several of these stories are, there is some doubt as to their authenticity. Archaeologist Margaret Murray was nearly a hundred years old when I talked to her about the haunted mummy case. She told me she had rather a fondness for the old wooden coffin-lid with its beautifully-painted scenes but she always used to refer to its evil reputation when taking her students round the exhibits at the British Museum and invariably some would refuse to enter the room containing the mummy case. Margaret Murray maintained that she originated much of the reputed history of the mummy case during the course of an interview which she did not take seriously. She was astonished to find the story retold as fact in later years but the story, in one form or another, still crops up from time to time. It is a part of haunted London and occasionally, even today, visitors to the Mummy Room at the British Museum maintain that they have odd sensations when they look too long or too hard at the mummy case of Princess Amen-Ra, exhibit 22542, case 35.

In fact, the whole story seems to rest on a series of misunderstandings, as the Keeper of the Department of Egyptian Antiquities told me in December 1972. Mr Douglas Murray and Mr W. T. Stead stated that they had knowledge of an Egyptian mummy that had been brought to England by a lady and placed in her drawing room. Next morning everything that was breakable in the room was found smashed to pieces. When the mummy was moved to another room the same thing happened. The lady's husband then took the object to the top of the house and locked it in a cupboard. That night sounds of heavy footsteps tramped up and down the stairs all night and forms transported heavy articles from the upper floors to the ground floor; strange lights flickered up and down the stairway, accompanying the forms that shook the staircase with their weight-or power. Next day all the servants resigned in a body.

It was about this time (1889) that Mr A. F. Wheeler presented to the British Museum a very handsome inner cover from a mummy case of a great lady, a Princess of Amen and a member of the College of Amen-Ra at Thebes. This valuable object was accepted by the museum authorities and placed on exhibition in the First Egyptian Room, where it remained until 1920.

Mr Douglas Murray and Mr W. T. Stead studied the coffin lid and felt that the expression on the face of the cover was that of a living soul in torment and they tried to obtain permission to hold a séance in the Egyptian Room with the object of bringing relief to the entity concerned. Their views and opinions were published in many newspapers and readers recalled the mummy that was said to smash crockery and furniture and gradually the coffin lid in the British Museum became associated with the disturbances; a new and curious incident being added with each publication of the story.

Later, the story gained a fresh lease of life with reports that the museum authorities were receiving so many complaints about the dire effects of the coffin lid on show in the Egyptian Room, that it had been moved to the basement. It was claimed that several members of the

museum staff had died as a result of handling the coffin lid and that Sir Wallis Budge had been instructed to negotiate the sale of the terrible object to a wealthy American. The cover was said to have been shipped on the Titanic (causing the ship to strike an iceberg) but bribery had saved the lid from being lost. In America calamities and ill-fortune followed in the wake of the coffin lid and it was then sold to a Canadian who took it to Montreal where it continued to cause misfortune for everyone who came in contact with it, until the owner decided to send it back to England on the Empress of Ireland, which sank in the St Lawrence River, taking with it the Egyptian coffin lid.

In 1934, Sir Wallis Budge felt it necessary to announce that the British Museum never possessed mummy, coffin or cover that had any of the reputed attributes. The Trustees never gave any order for the removal of the cover — exhibit 22542 — to the basement, although during air-raids in the First World War, it was moved to a place of safety. The British Museum Trustees have no power to sell any object in their charge, still less has a keeper the right to dispose of anything, whatever the circumstances. Finally Sir Wallis stated categorically, 'I did not sell the cover to an American. The cover never went on the Titanic. It never went to America. It was not sold to anyone in Canada, and it is still in the First Egyptian Room at the British Museum.' Later, the coffin lid was moved to the Second Egyptian Room where it still resides, an object of speculation, awe and wonder to many visitors if not to the museum authorities.

Sir Wallis Budge (1857-1934) translated the famous Egyptian Book of the Dead, considered to be of divine origin having been written entirely for the dead by the god Thoth. It is filled with spells and incantations for the preservation of the mummy and for everlasting life. Budge, in private if not in public, certainly believed in Ancient Egyptian magic and the power of their dead. He has been quoted as saying, 'Never print what I say in my lifetime but the mummy case of Princess Amen-Ra caused the war.' An enigmatic statement that he refused to enlarge upon. Today, the coffin lid is labelled, 'Mummy cover from the coffin of an unknown princess from Thebes; XXIst Dynasty. About 1050 BC. Presented by A. F. Wheeler, 1889.'

THE COLISEUM THEATRE, ST MARTIN'S LANE

The Coliseum used to have a soldier ghost that dated from the First World War. The uniformed figure used to walk down the dress circle gangway and turn into the second row, just before the lights were lowered for a performance to begin. The figure was recognized as a soldier who spent his last evening on leave at the theatre and the ghost was first seen on October 3 1918 — the date that the soldier was killed in action.

COVENT GARDEN UNDERGROUND STATION

In November 1955, following reports that the ghost of William Terriss had been seen here, I talked with several of the station staff and learned that peculiar happenings had been experienced in the immediate area of the station for some time. For the previous three years, engineers and gangers working on the line had complained of a ghostly figure in one of the tunnels after the station was cleared at night. There were echoing footsteps, occasional sighs, gasps and loud banging noises, which the workmen, long used to working in isolated conditions underground, had never previously experienced.

I talked with a foreman ticket-collector, Jack Hayden, who had been at the station for nine years. He told me that one night after he had locked all the gates of the station, and was making a final

check that the platforms were deserted, he suddenly noticed a tall and distinguished-looking man walking along the west-bound subway and climbing the emergency spiral stairs. Hayden quickly telephoned upstairs and told the booking-office clerk to apprehend the man coming up the stairs. Hayden himself took the lift up and met a puzzled clerk, who said no one had emerged from the stairs. Together the two men searched the spiral stairs from top to bottom and all parts of the station but there was no sign of the mysterious stranger.

A few days later, Hayden was having a meal around midnight in the staff mess-room at the station, which is just below ground level. The last train had gone and Hayden knew that the station was deserted, yet suddenly a door opened and he saw the same tall man standing looking in at him. This time he noticed the old-fashioned cut of the man's grey suit, his old-style shirt collar and his light-coloured gloves. Thinking that some passenger must have lost his way, Hayden asked the man what he wanted, but instead of answering, the figure moved out of view. Hayden quickly moved through a communicating door that gave him an uninterrupted view of the whole passage where the figure had stood, but there was no sight or sound of the man he had seen.

Covent Garden Underground Station, where the ghost of actor William Terriss has been seen more than a dozen times.

Four days later, at midday, he and Rose Ring, a station worker, were in the mess-room together when they both heard a loud scream and the next moment Victor Locker, a nineteen-year-old porter, burst into the room gasping that he had seen a strange-looking man standing in a corner of the next room and when he had moved towards the figure to ask what he was doing, he had experienced the feeling of something pressing down heavily on to his head and the man had vanished in front of his eyes. Subsequently, Locker added that the man he saw was wearing 'funny-looking clothes' and pale gloves. When Jack Hayden described the figure he had twice seen, the porter agreed that it was the same figure that had frightened him. Locker asked for a transfer and left Covent Garden Station shortly afterwards.

Subsequently, Eric Davey, a foreman at Leicester Square Station told me that he was satisfied that there was something strange at Covent Garden Station. He was clairvoyant and had been aware on several occasions of an unseen presence in the mess-room there. Furthermore, he believed that the spirit was trying to give a name sounding something like 'Terry'. When Hayden was shown a photograph of William Terriss, he immediately stated that Terriss was the man he had seen. William Terriss always wore light-coloured gloves.

Over the next ten years the ghost was seen more than a dozen times and when Hayden left the station in 1965 he said the apparition invariably appeared during November and December and always looked exactly the same, and it usually appeared near a wall. He spoke to it several times but it never answered. The last time he saw it, late one November night in 1964, he was walking down the spiral stairway when he encountered the ghost walking up the same stairs. He hurried past the silent figure that did not seem to notice him and almost fell down the last few steps. But

the knocks, the footsteps, and the feeling that he might see the figure at any time was all becoming too much of a strain and so he asked for a transfer and left the station. However, the ghost still walked, and inexplicable footsteps have been reported on many occasions, especially on Sundays when the station is closed to the public, and usually the footsteps seem to come from just within the tunnel that runs from Covent Garden to Holborn. The figure of William Terriss (if William Terriss it is) was seen several times by a signalman, a station master, an engineer and other workers in March 1972. Small wonder that some of the station staff at Covent Garden refuse to use the mess-room there.

THE DUKE OF YORK'S THEATRE, ST MARTIN'S LANE

Although the Duke of York's Theatre in St Martin's Lane has no resident ghost that I know of, it was the scene of some very odd experiences some years ago when a certain costume jacket became known as the 'Strangler Jacket' and actress Thora Hird was among those who were affected by wearing it.

In 1948, Thora Hird was leading lady in A *Queen Came By*, a play set in the days of Queen Victoria's Jubilee, and part of her costume was an old short-backed, bolero-style jacket that had been made some five years earlier. Although there seemed ample room in the jacket and the size was right, Thora Hird found that it produced an unpleasant tightness about the arms and chest. She said nothing at first, but began to detest the coat, which seemed tighter every time she wore it. One night, Thora Hird was unable to appear and her understudy, Erica Foyle, took over the part, and for the first time wore the jacket. She experienced exactly the same tight and unpleasant sensations, although she knew nothing of Thora Hird's impressions. That night Erica Foyle saw the apparition of a young woman wearing the tight-fitting jacket.

Erica Foyle told her experiences to the stage manager, Marjorie Page, and when Thora Hird related feeling similar sensations, Marjorie Page tried the jacket on herself and found that it affected her in the same way. Mrs Frederick Pifford, wife of the play's director, tried on the coat with no ill effect, until she removed it and those present pointed in horror at a series of red weals that had appeared on Mrs Pifford's throat, marks that might have been expected after an attempt at strangulation! During the course of a séance held at the theatre a medium described a vision in which a young girl provoked insane jealousy and anger in a man who attacked the girl, tearing her clothes, until the girl fell backwards and she was forced into a barrel of water until she drowned. The man then dragged her body up a flight of stairs where he wrapped the body in a blanket and carried it down the stairs again, wet and dripping with water. Here the vision faded. At this point, Marjorie Page, who was watching the proceedings, exclaimed with some excitement that she had seen a very similar vision at the time she had worn the jacket, but it had seemed so fantastic that she had said nothing about it at the time. A little later, a man tried on the coat — and promptly fainted. A younger man took a turn and immediately seemed to have difficulty with his breathing.

The subsequent history of the jacket is interesting. It seems to have become the property of a man named Lloyd who lives in Los Angeles and within minutes of wearing the jacket his wife felt totally exhausted, almost as though she was being strangled or drowned; she complained of a feeling of suffocation of the lungs and an oppressive weight on her legs. A sixteen-year-old girl felt as though fingers were plucking at her throat when she wore the coat, another woman who tried it on said it felt as heavy as armour and it hurt her and a third woman hurriedly removed it after three minutes, saying that it seemed to choke her. The mental condition of those wearing the jacket and knowing something of the story associated with it may be the cause of the impressions

received by later wearers of the 'Strangler Jacket', but what about the initial reactions of Thora Hird and her understudy? The origin of the jacket is obscure. There is some evidence that it was originally made for an early production of *Charley's Aunt* and was stored at a theatrical costumier's for nearly fifty years, but other people maintain that it was picked up from an old clothes stall at a London market. What is indisputable is that the coat is a piece of Victoriana and it was worn by a young woman in a play concerning Queen Victoria; perhaps the combination of these facts and circumstances sparked off some kind of psychic energy.

Gower Street, Bloomsbury

A teashop that used to stand at the north end of Gower Street (before the modernization of the road junctions there) was said to be haunted by the ghost of a man with a bandaged head, a man who vanished whenever waitresses approached him for his order. The restaurant used to be frequented by medical students from nearby University College Hospital but the immediate and quite inexplicable disappearance of the figure, which always occupied the same table, seems to invalidate the popular explanation that medical students were playing practical jokes. It seems more likely that it was the same ghost that haunted a boarding house in Gower Street a few years earlier.

The trouble began when a young lady lodger was awakened one night by a loud noise and starting up in bed she was terrified to see the head and shoulders of a man, swathed in bandages. The form, which seemed to have a luminosity of its own, appeared in an alcove of the room usually occupied by a bookcase, which had been torn from its fastenings and lay broken on the floor — a probable cause of the noise that had awakened the terrified girl.

A few days later, loud knocks were reported by several people in the house and the following week the figure with bandaged head was seen again. Later, more rappings were heard and thereafter the disturbances seemed to cease. No explanation was ever discovered for either the distinct rappings or the singular apparition.

King Street, Covent Garden

An old house in King Street, Covent Garden, has long been regarded as haunted and may be the one in which 'a handsome woman, but common' saw her 'friend', the son of Lord Mohun, after he had been killed. John Aubrey records that in the seventeenth century the gallant young son and heir of Lord Mohun had a quarrel with a Prince Griffin and it was arranged that a duel should be fought on Chelsea Fields, on horseback, with swords.

On his way to the rendezvous Mohun was stopped by a party of men who picked a quarrel with him and shot him dead. It was commonly believed that the whole thing was organized by Prince Griffin who knew Mohun to be a better horseman than himself.

The murder took place at ten o'clock in the morning and on the same day and at the same time this 'handsome but common' lady-friend in King Street saw the figure of young Mohun at her bedside. He drew the curtains aside, looked in on her and then disappeared. She called out to him and then to her maid, who did not see the figure, but the door of the room was locked and the maid had the key in her pocket. Aubrey arranged for a friend to question both the mistress and her servant and was satisfied that the account was a true one.

The same house has so affected some people that nothing would induce them to spend a night there by themselves. A surveyor, during the course of making some specifications of the

King Street, Covent Garden, where the ghost of the son of Lord Mohun appeared at the precise time of his murder in Chelsea.

building, stumbled down some very worn steps in the basement and found himself in a deep cellar. He knew that a lot of these old houses were built on the site of the old Convent Gardens of Westminster (St Peter's) Abbey and thought he would see how far the cellar extended, it having been suggested that some of the cellars connect with one another.

The surveyor noticed that the cellar was full of coal and, seeing a shovel close by, he set about moving some of the coal so that he could explore further, but as fast as he moved the coal, it slid or rolled back to where it had been previously. After a while, the surveyor gave up and returned upstairs where he talked to the housekeeper about the cellar and the steps and was surprised to learn that the old man seemed to have no knowledge of the stock of coal or of the worn stone steps.

Some time later, the surveyor had occasion to return to the house to check some measurements and, descending to the basement, he was amazed to find neither steps nor coal down there. A burly manservant in the house at the time rarely ventured down into the basement because, he said, he had seen a shadowy appearance of evil down there and he knew others who felt a bad influence in that part of the house. Once he fired a revolver at something he saw in the house, but without any visible effect. I understand that the cellars of this particular house have now been sealed and I could obtain no adequate reason for this action.

THE LYCEUM THEATRE, WELLINGTON STREET, STRAND

The old Lyceum Theatre in Wellington Street, off the Strand, had a ghostly corpse-like figure that stalked backstage during performances, but it seems to have disappeared since the theatre became a dance hall, its elegant Corinthian portico disfigured with massive poster boards. As the venue of many a beauty contest, more attractive figures now walk backstage!

At a meeting of The Ghost Club, W. J. Macqueen Pope related a gruesome experience at the richly decorated Lyceum, as it was about a hundred years ago. During a performance at the theatre, a man, occupying a box with his wife, chanced to look down towards the stalls and there noticed a woman in the fourth row dressed in beautiful coloured silks with what looked like a man's head on her lap! The man's wife noticed the direction of his gaze and asked him what on earth the woman had on her lap adding 'It looks like a man's head!' In fact, they both agreed that the pale-faced head with closed eyes had long hair, a moustache and pointed beard and they both thought it looked like the head of a cavalier. During the interval the man and his wife, overcome with curiosity, left their box and walked through the stalls of the theatre to obtain a closer look at the strange object, but they were disappointed to discover that any object on the lady's lap was now covered by a silk wrap. At the end of the performance they tried to intercept the well-groomed lady who appeared to be unaccompanied, but they lost her in the crowd of theatre-goers leaving the building. Years later, the man, by that time something of an expert in art and *objets d'art*, was invited to visit an ancestral hall in Yorkshire to value some paintings. There he saw a portrait of a cavalier and it was indisputably the man whose head he had seen at the Lyceum. During the course of enquiries he learned that the portrait was that of ancestor who had been beheaded by Cromwell, and he further discovered that the family had once owned the ground on which the Lyceum Theatre was built.

Metropolitan Music Hall, Edgware Road (demolished)

The Metropolitan Music Hall in Edgware Road had a ghost that dated from the First World War, a manager who had been killed on active service in France was often seen at early performances dressed in a brown suit and seemingly watching the stage and the attendance with a critical eye. After a while the figure was simply no longer there. It was never seen anywhere in the theatre except seated near the back of the stalls.

Red Lion Square, Holborn

A London square that is unique in that it used to be haunted by three ghosts walking together. The square, much altered in recent years for the benefit of motor traffic, was built in 1698 on the Red Lion Fields where, it was commonly believed, the remains of Oliver Cromwell, Henry Ireton, the Parliamentarian general who married Cromwell's daughter Bridget, and John Bradshaw who, as president of the court, pronounced the death sentence on Charles I, were brought from Westminster. The bodies of all three men were disinterred from their tombs in Westminster Abbey after the Restoration and publicly hanged at Tyburn, as an expression of public feeling for their part in the Civil War and the harsh rule afterwards.

Although Red Lion Fields was not on the route from Westminster to Tyburn, the tradition is very strong and it seems always to have been believed that the bodies were brought to Holborn. One possible explanation is that since a gallows stood at that time near Red Lion Fields, it is not unlikely that there was a misunderstanding as to the gallows on which the bodies were to be exhibited, which resulted in the remains arriving at Red Lion Fields and soon afterwards being taken to Tyburn to be hanged on the famous gallows there. It is by no means unlikely that further desecration of the bodies took place at Red Lion Fields, the site of Red Lion Square.

Red Lion Square, Holborn, has three ghosts that walk arm-in-arm and three haunted houses.

Those who have seen these ghosts say they walk three abreast and appear to be in deep conversation with each other. They ignore the present paths, roadways and railings and walk in a straight line diagonally across the old area of the square from south to north.

Historian Sir John Prestwick states that Cromwell's remains were 'privately interred in a small paddock near Holborn on the spot where the obelisk in Red Lion Square lately stood'. Other authorities assert that the bodies of Cromwell, Ireton and Bradshaw were lodged at the old Red Lion Inn at Holborn, before being dragged on sledges next day to Tyburn.

A number of the older houses in the square were haunted within living memory. One was the scene of a murder and thereafter the murdered woman's ghost was sometimes seen on spring mornings in the vicinity of the hall and stairway. The murder took place one April morning. The house next door had haunted rooms at the top of the property and a former occupant told me of distinct footsteps that were often to be heard approaching one of the doors, although nothing was ever seen. Other people in the house maintained that they frequently saw the ghost of an elderly man in the lower part of the premises.

Mrs P. Fitzgerald, the artist, of Worthing, Sussex, once had a studio in Red Lion Square, in a house owned by Dr Josiah Oldfield. One night as she returned to her studio Mrs Fitzgerald saw a poorly-dressed woman, almost a gipsy, come out of the house and the strange figure seemed to hiss at the artist as she passed, 'Lady, don't paint the bridge.' When Mrs Fitzgerald turned to reply, there was no sign of the figure and Dr Oldfield informed her that he had no knowledge of anyone with such a description, although he seemed reluctant to discuss the matter.

A few days later Mrs Fitzgerald was asked to paint a roof garden which had a bridge leading from one floor to another and something, she knew not what, made her refuse the commission. On the day that she would have been working on the painting the whole bridge and part of the roof garden collapsed and it is likely that she would have been killed had she agreed to paint the bridge.

Years later Dr Oldfield told her that a gipsy, suspected of witchcraft, had been killed by a mob on the premises at the time of the Great Fire of London. In December 1972, my friend Dr Peter Hilton-Rowe was good enough to tell me about yet another haunted house in Red Lion Square and Mrs Beryl Sweet-Escott of Dedham, Essex, has recounted her experience for me, as follows:

I have a vivid recollection of an apparition I saw on the staircase of a house in Red Lion Square. I think it was in the summer of 1936, but at all events it was a bright and sunny day. A dressmaker who lived on the third floor was making me a garment of some kind (I cannot remember her name, unfortunately) and I had an appointment for a fitting, probably about 3 p.m. I started to climb the stairs — a fine, wide

Georgian staircase, uncarpeted, with the usual twists and turns. At the corner, before reaching the second floor, a charming old gentleman stood back to let me pass. He was white-haired, wore a long blue coat, white breeches and stockings, and buckled shoes. He had what I think was a three-cornered hat under his left arm. He bowed and smiled and I passed on up the stairs. What is odd to me is that I was neither surprised nor alarmed. He was not, I would say, transparent, but appeared semi-solid, if you know what I mean.

In the middle of my fitting, I said to my dressmaker friend, 'I thought I saw a ghost on your stairs.' 'Oh, did you?' she said, mouth full of pins. 'What did he look like?' I described him and she said matter-of-factly, 'Oh yes, we all know him here — we've seen him several times and we're rather fond of the old boy. He's quite harmless of course, and always has such nice manners!' I never saw any of the other occupants of the house. I have an impression that it was Number 10 but am not sure.

THE STRAND, WC2

Mr Alan Dent, the well-known theatre and book critic, has related to me his experience of seeing the ghost of Baroness Burdett-Coutts in the Strand, just east of Coutts's Bank, one sunny June morning during the Second World War.

There had been a heavy air-raid the night before and under the clear summer sky workmen were busy clearing away the rubble and broken glass. Suddenly, Alan Dent noticed an elderly lady walking ahead of him, a somewhat singular figure in Edwardian dress: black satin, white lace beneath the bone-supported collarette, a small black and feathery hat, diamond earrings, black shoes and hands hidden in a dark muff. She was clearly walking and not floating as many ghosts are traditionally said to do.

As he followed the figure he had the fancy that he had seen her once or twice before, once in Long Acre and another time in Oxford Street, but always from the rear. This time he decided to pass the old lady and then look back and obtain a full view. As he quickened his steps and passed her, he had a glimpse of a pale complexion and a slight pout as she continued in an unhurried but purposeful way.

Passing Coutts's Bank, having been out of sight of the figure for less than thirty seconds, Alan Dent paused at a shop window and then looked round and prepared to walk back the way he had come. But there was no sign of the old lady. She had completely vanished and there was no one in front of him for the whole length of the bank. She was not crossing the road and she was not on the opposite pavement. Nor, at that moment, was there any taxi or car in sight, in either direction. Deciding that she must have entered the bank, Alan Dent hurried to the entrance where a commissionaire was just opening the doors, the time being ten o'clock. No one had yet entered the bank by the front door.

Some days later Alan Dent happened to describe this strange experience to the landlord of a tavern in Long Acre, a shrewd old Welshman named Arthur Powell, who listened carefully to the story and then suggested that the figure sounded like the Baroness Burnett-Coutts going into her own bank. He recognized Dent's description for he had seen the old lady many times as his father had been one of her coachmen. But she had died forty years before.

Baroness Burnett-Coutts was a great friend of Charles Dickens and Henry Irving and the Duke of Wellington, also of Queen Victoria until 1881. Then the sixty-seven-year-old baroness married her former secretary, an American forty years her junior. Queen Victoria was not amused, rather she was shocked and she never visited the baroness again. When Baroness Burnett-Coutts died, at the age of ninety-two in 1906, King Edward VII said she was the most remarkable woman in the

Coutts Bank in the Strand where the ghost of Baroness Burnett-Coutts was seen by theatre-critic Alan Dent.

kingdom after his mother. The baroness's family told Alan Dent that her ghost is also reported as having been seen in the East End of London where the Baroness endowed a market and a block of dwellings in Bethnal Green. And Alan Dent never walked along the Strand without thinking about the baroness and hoping to see her again.

THEATRE ROYAL, DRURY LANE

The best known of all theatre ghosts is the Man in Grey at the Theatre Royal, Drury Lane. I first heard the story from that great theatre historian W. J. Macqueen Pope many years ago, and it was a fascinating account, for 'Popie' told me that he had himself seen the ghost, not once but several times.

The ghost is a slim figure of a young man dressed in grey. He has a white wig, carries a three-cornered hat, wears riding boots and has a sword hanging from his waist. One summer afternoon in 1955, 'Popie' showed me the precise track of the ghost. He is first seen occupying the first seat of the fourth row of the upper circle and then moves across the theatre along the gangway at the back until finally he disappears at the far end into the wall near the royal box.

The figure is always seen in daylight between 10 a.m. and 6 p.m. and all witnesses agree on the romantic attire, although some people say that he has powdered hair and is not wearing a wig, and others report that he is wearing the tri-corn hat. Invariably, no sound accompanies the appearance or movement of the apparition, which walks leisurely and without hurrying, as though he is thoroughly accustomed to the theatre — as indeed he was.

'Popie' thought that the young man, whose handsome face with square chin has been clearly seen so many times, probably had a girl friend in the theatre in the eighteenth century. She was possibly a favourite of the theatre manager of the time and the young man may have been ordered out; perhaps an argument and a fight followed, and the young man fell, mortally wounded by a stab from a dagger, and the body was hastily walled-up in a little passage along which he had walked every night to meet his sweetheart.

This theory is based on a discovery in mid-Victorian days when during structural alterations workmen on the upper circle reported that part of the main wall sounded hollow. When the wall was broken down a small room or part of a passage was disclosed, and on the floor lay the skeleton of a man with a Cromwellian-style dagger still embedded between the ribs. A few pieces of cloth were found among the bones, but they crumbled to dust as soon as they were touched. The place where the gruesome discovery was made corresponds exactly with that part of the wall where the ghost is said to disappear. The walls where the skeleton was found were unaltered during the 1796 rebuilding and after the fire of 1809.

An inquest followed the discovery, but in the absence of contemporary evidence an open verdict was returned and no one knows who the victim was or why he was killed. The remains were buried in a little graveyard on the corner of Russell Street and Drury Lane; a place that ceased to be a burial ground in 1853 and is now marked by a small open space and children's playground, known as Drury Lane Gardens.

It seems indisputable that scores of people have seen this daylight ghost and 'Popie' told me that once, during a rehearsal, the ghost walked while over a hundred people were on stage and seventy of them saw it. 'Popie' himself saw the phantom many times over the years, both before and after the Second World War and in his history, *Theatre Royal, Drury Lane*, he writes that he wished to put on record that he had seen this apparition 'on numerous occasions'.

Oddly enough, the ghost is regarded as a good omen for its appearance during rehearsals or during the early days of a run at the Theatre Royal invariably seems to forecast a success for the production. The ghost was reported to have been seen within a few days of the opening nights of such successful musicals as *Glamorous Nights, Careless Rapture, Crest of the Wave* and *The Dancing Years*. The ghost was not seen before or during the run of *Pacific 1860*, which turned out to be a failure, but he was seen again just before the successful runs of *Oklahoma, Carousel, South Pacific, The King and I* and *My Fair Lady*.

The Dancing Years was playing the night war broke out and Ivor Novello called everyone in the half-empty house down into the stalls so that they would be less vulnerable should bombs fall. One did fall on the theatre three years later; it landed in the bar where the fire-wardens were sleeping, but it failed to explode. The wardens moved out of the room and twenty minutes later an incendiary bomb came down through the same hole and set everything alight. People have always been lucky at 'The Lane'. Even the ghost, appearing as it does only between the hours of 10 a.m. and 6 p.m., has never really frightened anyone.

One spring morning in 1938 a theatre cleaner was in the upper circle. It was just after 10 a.m. and a rehearsal was in progress. As soon as the cleaner entered the circle she saw a man dressed in grey and wearing a strange hat, sitting on the end seat of the fourth row, by the centre gangway, gazing down at the stage. She thought that it must be an actor, but decided to make sure, and, putting down her pail and broom, she went to speak to the figure. As she drew near it seemed to melt and had soon disappeared. Then a movement caught her eye near the exit door on the right-hand side of the circle and she saw the same figure, just as it vanished into solid wall. She said she had never heard of the Man in Grey, although her description fitted with other first-hand accounts, even to the sword and riding boots.

Some years earlier, during a matinee performance, a lady occupying a seat in the upper circle asked an attendant whether actors in the musical came out among the audience. They did not do so in that performance, and the attendant asked the reason for her question. The lady replied that she had noticed a man in a long grey cloak, with a white wig and three-cornered hat, pass through the entrance doors ahead of her. There was no person in the theatre remotely resembling such a description. Over the years, firemen, theatre officials, producers, theatre-goers, visitors and residents have all seen a strikingly similar figure.

However, on the two occasions that psychic investigators visited the theatre they had little success. The first occasion was during a period when several people had claimed to see the ghost. The party consisted of six people, including Wentworth Day; Harry Price, the noted psychic investigator; Jasper Maskelyne of the famous conjuring family; and Macqueen Pope. Suddenly, Wentworth Day's secretary gripped his arm and pointed to the wall where the skeleton was discovered. Wentworth Day told me that he looked immediately and saw a grey-blue, almost luminous light hovering there, then it moved across the darkness of the royal box. It seemed to move with the odd and uneven action of a man with a limp and then vanished. A moment later, the same form appeared at the back of the upper circle, in mid-air, about four feet from the floor. Again it moved unevenly, seeming to have no shape and certainly casting no shadow. Suddenly it was gone. No one else in the party turned quickly enough to see anything. A few years later, another party of celebrities, including Tod Slaughter and Valentine Dyall, spent several hours at the theatre and were even less fortunate — none of them heard or saw anything inexplicable, as I relate in my biography of Boris Karloff.

During the war, the theatre was taken over by the Entertainments National Service Association, and in 1942 Stephen Williams, the broadcasting officer, reported that he saw the ghost clearly while he was climbing the grand staircase near the upper circle entrance. The following year, Mrs R. Hogben, a member of the ENSA Headquarters staff, saw the same figure. She was a stranger to London at the time and had never heard of the theatre ghost.

The ghost was also seen at this period by stage, radio, film and television actor Henry Oscar who was director of drama for ENSA during the war. He told me that he was taking his turn at fire-watching one night in the huge and empty theatre; enemy bombers were overhead and Oscar was making his rounds of all parts of the theatre, and he was just crossing the stage when, as his torch beam swept across the corner of the auditorium, he caught sight of a movement and he saw a slim figure coming towards him from about the level of the first box, seemingly suspended in space. 'There was no doubt at all in my mind that this was the same apparition that habitually haunted the upper circle,' he told me. 'It was certainly no mortal intruder — too shadowy in outline, besides being quite definitely in costume: the riding boots, grey breeches and coat, the ruffled shirt and tri-corn hat, even the sword hilt were all plainly visible in the moment that I saw the figure.' Henry Oscar did not stay long enough to watch what happened to the form; he made a hurried exit from the stage back to the office that served as fire-watching headquarters at the theatre, and during the next round of inspection there was no sign of the mysterious form that he had seen.

In 1949, John Ellison, a well-known BBC interviewer, commentator and question-master, went to Drury Lane to look for the ghost that had been seen two days before. A reporter noticed 'a distinct psychic tension' at the Aldwych end of the upper circle and one BBC engineer experienced 'pins and needles' and at the same spot another said he felt as though his hair was trying to stand on end. John Ellison was intrigued and when he reached that particular place he noticed a decided chill, which he could not account for, and he found that he did not wish to stay in that part of the theatre, which was a spot on the ghost's 'walk'.

In September 1950, actor Morgan Davies, a leading actor in *Carousel* then playing at the theatre, saw the Man in Grey. At a Saturday matinee performance the house was full as usual, and Davies' attention was drawn to one empty box. Yet, when he looked again he saw that the box was now occupied by a figure wearing a grey cloak, open at the front to reveal long sleeves with ruffles. The figure stood in the box, swaying slightly, and lifted an arm. Much to his astonishment, Davies found that the arm was transparent and he could see through it to the door of the box, which was illuminated by a glow of light. Morgan Davies was on stage for twenty-five minutes in that particular scene and he estimated that for at least ten minutes the figure was visible in the box, then it vanished. The only other actor taking part in the scene was facing away from the box in which the figure appeared and so did not see the strange appearance, although one of the chorus girls said that she too had seen such a figure during another matinee performance. Morgan Davies said at the time he knew nothing of the reputed Man in Grey.

More recently, Eric Rosenthal, 'South Africa's Walking Encyclopaedia', told me that he met someone who had seen the ghost at the Theatre Royal, also during a matinee performance, and this witness too had never heard of the ghost. The figure was described as greyish in colour, of medium height, long light-grey hair under a three-cornered hat and with an erect posture. The figure disappeared when a member of the audience walked towards it.

Some years ago, I learned that the theatre cat, James, never would go near certain parts of the theatre. The cat, docile and friendly enough otherwise, would shriek and nearly go mad if it was carried into the upper circle. Two of the actors in *Gone with the Wind* saw the ghost, and Dame Anna Neagle told me in August 1973 that there was a lot of excitement — or apprehension — during the early run of *No, No, Nanette* when apparently ghostly manifestations were experienced by some of the cast.

In his *Encyclopaedia of London* (1951) William Kent refers to the Man in Grey in a compact and lucid paragraph:

> Drury Lane Theatre is the locus of an authenticated 'haunt'. Said to have been seen by hundreds of persons at different times the spectre, in eighteenth-century costume, emerges from the wall at the left of the circle and traversing the rear of the seating, enters the opposite wall of the auditorium. Its appearances are frequent but not cyclic; it normally favours matinees of successful productions. Its corpus, together with a dagger, was discovered a hundred and three years ago in a sealed room within the wall from which it walks. It is three-dimensional but not opaque, and becomes imperceptible when approached. The purpose of its perambulations cannot be ascertained, for it does not react in any way to endeavours to communicate.

There are other ghosts at the Theatre Royal, as one would expect in such a historic building. The iron foot-scraper by the stage door has been worn into a curve by three hundred years of use. George II was brought the news of the Young Pretender's defeat on Culloden Moor whilst watching a play from the royal box, and such memorable actors as Joey Grimaldi, Dan Leno, Mrs Siddons, Charles Kean and David Garrick are forever associated with this beautiful theatre.

The ghost of actor Charles Macklin, who murdered another actor in the Green Room 200 years ago, has been reported from time to time, stalking across the theatre in front of what used to be the pit. A grand old actor, Macklin was tall, emaciated and hatchet-faced and he had a quick temper. In 1735, during the course of an argument, he thrust his stick at another actor, Thomas Hallam. The stick pierced Hallam's eye and he died as a result, yet it is Macklin's ghost that is occasionally seen at the theatre, usually during the early evening when the tragedy most probably took place.

Another ghost at Drury Lane is that of the much-loved comedian Dan Leno, a ghost seen by, among others, comedian Stanley Lupino (father of actress Ida Lupino). He often spoke

about the experience to his friends and other comedians, including Arthur Askey, who knew Lupino well; he has told me that he has no doubts that Lupino did have the experience that he described so vividly.

Late one night after appearing at the theatre in pantomime Lupino felt too tired to go home and he lay down on the couch in his dressing room. Almost immediately he had the feeling that he was not alone in the room and he heard a sound, which he afterwards described as resembling a curtain being drawn aside. Sitting up, he saw the dark form of a man cross the room and pass through a closed door. Puzzled, Lupino sought out the theatre caretaker and learned that no one had been near the dressing room; in fact, there was no one else in the theatre at the time.

Back in his room, Lupino again prepared to rest when another noise attracted his attention, this time close beside him. He sat up and saw himself reflected in the make-up mirror, and beside his own face he saw the deathly white but unmistakable features of Dan Leno. Really frightened by now, Lupino sprang up and rushed out of the theatre and spent the night at the Globe Theatre. He never forgot the experience. He learned afterwards that the room had been the favourite dressing room of Dan Leno, and the last one that he had used.

Other actors and stage-hands have also seen the famous old-time comedian, and not infrequently occupants of that particular dressing room report the rhythmic but quite inexplicable sound of tapping, and Macqueen Pope reminded me that Dan Leno was well-known for his clog-dancing as a young performer. A member of the cast of a Dan Leno pantomime asked once whether she could spend a night alone in his dressing room. Later, she too said she had seen the ghostly face of Dan Leno and fainted at the sight.

Macqueen Pope told me about a lady who had written to him after seeing yet another ghost at the Theatre Royal. She attended a matinee performance with her brother and sister and they had occupied end seats in the dress circle. The informant and her sister noticed a man with very long hair a few seats away in the same row, wearing strangely old-fashioned clothes — almost mid-nineteenth century in appearance. Their brother, to their surprise, said he could not see the man. The play opened and the attention of all three theatre-goers was centred on the stage, but at the end of the first act, when the lights went up, the ladies were amazed to see that the man was no longer there. Yet his position would have meant that he had to pass them to leave, and certainly no one had disturbed them. Some time later, the same correspondent wrote again to Macqueen Pope to say that she had just read his book on the Theatre Royal and had recognized from a photograph in the book the mysterious person she and her sister had seen: it was undoubtedly Charles Kean, the actor-manager who had loved Drury Lane Theatre and who had died in 1868.

Several actresses have felt friendly hands guiding them to the correct positions when they have been on the great stage for the first time at the Theatre Royal. In particular, Betty Jo Jones, the American comedian, told Macqueen Pope during the run of *Oklahoma* that she felt invisible hands helping her. She said she was gently guided to a position downstage, which was greatly advantageous both to herself and to the production as a whole. The following night she had precisely the same experience; thereafter she used the new position and once, just as she had moved there, she felt a kindly pat on the back.

Early in the run of *The King and* I, singer Doreen Duke had a similar experience: the feeling of two hands on her shoulders guiding her to the right place at the right time, and occasionally she too felt an invisible pat of encouragement. Like Betty Jo Jones, she was certain that the help she had had at Drury Lane Theatre was 'not of this world'. And there is a man who swears that one summer afternoon in 1948 he saw the forms of King Charles II and a crowd of his gaily-dressed courtiers pass down the side gangway of the stalls, mount the stage and disappear among the company of *Oklahoma*.

UNIVERSITY COLLEGE, GOWER STREET

University College was long ago dubbed 'the Godless University' for its freedom from religious trammels, in accordance with the wishes of its founders, Lord Brougham, Thomas Campbell, James Mill and Jeremy Bentham (the law reformer and natural scientist whose original manuscripts are still preserved in the building).

Bentham's ghost is reputed to haunt University College, and on winter evenings people have heard the tapping of his stick, and there have been other reports of people actually seeing him — an eccentric figure, complete with his famous white gloves and his walking stick called 'Dapple' that was his constant companion.

One such report came some years ago from Mr Neil King, the school's mathematics master. He was a level-headed and practical man who was surprised to hear, one evening when he was working late, the tap-tap-tap of a walking stick approaching his room along the corridor. He listened for a moment. There was no mistaking the sounds, and they were approaching. In another moment they would pass his room. Quietly he rose from his desk and opened the door, giving him an uninterrupted view of the corridor from which the sounds seemed to originate. He did not expect to see anything but there was Jeremy, complete with white gloves and walking stick, tap-tapping his way along the corridor, apparently quite oblivious to the wide-eyed mathematician standing in his path. Frozen into inactivity by surprise at the encounter, Neil King stood his ground as the singular form walked right up to him and when he was almost upon the schoolmaster, the form seemed to suddenly dart forward and almost throw itself 'bodily' at the teacher; but there was no sensation of impact and then King realized that all sight and sound of Jeremy Bentham had disappeared.

Jeremy Bentham (1748-1832) is an extremely important figure in the history of philosophy. His doctrine of utilitarianism had a wide influence in radical politics, but his idea of mummification as permanent memorials ('auto-icons' he called them) never became popular and instead of driveways lined by a gentleman's ancestors varnished against the elements, very few mummified corpses are on general view apart from Lenin in Moscow and, until recently, the unknown man in St James's church, London.

Bentham eagerly discussed the treatment of his own body before his death and his skeleton was padded and dressed in his own clothes and can be seen today, in a moth-proof glass-sided box in a cloister near the entrance hall at University College. He sits in the chair that he often occupied in his lifetime, with one hand on 'Dapple' and wearing his white gloves. The mummification of the head was not entirely successful and after some years it was replaced by a wax likeness, made by a distinguished French artist. The original head is still preserved separately.

From time to time, the sound of his footsteps and the ominous tap-tap of his walking stick are still reported from the deserted corridors of University College. Occasionally, books and other objects are found displaced in one classroom and this disturbance has been attributed to the presence of Jeremy Bentham's ghost. Once a loud sound described as 'like flying wings' so startled a student late one evening in the corridor that he could see was deserted, that he did not wait to hear any phantom footsteps!

UNIVERSITY COLLEGE HOSPITAL, BLOOMSBURY

University College Hospital, Gower Street, the largest teaching hospital in London, has a ghost that has been seen by patients and nurses. The ghost is known as 'Lizzie' and is generally regarded as having its origin in Lizzie Church, a nurse who tended her fiancé at the hospital some seventy

years ago. She accidentally administered an overdose of morphine and her sorrowing ghost haunts the scenes of her sadness. Some people think that she is most often seen when morphine injections are being given, perhaps as a warning to the nurses not to make the mistake that she did. Patients have drawn attention to a strange nurse watching the injections and although all the nurses at the hospital may not have seen Lizzie they all know about her.

GHOSTS OF MAYFAIR, SOHO AND THE WEST END

BERKELEY SQUARE, MAYFAIR

Perhaps the most famous of all haunted houses in London is Number 50 Berkeley Square. The house had such a reputation in Victorian days that our country ancestors would not dream of a visit to London without a look at the 'haunted house in Berkeley Square', and with such notoriety it is not surprising that many unsubstantiated stories and legends have come to be associated with the house, which has been occupied for many years by Maggs Brothers Limited, the well-known antiquarian booksellers.

The house contains some beautiful Adam fireplaces and dates from the eighteenth century, and there are those who believe that the ghostly happenings date from soon after the place was built. By 1872, the house was famous and Lord Lyttelton seems to have been one of the few people brave enough to have spent a night alone in the haunted room on the top floor — and who lived to tell the tale, although he was always reluctant to do so. He had with him two blunderbusses loaded with buckshot and silver sixpences (the latter to combat evil forces) and during the night he fired at 'something' that seemed to leap at him from the darkness. He was aware of a vague shape falling to the floor 'like a rocket' but he could find no trace of any physical thing that he had shot. He wrote in *Notes and Queries*, following an enquiry as to whether the place was haunted, 'It is quite true that there is a house in Berkeley Square said to be haunted, and long unoccupied on that account.' Bulwer-Lytton's famous ghost story, *The Haunted and the Haunters*, is supposed to have been founded on the Berkeley Square haunting.

In 1912, Jessie A. Middleton published *The Grey Ghost Book* and says that many years earlier she heard about a child ghost at the house that used to be seen in a Scots kilt. The poor child was said to have been frightened to death in the nursery at the top of the house, and the pathetic little ghost was seen so often, frequently sobbing and wringing its hands, that no one would live in the house. Another story concerns a young girl who threw herself out of the top-floor window to escape the attentions of her lecherous uncle. Her ghost haunted the house and would be seen clinging to the window-ledge, screaming and screaming, as she must have done before she fell to her death. Yet another story, which may have a grain of truth in it, is told of the house being occupied by a gang of counterfeit coiners who made weird noises at night and constructed strange sights to scare away inquisitive visitors. Such a story would tie in well with the sounds of furniture, or heavy boxes, being dragged across bare floors every two months or so at a time when the house was empty. Bells were heard ringing too, a window would be flung open and stones, old books and similar objects would land in the street at the feet of startled onlookers. Whenever investigations were made, it is said, the house was found to be deserted. In a later issue of *Notes and Queries* (2 August 1879) a correspondent stated that the house contained 'at

Number 50, the famous 'haunted house in Berkeley Square' long reputed to be haunted by a frightful 'appearance' that caused madness and sudden death.

least' one room where the atmosphere 'is supernaturally fatal to body and mind'. He went on to say that a girl saw, heard or felt such horror that she went mad and never recovered sufficiently to relate her experience, whilst a man, sceptical of ghosts and haunted houses, arranged to spend a night in the same room and was found dead in the morning. Even the party-walls of the house, when touched, were stated to be 'saturated with electric horror'. Certainly during the course of the enquiries that he made Lord Lyttelton discovered that people occupying the neighbouring houses were troubled by odd noises that they could not explain. Probably the story that did more than any other to enhance the reputation of the house concerned two sailors who found themselves penniless in London in the 1870s. Chancing to walk through Berkeley Square, they saw the 'For Sale' sign outside Number 50 and broke in to obtain a roof over their heads for the night, Settling themselves into a room on the top floor, they were disturbed during the night first by banging noises, like doors slamming, and then by footsteps that seemed to slither and slide up the stairs and approach the door of the room the two men were occupying. After a moment, the door handle turned and 'something shapeless and horrible' oozed into the room. One of the sailors dodged past the shuddering mass and fled down the stairs and out of the house, deaf to the screams of his terrified companion. Dashing into the arms of a policeman who chanced to be passing, the frightened man blurted out his story and the policeman proceeded to search the house. He saw no sign of any ghost but he did discover the body of the other sailor in the garden, with his neck broken. It appeared that he had fallen, or been pushed, from the upstairs window and was impaled on the spiked railings bordering the pavement.

It is difficult to discover any facts about the haunting, and the basis of the whole story may well lie in the eccentric behaviour of a certain Mr Myers who leased the property in 1859 in readiness for his forthcoming marriage. But Mr Myers was jilted and the shock and sadness

caused him to become a broken, morose and solitary man, who would never allow a woman near him. He existed for the rest of his life in the ill-fated room at the top of the house, only opening the door to receive sustenance from a manservant. Often, he would sleep most of the day and at night wander about the room, candle in hand, a sad and lonely man whose shadows on the curtains and movements at dead of night became part and parcel of a legend of haunting — a legend that still persists.

When I called there in June 1970, I learned that the occupants are still pestered by curiosity seekers as they have been for the past thirty years. During the Second World War, fire-watchers used the building (including the 'haunted room' — now used as an accounts department) and reported nothing untoward or inexplicable. Perhaps at long last the house is at peace, sobered by the down to earth staff of Maggs Brothers Ltd.

BROADCASTING HOUSE, LANGHAM PLACE

The British Broadcasting Corporation have a ghost that haunts the upper floors of one of their premises in Langham Place. The third and fourth floors harbour the ghost of a limping butler who walks the corridors, carrying an empty tray. The form has usually been seen in the early morning, and one engineer took the figure to be a real waiter, until it disappeared as he watched. Another member of the BBC staff described the form as completely lifelike but moving abnormally slowly, almost like a slow-motion film. A couple of years ago, broadcaster Brian Matthew told me that a room at Broadcasting House was occasionally visited nocturnally by a dark, bat-like creature that seemed to jump out of a wall. The old home of the BBC in Savoy Hill, off the Strand, was, and perhaps still is, haunted by the ghost of actress Billie Carleton, who died in her flat there in 1918. The doors of the flat have opened, silently and by themselves, literally hundreds of times in the presence of scores of people.

BURLINGTON ARCADE, PICCADILLY

There is a flat near Burlington Arcade that was the scene of a murder by strangulation over fifty years ago. Some people who spend a night at the flat find themselves awake at two o'clock in the morning in a cold sweat with the overpowering feeling that they have been almost strangled. The present occupant of the flat sleeps undisturbed but many visitors, who know nothing about the history of the place, say that they cannot spend another night in the flat. More recently, Burlington Arcade itself was the scene of apparent poltergeist manifestation when a leather-goods shop and a tobacconist seemed to attract the attention of 'Percy the Poltergeist'. Four times in as many months objects in the leather shop were moved from shelves during the night. Once, three leather folios were found placed in a semicircle on the floor around an electric fire; the previous night, after everyone left for home, they had rested on a shelf five feet from the floor. Some weeks before other articles had been removed from shelves and arranged in circles on the floor. At the tobacconist's shop three heavy pewter tobacco jars were removed from a shelf in the first-floor showroom and placed in a semicircle around a table. There was never any sign of forced entry and Scotland Yard could offer no explanation. Nothing was missing and nothing was damaged. There has never been a logical explanation, although I recall talking to a president of the Society for Psychical Research about the case and he said that he could not help but notice the extra trade that the publicity brought to the shops concerned.

Burlington Arcade, the scene of two poltergeist infestations. Nearby there is a flat where a fifty-year-old murder is re-enacted.

THE GARGOYLE CLUB, SOHO

This is one of the oldest clubs in Europe, and the building once housed a musketry school that belonged to Charles II. Among those who have lived here is Nell Gwynne. She might well have some sympathy and understanding for the strippers who once worked at The Gargoyle.

Several girls at the club experimented with wineglass and letters a few years ago, and they happened to hold the 'séance' in the Nell Gwynne Room. They obtained what appeared to be the beginning of a message when one of the club's owners stopped the proceedings and told the girls they were foolish to play around with such a subject. Two of the girls were determined to carry on with the experiment and one night they hid themselves in the Nell Gwynne Room until everyone else had left the club. With only candles for lighting (the electricity had been switched off) they started another séance, and almost immediately obtained a name that could have been a misspelling of Nell Gwynne. Then the glass began to move about wildly. Suddenly frightened, the girls became aware of a presence in the room and one of them began to lose consciousness. The other became terrified as she heard senseless mumblings coming from the lips of her unconscious friend, and unaccountable scraping noises from the direction of a locked door that only led to a fire escape, and she rushed to a window and called for help. Soon the police arrived and rescued the frightened girls.

A former club owner, Mike Klinger, claimed that he and two other witnesses all saw a tall figure, cowled and shrouded, on the pavement near the Meard Street entrance to The Gargoyle, but the figure vanished into thin air as they watched. Dylan Thomas, the poet, told me that he found a unique and fascinating atmosphere at The Gargoyle. He was certain that the place was haunted and said he wouldn't spend a night there for anything. Some witnesses have reported

Green Park has a haunted tree and the sounds of a 200-year-old duel at dawn.

seeing a well-built young woman in a high-waisted dress and wearing a large flowered hat drift, rather than walk, across the floor of the club, and disappear near the lift shaft. The figure could well be Nell Gwynne herself.

GREEN PARK, PICCADILLY

Although formerly part of St James's Park, Green Park has a very different atmosphere with its air of quiet mystery. Even on the brightest day there is a stillness, an air of expectancy, and a sensation of sadness along the shady walks and among the gnarled and ancient trees.

Green Park was only a meadow with a few trees and ditches in the days of Elizabeth I. In 1554, Royalist forces fought here to resist Sir Thomas Wyatt's troops attacking London, and in the years that followed the park was the scene of numerous robberies, murders and rapes until well into the eighteenth century. It was also a favourite duelling-ground. The later Earl of Bath was wounded here in a duel; Viscount Ligonier and Count Vittorio Alfieri, the Italian poet, fought here in 1771; Sir Henry Colt fought Beau Fielding, the lover of the Duchess of Cleveland, behind Bridgewater House where the duchess was residing. The ghostly sounds of the latter duel are said to be heard at dawn on the anniversary of the fight. For several minutes the misty air crackles with the sound of battle, the footfalls of the combatants are heard on the damp ground and the signs of breathing billow above the ground mist.

There is one particular tree in Green Park that has a bad reputation. People never slumber beneath its twisted branches, summer lovers never linger in its shade and even birds shun its gnarled and ancient branches. I have talked with two park attendants who swear they have heard sounds

emanating from the tree. There is the harsh and loud sound of a man's voice in conversation that ceases almost as soon as you become aware of it. There is a low and cunning laugh that strikes a chill into the hearer, and also a strange and sad groaning sound like that of someone in mortal agony and utter despair. The tree is a favourite one for suicides in Green Park and in fact few people fail to discern a sense of gloom, and a sudden feeling of sadness and despair overwhelming them in the vicinity of this tree, so that they are glad to move quickly on to less unwelcoming parts of the park. It is not difficult to imagine a person contemplating suicide, reaching the final decision and hanging himself, as so many have done, from the 'tree of death' as it is called. Sometimes visitors have had the sensation of being followed when they pass the tree. Children rarely play there, and occasionally an unexplained figure in black has been reported, standing close to the trunk. It is a tall, watchful figure that disappears when the person who sees it looks a second time.

THE GRENADIER, HYDE PARK CORNER

One of the best-known haunted pubs in London is The Grenadier, Wilton Row, behind St George's Hospital and near Hyde Park Corner. This is a result of the television film I arranged and several subsequent broadcasts. I have been interested in the haunting associated with this fashionable and authentic Georgian inn since I took medium Trixie Allingham there for lunch some years ago and she immediately sensed that a serious quarrel and fight had taken place there, and that there was a ghost in the cellar.

The Grenadier was once the officers' mess for the Duke of Wellington's Regiment and the alley that runs beside the pub, Old Barrack Yard, recalls the time when soldiers drilled there, as they did in 1815 before leaving for Waterloo. In those days, the pub was called The Guardsman and one of the bars was situated in what is now the cellar, and the present bar served as a dining room for officers. Not infrequently officers off duty would drink to excess and gamble beyond discretion, and this sometimes led to quarrels and brawls. In one such fight, when an officer was caught cheating, rough justice was handed out by his companions. He was flogged on the spot and afterwards he staggered down the steps to the cellar, more dead than alive. There he expired and, it is said, his ghost haunts The Grenadier to this day, especially during the month of September, the month of his death.

Several successive landlords have told me that an indefinable but definite 'atmosphere' builds up over the year and reaches its climax during September when all sorts of things happen and many people notice 'something' in the atmosphere. Then, as September passes, things gradually quieten down only to build up again to reach a zenith the following September.

I remember Roy Grigg telling me that he had no doubt about the periodical haunting of the pub, for his Alsatian dog showed all the signs of terror and dismay each September, growling and snarling for no apparent reason and always scratching and trying to dig its way into the cellar. As the month passed the dog became calm again for another year.

It was a September evening too that Roy Grigg's young son saw a black shape on the landing outside his bedroom. As the boy watched the shadow, or whatever it was, grew larger and then smaller and then suddenly disappeared. No living person was upstairs at the time, apart from the terrified boy, lying in bed with the door open.

About ten days later, and still in September, the boy's mother, Mrs Grigg, was half-undressed in her bedroom, knowing that she was alone in the pub at the time, when she saw a man mounting the stairs towards her bedroom. She quickly covered herself and then turned to meet the intruder — but now all was silence and there was no sign of anyone upstairs, on the stairs or downstairs.

Mrs Grigg said the man was a stranger and she never saw him again.

A year later, almost to the day, a visitor was having a drink in the bar when she saw a man go up the same stairway, but the 'man' vanished as completely as the figure seen by Mrs Grigg. A boyhood friend of Roy Grigg later spent a disturbed night in one of the bedrooms. After hearing that the room was supposed to be haunted, he arranged a rosary over the bed to guarantee him a good night's rest; but he was awakened in the middle of the night by something that touched him, an indistinct figure that hovered at the side of the bed, moved to the foot of the bed and then vanished.

Geoffrey Bernerd, a later landlord, is equally convinced that peculiar happenings have occurred at The Grenadier: knocks, raps, objects moved, lights switched on and off during the night, taps turned on... These and other apparent phenomena he described during the course of a film made there when I took the BBC to The Grenadier for a programme broadcast one All Hallows Eve. That day, too, I met Bernerd's teenage daughter and she told

The Grenadier, Wilton Row, where the ghost of a murdered guardsman returns each September.

me that sometimes she was very frightened at night when she slept at The Grenadier, although she never really saw anything except what she described as a shadow which should not have been there: a child's description of a ghost perhaps?

THE HAYMARKET THEATRE, HAYMARKET

A London theatre with more than one ghost is the Haymarket, in the very centre of London's West End and second only to the Theatre Royal in age. Here, in 1736, the *Historical Register* so scathingly portrayed Sir Robert Walpole, the distinguished statesman, that it led to the licensing of all plays by the Lord Chamberlain — an act that was not abolished until two centuries later.

Every few years, the ghost of partner-manager David Edward Morris (a jealous, pompous and quarrelsome individual, not a man of the theatre and only interested in commercial profit) is said to return to the Haymarket. The ghost opens and closes doors in the presence of reputable witnesses — just for devilment, as indeed Morris might have done in his lifetime.

During the First World War, when Frederick Harrison was manager (he was there from 1896 to 1926), he and his business manager Horace Watson were in Harrison's office at three o'clock one morning when the door, which had long been securely closed, opened by itself and as mysteriously closed again. Both men were convinced that the ghost of Morris had visited them.

Another well-known ghost at the Haymarket is that of John Baldwin Buckstone, actor-manager at the theatre in its golden era from 1853 to 1878, an honest and handsome man whose spirit still lingers

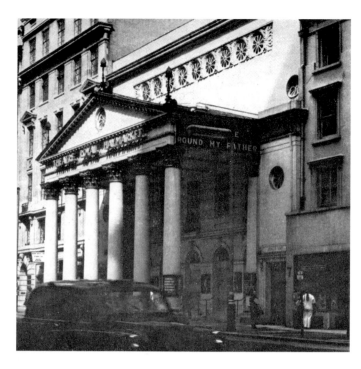

The Haymarket Theatre is haunted by three of its former managers: David Morris, Henry Fielding and the genial and much-loved John Buckstone.

about the theatre he loved, especially in the vicinity of the rooms he used so much during his lifetime. His ghost — if ghost it is — has often been heard walking about his old room and rummaging among the contents of a cupboard. Sometimes the door of the room opens, footsteps sound across the floor in the direction of the cupboard and then return, the door closes and the episode is over until the next time. On other occasions, drawers and wardrobe doors open and close by themselves.

Another ghost that has been seen at the Haymarket is that of an elderly man who walks noiselessly about the passages of the theatre and backstage. This apparition especially haunts the oldest part of the theatre known as the Companionway.

A few years ago, Mrs Stuart Watson, when chairman and managing director at the Haymarket, was about to walk down the three steps to her private box from the Companionway, which led to her office, when she was astonished to see not only her own shadow preceding her, but another also. As she turned off towards her box she saw the other shadow continue along the Companionway towards her office. She never discovered any reason or cause for the second shadow. When this figure is seen it appears to be dressed in eighteenth or nineteenth century clothes and it has been suggested that it could be novelist Henry Fielding, manager at the Haymarket in the 1730s but better known as the author of *The History of Tom Jones* and *Joseph Andrews*.

Actor Victor Leslie told ghost-hunter Thurston Hopkins that he often heard a voice in one of the rooms at the theatre and late one evening when he entered his dressing room he was startled to see a strange man sitting in an armchair, gazing placidly about him. Leslie backed out of the room, locked the door, and fetched the theatre caretaker. Unlocking the door, they both entered the dressing room to find no trace of the man Leslie had seen, but an old book lay open beside the chair that the figure had been occupying and Leslie was quite certain that the book had not been there half an hour earlier. The book, an old theatrical account book of some fifty years earlier, was

always stored in a cupboard in the dressing room and, as far as could be established, had not been touched by human hands for many years.

Not long afterwards, Hopkins spent a night with a friend inside the deserted Haymarket Theatre, sitting in darkness in the front row of the stalls. After some considerable time both the watchers heard footsteps from the direction of the stage, apparently from behind the closed curtains, footsteps that seemed to be walking in the direction of the haunted dressing room. Both men hurriedly climbed onto the stage and although they could still hear the footsteps ahead of them they could see nothing to account for them. As they entered the dressing room, Thurston Hopkins told me that he heard a rustling and shuddering noise, which he thought might be a rat. Then they noticed a book lying open on the table and the leaves were turning over by themselves. After a moment, the atmosphere in the room seemed to change and everything was quiet. They discovered the book had belonged to John Buckstone, the actor-manager who haunts the theatre he loved and served for over twenty years.

During the production of *Yellow Sands* actress Drusilla Wills was backstage talking to a friend when she saw an elderly man dressed in old-fashioned clothes pass between her and her friend. She mentioned the fact and discovered that her friend had not seen the figure. Later, Miss Wills saw a picture of Buckstone and found that the old man she had seen had been of similar appearance and had been dressed in almost identical clothes. She had not been in the least frightened at the experience, assuming that the figure was a real person. Mrs Watson too has seen the ghost of Buckstone and confirms the solid appearance, 'He is not a misty figure and you can't see through him. He looks real flesh and blood.' Buckstone once lived in a house at the rear of the Haymarket Theatre — a property that was later converted into the theatre's offices and dressing rooms.

A theatre fireman used to say that he often saw Buckstone's ghost walking along passages in the theatre and whenever he tried to follow the figure he always lost sight of it after it turned a corner ahead of him, but when he reached the corner there was no sign of the silent harmless ghost. A theatre cleaner said she and the fireman both saw the figure early one morning crossing the dress circle. Once the fireman saw the figure standing against a door that the theatre employee knew was locked and bolted. Thinking for a moment that the normal-looking figure was a real person, he called out that the door was locked and there was no way through. Even as he spoke, the form seemed to melt and disappear into the closed and solid door.

Some years ago, a commissionaire who had not long been at the Haymarket, and knew nothing about the ghost of Buckstone, went to see the theatre manager of the time, Mr Stuart Watson, and said he had seen a strange man in the empty theatre at night on several occasions. Watson asked for a description of the man and then showed the commissionaire a photograph of Buckstone, which was immediately recognised as the mysterious stranger.

Stuart Watson himself had a curious experience in the room that is now the stage director's office. He was working there late one evening when suddenly all the lights were extinguished and as he stumbled about in the total darkness, endeavouring to discover what had gone wrong, he began to notice an intense coldness and as this increased he became very frightened. Eventually, he found his way out of the room but he never discovered any reason for either the temporary loss of electricity in the office or the unusual and terrifying cold. He never experienced either again during the quarter-century that he was manager at the Haymarket.

The late Margaret Rutherford told me that when she was at the Haymarket in *The School for Scandal* she and her husband Stringer Davis spent one night in her dressing room where a bricked-up doorway used to give access to the stage. During the night they both heard curious creaking noises from the direction of the bricked-up doorway, almost as though a door was still there, and the rattle of bottles from the direction of an empty cupboard. The following evening,

both Margaret Rutherford and her dresser thought that they glimpsed John Buckstone entering the dressing-room.

During the same run, actress Meriel Forbes (Lady Richardson) thought she saw the figure of Buckstone sitting in one of the boxes and then, noticing the light-coloured hair, decided that Mrs Stuart Watson was occupying the box. In fact, Mrs Watson was not in the theatre that night and the box, according to the theatre records, was empty and unoccupied. In 1963, when Michael Flanders was appearing at the Haymarket in *At the Drop of a Hat*, the assistant stage manager saw a man standing behind the performer's wheelchair. Thinking that it must be a stage hand who had been trapped on the stage when the curtain went up, the stage manager was about to give instructions for the curtain to be lowered when the figure moved and it was seen that it could not be a stage hand since the figure was dressed in a long black frock-coat. As the stage manager watched, very puzzled as to who the man could be, the figure suddenly vanished mid-stage. A description of the figure admirably fitted John Buckstone.

Mrs Stuart Watson feels that Buckstone returns to the theatre because he had been so happy there and she says she finds that she is no longer frightened of the ghost. Whenever she feels that 'he' is near, when her door rattles, or when it opens by itself, she always welcomes the kind and gentle ghost and she would hate to do anything to offend or hurt him. The ghost is first said to have been seen as long ago as 1880, a year after Buckstone's death, when the figure, recognised as the genial and much-loved actor manager, was seen in Queen Victoria's box, where he had often been seated beside the queen during his lifetime. If tragic and violent happenings can cause hauntings, perhaps overwhelming love and affection can also.

HILL STREET, MAYFAIR

In a house in Hill Street, Mayfair, the 'bad Lord Lyttelton' (Thomas, the Second Baron) was awakened by what sounded like a bird fluttering in the bed curtains on 24 November 1779. As he awoke he saw the figure of a woman in white standing by his side and who warned him that he would soon die. Lyttelton asked whether he would not live two months and was told that he would die within three days. Next morning, he told his guests about the experience. On the fateful day he went to Pit Place, his house at Epsom, taking a number of friends with him. He declared that he felt perfectly well and was certain of bilking the ghost. Just after eleven o'clock in the evening he went to bed. When his manservant William Stuckey was helping him to undress, Lord Lyttelton suddenly put his hand to his side, collapsed, and died without a sound. There are slightly different versions of his death but all agree that he was in good health when he went to bed, that he died before midnight and that the warning came three nights earlier. Some people say the visitant was the ghost of a Mrs Amphlett, who had recently died of a broken heart after Lord Lyttelton had seduced both her daughters.

LONDON PALLADIUM, ARGYLL STREET

During the course of an interview in March 1973, George Cooper, stage doorkeeper at the London Palladium, revealed that this famous West End theatre has a ghost. The Palladium occupies the site of Argyll House, the London home of the Duke of Argyll, a family whose association with the area is preserved by the name of the road in which the Palladium stands. At the back of the royal circle there exists the old Crimson Staircase, which is said to be a remnant from a previous house, and it is down this staircase that the ghost of a lady in a crinoline has been observed on several occasions.

She has been seen by members of the staff and, more rarely, by artistes and visitors to this scene of the success of so many music-hall stars, where the annual Royal Variety Performances took place. No sound accompanies the appearance and no one knows who the figure is or why she haunts the dim passages of the existing London Palladium.

The Royalty Theatre, Dean Street (demolished)

The Royalty Theatre that used to stand in Dean Street, Soho, had several ghosts. One was a little old lady dressed in early Victorian costume. She was a misty and grey form but she always seemed to be cheerful, smiling and nodding happily whenever she was encountered about the theatre by the staff or when she occasionally mingled with the audience during a performance. She was repeatedly seen by scores of people, for she had the habit of entering the theatre just as the performance was about to start and then, as the theatre-goers glanced towards her to see which part of the auditorium she was making for, she would, suddenly vanish. Most of the attendants at the old Royalty knew the ghost, with her ringlets and silk dress and bonnet, and many regular patrons saw her several times.

Another ghost at the Royalty was a woman in white, in the full dress of the Queen Anne period, who used to descend the staircase and vanish in the centre of the vestibule, some (those perhaps whose hearing as well as their sight was psychically attuned) claimed that she shrieked as she vanished. Courteney Merrill of Bournemouth used to be secretary and manager of The Gargoyle Club next door and he saw the Royalty Theatre ghost on several occasions. 'She had a very sweet face,' he said, 'and always appeared to be seeking something or someone. She was perfectly harmless and never gave the least feeling of fear to those who saw her. Frequently she was seen walking down stairs that did not exist.'

When he was rehearsing *Murder in Motley* in April 1934, at the Royalty, Joe Mitchenson, the actor and theatrical archivist, saw an elderly and well-dressed lady seated in the prompt box. He was in the dress circle and immediately thought of the theatre ghost, but when he went forward to obtain a closer view there was nobody there.

This ghost seems to have some historical foundation for during the reign of Queen Anne a woman was murdered in the house that then stood on the site and her skeleton was discovered in the basement of the old theatre.

There was also the ghost of an unknown woman in grey that used to be seen sitting quietly in one of the boxes, a box where other people maintain that they have heard gasps and sighs that had no rational explanation. So audible were those noises on occasions that anyone occupying the box at the time had the greatest difficulty in not believing that there was an extra person in the box with them.

Some people think that the grey lady was Fanny Kelly, an actress who managed the theatre in the 1840s for the then Duke of Devonshire. Fanny is said to have committed suicide. Macqueen Pope was among those who told me that they had seen this mysterious woman in grey, while Thurston Hopkins maintained that the theatre was also haunted by a gipsy girl dressed in green and scarlet, another ghost that had its origins in the house that formerly occupied the site. This spectre only walked when an orchestra was playing, for the music of the violin attracted her and reminded her of her Romany lover and his 'Devil's staff', as the Romanies call the violin. There was a story that the Romany fiddler had murdered the young gipsy girl and buried her body inside a hollow wall that later became a wall of the Royalty Theatre, and it is said that workmen, during the building of the theatre, discovered a girl's body in a wall encased in a tomb of plaster of Paris.

St James's Palace, Pall Mall

St James's Palace is probably more haunted than any London royal palace, but it is only rarely that news filters through to keep alive the ghostly legends connected with the historic collection of buildings that were erected by Henry VIII and now house the Lord Chamberlain's Office and other court officials.

Henry VIII acquired the ground in 1532 and he built the palace on the site of a hospital for 'maidens that were lepers living chastely and honestly in divine service', which dated from about the year 1100. Only the fine brick gateway of Henry VIII's palace remains today, but an inner courtyard contains fourteen stones bearing crosses, worn but still visible, pathetic reminders of the hospital here 900 years ago, for the crosses mark the graves of fourteen leprous maidens who sleep, apparently undisturbed.

Not so poor Sellis, the Italian valet, who was almost certainly murdered by his master, Ernest, Duke of Cumberland. The blood-drenched figure of little Sellis, his throat cut from ear to ear, has been seen propped up in bed, in the position that his body was discovered, in the part of the palace that today looks like a country house.

Ernest, George III's wicked fifth son, came back to his chambers at the palace late on May 31, 1810, after a visit to the opera and a night of debauchery. Almost immediately the sounds of shouts, cursing and scuffling were heard by the startled servants, but they were used to such disturbances and they knew better than to interfere. After a while, things quietened down and then the Duke called for Yew, his other valet. Yew found the Duke standing in the middle of his room, cool and composed, but his shirt-front was covered with blood and his bloodstained sword lay on the floor at his feet. The Duke declared that he had been set upon as he had entered the apartment and had only succeeded in driving off his assailant at the expense of being seriously wounded himself. He instructed Yew to fetch Sir Henry Halford at once. The distinguished physician arrived within minutes and discovered that the Duke's wounds were superficial in the extreme, and the only deep cut being on the Duke's sword hand. By the time the wounds were dressed to the Duke's satisfaction and the room restored to its accustomed elegance, more than two hours had passed since the Duke had returned to the palace, and now he asked Yew to fetch Sellis. Yew's subsequent sworn statement tells of his going straight to Sellis's room and there finding the valet propped up in bed against the headboard, his head almost severed from his body by a frightful gash and a razor, covered with blood, at the opposite end of the room — too far from the body to have been used by Sellis himself or to have been thrown away by him in such a condition.

At the inquest the Duke maintained that Sellis had tried to murder him and had then committed suicide, an unlikely suggestion in view of the fact that while the Duke was large-boned and heavy, Sellis was small and slight. The truth is that the Duke had seduced Sellis's daughter who had committed suicide when she found that she was expecting his child, and in order to silence the indignant servant, the Duke had attacked the poor man while he was in bed, holding him by the hair with one hand and cutting his throat with the other. He had then gashed himself with the razor, which he had then thrown to the floor before returning to his own room to disarrange the furniture, bloody the sword and generally act as though he had been attacked. The Duke of Cumberland was disliked in London before the Sellis affair, and although the matter was hushed up as much as possible, afterwards he was openly booed in the streets and so hated that he hardly dared show his face in public.

From time to time, scuffling noises, the sound of cursing and the sickly-sweet smell of blood is said to return to parts of the palace, and the awful spectre of Sellis with his throat cut and the body and bedclothes drenched with blood has been seen at this palace, which is so full of history that it would be surprising if it did not have a dozen ghosts.

In the seventeenth century, the Duchess of Mazarin was mistress to Charles II and Madame de Beauclair was mistress to Charles's brother and successor James II. Both ladies, living in retirement, were allotted handsome suites of apartments in the palace and they became great friends. On more than one occasion they discussed the immortality of the soul, the evidence for apparitions, and the possibility of returning to earth after death. They gave each other a solemn undertaking that whoever should die first would return, if it were possible, to show herself to her friend. This promise was reaffirmed in the presence of witnesses when the Duchess of Mazarin lay dying.

Some years later, Madame de Beauclair stated that she had no faith in an afterlife, for she considered the fact that her friend had not returned to her as proof of the non-existence of a future life. A few months later, Madame de Beauclair sent an urgent message to a friend with whom she had discussed the matter of life after death, entreating her to come at once if she wanted to see her alive. The lady concerned

St James's Palace, haunt of the murdered Sellis and the scene of a spectacular death-pact fulfilment.

was unwell, and hesitated and was about to send her excuses when a still more urgent message arrived, accompanied by a casket of jewellery, imploring her to come at once.

Hurrying to St James's Palace she was surprised to find Madame de Beauclair seemingly in the best of health and still more surprised when her friend told her that she had been visited by her dead companion, the Duchess of Mazarin, and knew that she would soon be dead herself. The ghost of the Duchess had apparently walked round the bed of Madame de Beauclair, 'swimming rather than walking', and had stopped beside an Indian chest and said, 'with her usual sweetness', 'Between the hours of twelve and one tonight you will be with me.' Having made this grim prophecy the apparition vanished. The midnight hour was close at hand and, even as the clock began to strike the hour, Madame de Beauclair exclaimed suddenly, 'Oh, I am sick at heart!' and about thirty minutes later she was dead.

St James's Park

Nearby St James's Park has several ghosts, the best-known being the figure of a headless woman who walks between the Cockpit Steps and the lake in the park. The ghost was first reported by Coldstream Guards, quartered nearby at Wellington Barracks, early in the last century. Some twenty years before the figure was seen, a sergeant at the barracks murdered his wife and threw her headless body into the canal, which then ran through the park. That some inexplicable figure was seen seems indisputable for investigation into the affair, including statements taken down at the time and subsequently sworn before a magistrate at Westminster, are still available for examination. Two of the statements are curiously dissimilar yet not conflicting.

One of the Coldstream Guardsmen testified that he was on duty one night (3 January) when, at about 1.30, he saw a headless figure seemingly rise from the ground about two feet away from him. Although much alarmed, he was able to observe the dress worn by the figure. It was a red-striped gown with red spots between the stripes, and he further noticed that part of the dress and the figure appeared to 'be enveloped in a cloud'. After about two minutes the figure disappeared. Another man testified that he was on guard duty one night when he heard a 'tremendous noise' and a feeble voice calling faintly, 'Bring me a light! Bring me a light!' The sentry responded, but received no answer to his offer of help. A few moments later, noises, like window-sashes being lifted hastily up and down, sounded in different places at the same time. This, it was stated, could not possibly have been due to one person. A civilian witness reported that he had seen a woman wearing a red and white dress running towards the park from the Cockpit Steps one foggy night and another late traveller, in a distraught condition, reported that he had narrowly missed running down a woman who ran across the road near the Cockpit Steps. The woman didn't seem to have a head and her dress appeared to be white but spattered with blood. A number of other people, soldiers and civilians, have heard strange noises that they have been unable to account for during the hours of darkness in the vicinity of Birdcage Walk. Some have likened the sounds to running footsteps. Occasionally, an unexplained figure in a light-coloured dress is reported to disappear in the direction of St James's Park.

St James's Place, SW1

At 19 St James's Place, in 1864, an apparition was seen by four people. The house had long been the home of Miss Anne and Miss Harriet Pearson, who were devoted to each other. Miss Anne died in 1858 and Miss Harriet lived on in the house by herself for six years. In November 1864, she became very ill while staying at Brighton, and urgently desired to return to her London home. She was brought back and devotedly nursed by her housekeeper, Eliza Quinton. Also in the house at the time were two of her nieces, Mrs Coppinger and Miss Emma Pearson, and her nephew's wife, Mrs John Pearson. On 23 December, Mrs Coppinger and Miss Pearson went to bed, leaving Mrs Pearson on duty in the sickroom. They left their bedroom door open in case they were called, and the lights burning on the staircase and landing. About one o'clock they both saw a woman go past the open door and into the room where the patient lay. She wore a shawl and black cap. Mrs Coppinger called out, 'Emma, get up. It is old Aunt Anne!' and her cousin answered, 'So it is, then Aunt Harriet will die today.' Mrs Pearson then came rushing out of the sickroom in great agitation, having also seen and recognised her dead aunt. The three women roused the housekeeper and together they searched the whole house without finding anyone. Miss Harriet Pearson died at six o'clock. Before she died she told them all that she had seen her sister and knew she had come to call her away.

St James's Theatre, King Street, SW1 (demolished)

The now-vanished St James's Theatre of King Street, St James's, was reputed to be haunted by the ghost of an eighteenth century actress — one of the reasons that actor-playwright Emlyn Williams set his play *A Murder Has Been Arranged* in the theatre which had a Roman façade and an interior that resembled the theatre of the Palace of Versailles. St James's was opened in 1835, so any ghost in eighteenth-century costume must have either been an actress in period dress or some

The house in St James's Place where an apparition was seen and recognized by four people independently.

shade from the earlier building that previously occupied the site. This was Nerot's Hotel, to which Nelson came in 1800 after the Battle of the Nile. There was also an unidentified ghost that touched people in one of the dressing rooms, and actors occupying that particular room sometimes found themselves helped on with their clothes, and occasionally they had the impression that they were being brushed down just before their call — the spectre of a former stage dresser perhaps. I have heard no word of any haunting in the office block that now occupies the site of that lovely little theatre, which is where an operatic burletta written by Charles Dickens was once staged.

St Thomas's Church, off Regent Street (disused)

The once fashionable St Thomas's Church, Regent Street, has, or had, a ghost priest in a black cassock. The church, now approached by way of Tenison Court, was built in 1702 as a chapel of ease to St James's, Piccadilly, and lost its Regent Street frontage in the 1860s. Closed for several years, in 1972 a firm of architects applied for permission to demolish the church and to replace it with shops, offices, flats, and an underground car park.

Here, where thriller-writer Dorothy L. Sayers was once a churchwarden and Christopher Fry's 1951 play *A Sleep of Prisoners* was first produced, Prebendary Clarence James May told me he saw a ghost when he was curate at St Thomas's in the 1920s.

Entering the church one morning in 1921, the assistant priest saw the figure of a man dressed in a black cassock, kneeling before the altar. The young curate thought that it must be a priest who used to be associated with the church and he waited for the kneeling figure to finish his prayers. Presently the figure rose, passed in front of the high altar and disappeared from view. Thinking

that the stranger had gone into the sacristy, Mr May decided to make himself known to the visitor. He hurried towards the sacristy door, reaching it, as he thought, immediately after the cassocked priest, but to his astonishment he found the door locked, the key hidden in its customary place and no sign of the strange priest.

Puzzled by the apparent disappearance of the lifelike figure in black, Mr May cast his eyes round the deserted church and slowly walked back towards the altar. As he did so, his footsteps distinctly audible on the flooring of the chancel, he realized that the feet of the unknown priest had made no sound whatever as he had walked towards the sacristy. This fact, coupled with the quite inexplicable disappearance of the figure, convinced Prebendary Clarence May that he had seen a ghost, as he recounted in his book of reminiscences many years later.

Although Mr May never established with any degree of certainty the identity of the black-robed ghost priest of St Thomas's, he did discover, on very good authority, that a phantom priest had been seen in the church on at least three occasions during the previous twenty years, and the general conclusion was reached that the form was that of a previous rector who had died some twenty years earlier. One is inclined to regret that in the busy underground car park, or the impersonal shops and offices, the silent and harmless figure of a priest in a black cassock will probably pass unnoticed.

VINE STREET POLICE STATION, PICCADILLY

In ancient times, a vineyard existed in Vine Street, off Swallow Street, Piccadilly, which gave the place its name. Now the tiny street houses a grim hundred-year-old police station that is said to be haunted by the ghost of a police sergeant who committed suicide in the cells early last century.

The heavy pounding of footsteps have been heard from deserted corridors and locked cell doors have been found inexplicably opened time and time again. Official papers and documents, especially in one particular office, have been found scattered and disarranged, as though someone has been reading them or searching for something. This has happened when the doors of the office have been locked and it has been impossible for any human being to enter the place. In 1969, a senior police detective stated that he was thoroughly scared by what had been going on at Vine Street Police Station, especially on two frightening occasions when he had felt the unmistakable presence of someone else in the office when, in fact, he was there alone. He had made no official report for fear of being laughed at, but afterwards he was careful not to spend much time in that room unless someone else was there with him. Another police officer heard the heavy footsteps, which he said he would never forget. He found himself listening to the pounding footsteps apparently approaching him along a corridor that he could see was utterly deserted. As soon as he gathered his wits together he ran, but he found that the sounds of heavy footsteps ceased as soon as he moved.

WESTMINSTER ABBEY, WESTMINSTER

There is a strange legend associated with the founding of Westminster Abbey and there have been many reports of ghostly incidents in the 900-year-old building, including the figures of a monk, a First World War soldier, ghostly footsteps and a door that opens by itself. The latter was experienced during a recent visit by a film unit.

The place where Westminster Abbey now stands was once known as the Isle of Thorney and legend has it that a sacred grove among the wild roses and sweet-smelling thyme blossomed into

Vine Street Police Station where inexplicable footsteps sound in deserted corridors.

a primitive church centuries before the present abbey was founded. A poor fisherman was casting for the last time in the dying sunlight just off the opposite bank when, as he drew in another empty net, he heard a voice hail him from the shore. The stranger, an old man dressed like a monk, asked to be ferried across to Thorney Island and, once there, to the fisherman's surprise, the quiet stranger asked him to wait, as he disappeared through the brambles towards the primitive place of worship. After a moment, the fisherman later recounted, the darkness of the little island, 470 yards long and 370 yards wide, was illuminated by a thousand golden lights and he saw choirs of angels descend out of heaven towards the church. His ears were full of the sound of celestial singing and the sweet smell of incense was all around.

The mysterious stranger reappeared and indicated that he required to be rowed back across the river. As he stepped ashore the bewildered fisherman asked him the meaning of his 'vision', whereupon the 'monk' stated that he was Peter, 'keeper of the keys of heaven', and he had consecrated the church. He told the now amazed fisherman to cast his net next day, 'and you will catch some good salmon — but you must give a tenth to the Abbey of Westminster.'

Next day, the fisherman's net was full and he dutifully took a tenth of the catch to the abbey and told his story. And he saw for the first time the marks of consecration on the little church: twelve crosses and stumps of candles. Cynics say the story was invented by the monks to enhance the prestige of the abbey and to make sure of their tithe of the river's salmon, but other people point to the abbey's red flag of St Peter with its crossed keys of gold and regard it as symbolizing a link between the saintly stranger and the fisherman of long ago.

One primitive church, said to have been built by Sebert, King of the East Saxons, was consecrated by Mellitus (created Bishop of London by St Augustine in 604) who called it West Minster to distinguish it from the old St Paul's or the East Minster, built about the same time. This church was destroyed by the Danes and rebuilt by King Edgar in 985. The present abbey was founded by Edward the Confessor in 1049-65, and some of the original foundations have been discovered beneath the present structure in the Chapel of the Pyx (originally used as a treasure-house for the jewels and moneys of the Crown) and in the crypt beneath the Chapter House, known as the Confessor's Chapel, where the walls are 17 feet thick, Henry III rebuilt the entire structure, and in 1269 the portion then completed was consecrated.

In 1303, thieves gained entrance to the treasure-house and carried away some millions of pounds in jewels and gold, but most of the treasure was recaptured from temporary burial in a plot of flax in the middle of the Great Cloister. The thieves were executed and then skinned, their skins being tanned and used to cover both sides of a door opening into the passage from the cloisters, a doorway which the monks used to gain entrance to their dormitory, and so they were continually reminded of the theft and of what happened to those who committed sacrilege. This door still exists and attendants show a small piece of the skin of one of the thieves, Richard le Podlicote, which was framed for preservation after having been on the door for centuries.

Some years ago, a policeman on duty one autumn night saw a man in ecclesiastical robes hurry towards the abbey entrance and disappear through the closed doors! As he approached the abbey to investigate, he felt a tap on his shoulder and saw, approaching through the evening gloom, a procession of black-clad figures, walking in twos. They were men with bowed heads, their hands clasped before them, but their feet made no sound on the stone paved sanctuary. They passed close to the astonished policeman and, like the figure that had preceded them, they disappeared through the closed western doors of the great abbey. After a moment, the officer approached the doorway and heard 'sweet and plaintive' music from within the closed and unlit abbey. As he listened he was distracted by the sound of someone passing nearby and, when he turned to listen again, all was quiet within the historic building.

In the seventeenth century, James I appointed David Ramsay, a keen student of magic, alchemy and astrology, to be Page of the King's Bedchamber, Groom of the Privy Chamber and Keeper of the King's Clocks (in fact, he was the first president of the Clockmakers' Company). Ramsay thought that the unrecovered treasure might be hidden somewhere within the abbey precincts once he maintained that he had located the whereabouts of the treasure by means of a divining rod, but he had not safeguarded his efforts adequately and was interrupted by 'demons' who so frightened him that he fled and never recovered the treasure! Ramsay knew all about the reputation of 'Tom', the great clock at Westminster, which was popularly believed to be haunted and to strike out of order whenever an important member of the royal family was about to die. The belief persisted after the clock was removed to St Paul's in the nineteenth century.

The best-known ghost of Westminster Abbey is 'Father Benedictus', a monk said to have been murdered when the thieves robbed the abbey in 1303, although there is no record of any monk being killed inside the abbey. Those who have seen the apparition describe the figure as tall and thin, with a prominent forehead, sallow skin, a hooked nose and deep-set eyes. Among the witnesses were two young women who saw the form one Saturday evening in 1900. They were in the abbey for evensong and turning towards the south transept they saw a Benedictine monk standing silently watching them. His hands were hidden in the sleeves of his habit and his cowl was thrown back to reveal a domed head. His leisured gaze swept over the assembled congregation and then he slowly walked backwards, pausing occasionally to look contemptuously at some member of the public. At length he disappeared through a solid wall and one witness estimated

that she had watched the mysterious and somewhat frightening figure for over twenty minutes. Father Benedictus is said to often walk through the cloisters between five and six o'clock in the evening and occasionally he is reported to talk to people, before vanishing into solid stone wall.

Some years ago, the figure was seen by three visitors who stated that the cowled figure approached to within five feet of where they stood, and they noticed that his feet were an inch or so above the ground — the stones of the floor of the cloisters having been worn down since the monk walked there in the flesh. On the occasions when the figure is reported to have spoken, he is said to talk in what sounds like Elizabethan English and he once said that he was killed in the reign of Henry VIII. After giving a talk at the Wigmore Hall in 1967, a member of my audience, Mrs Cicely M. Botley, told me that she and two friends saw a brown-robed apparition inside the abbey on the night before the marriage of the Duke and Duchess of York (later King George VI and Queen Elizabeth) in 1923.

The unexplained figure of a khaki-clad soldier of the First World War, mud-stained and bareheaded with his eyes full of strange pleading, has been seen near the tomb of the unknown warrior. Sometimes he has been seen with outstretched arms as though imploring help or deliverance. One witness of this apparition told me that the figure seemed to be trying to say something but no sound of any kind accompanied the appearance, which lasted only a few seconds in the dying sunlight of a winter's day. The form has become known as the ghost of the Unknown Warrior.

A historical ghost haunts the Inslip Rooms in the deanery at Westminster Abbey where heavy footsteps have been repeatedly heard in the passage and on the stairs at dead of night. They are believed to be those of John Bradshaw, president of the High Court of Justice, who, during the Commonwealth, occupied these rooms. It was here that Bradshaw, having put aside all legal objections to the court, refused to allow Charles I to speak in his own defence and, having pronounced the death sentence on the king, finally signed the warrant authorizing the execution. Bradshaw's ghost has also been reported to have been seen here.

In June 1972, Dr Edward J. Moody of the Department of Anthropology at Lawrence University told me about the experiences of a film unit during filming in the crypt of Westminster Abbey, beneath Poets' Corner. Among other happenings, I was told about the curious behaviour of a certain door which would not remain closed but opened by itself time after time; there was an odd and peculiar noise which almost defied description but which was noticed by everyone present although nothing could be discovered that might have accounted for it; and there was the curious action of some of the lighting apparatus when lights switched themselves off three times in succession.

CHAPTER FOUR

THE HAUNTED THAMES AND ITS MARGINS

There is a theory that underground water might account for some of the sounds and movements of objects commonly attributed to poltergeist activity, a theory carefully tested and examined by a former president of the Society for Psychical Research, Guy Lambert, CB. I have discussed the matter with him on several occasions, both at the offices of the SPR and at The Ghost Club, and while I feel this may be the solution in some instances, I am quite sure it is not the answer in a number of cases.

Whether or not the presence of water contributes to psychical phenomena, it is indisputable that a great deal of psychic activity is associated with water and London's great river is no exception. It may not have such a spectacular apparition as the famous Flying Dutchman, long reputed to haunt the waters around the Cape of Good Hope, a spectre that has found an entry in not a few ships' logs and the late Commander A. B. Campbell, RD, is among those who have personally assured me that they have seen the phantom ship in full sail in those wind-swept seas; but there are many and varied reports of ghosts and ghostly activity on the Thames itself and along its borders.

ADELPHI

Very few Londoners or visitors to London have been inside the Adelphi Arches, that oblong 'underground village' of subterranean streets, vaults and arches that cover an acre of ground between the Strand and the Thames.

The four Adam brothers built the famous area that they called Adelphi on the site of Old Durham Palace over two hundred years ago. This was before the construction of the Victoria Embankment and to overcome the difficulty of building on muddy foundations immense arched vaults were constructed. Some of these vaults remain. A few have been modernized and serve as garages but the arches in their original form were long used by Messrs Sichel as wine and cask cellars. In one of these dark arches, marked on the Drummond Estate map as 'Jenny's Hole', resides the ghost of a murdered girl.

The old Adelphi, pulled down by the Drummonds in 1936 and replaced by the present concrete-and-glass monstrosity, had been known and loved by scores of famous people. Charles Dickens (who had worked as a boy in a rat-ridden boot-blacking warehouse nearby) loved to wander about the 'dark arches'; David Garrick lived there and entertained Dr Johnson, Boswell, Sir Joshua Reynolds and others in his house over the arches; Benjamin Disraeli knew the old Adelphi, as did Rowlandson; the King and Queen of the Sandwich Islands both died at the Adelphi in 1823; Bernard Shaw lived there, and Thomas Hardy

and Sir James Barrie; even Napoleon Bonaparte stayed briefly at the old Adelphi and may have wandered moodily about the arches. Now all they would recognize would be the arches themselves, dark, mysterious and at times terrifying, the haunt of the homeless and drug-addicts — and Jenny's ghost.

In 1875, at the spot now known as Jenny's Hole, the body of an unknown young woman was discovered. She was a poor Victorian prostitute and she had been strangled, probably by one of her customers, on the squalid pile of sacking and rags where she plied her trade.

Even today, the dark corner harbours the ghost of poor Jenny. Her pale rag-clad form has been glimpsed from time to time briefly before it disappears into these ancient and solid walls, but more often muffled screams — the last sounds that Jenny ever made — hang for a moment on the air. There is also sometimes a frenzied tattoo as her heels rattle again against the unfriendly stone before silence returns to the arches and they resume their centuries of quiet.

BLACKWALL TUNNEL

Victorian Blackwall Tunnel, London's one nineteenth-century tunnel which still serves its original purpose (although now more than doubled in size and set off with handsome motorway approaches) had its share of tragic accidents during construction and inevitably there have been fatalities to users of the tunnel in recent years, among them a youngster who periodically haunts the scene of his death. One report circulating in October 1972, told of a motorcyclist who gave a young man a lift at the tunnel entrance on the Greenwich side. Arriving at the other end of the tunnel, he turned to say something to his passenger (who had mentioned his address) and to his dismay found that he had no one on the pillion-seat. Fearful that the young man had fallen off in the tunnel, the motorcyclist returned to the Greenwich side in the hope of preventing an accident. He traversed the whole length of the tunnel four times but could find no trace of the young man he had picked up. More than a little worried, next day he went to the address mentioned by the youngster, only to learn that the boy he described had been dead for some years. Similar stories are reported from time to time from various parts of the country, an interesting phenomenon that represents twentieth-century folklore.

BUCKINGHAM STREET, STRAND

Buckingham Street, which leads to Watergate Walk (containing the old Water Gate, a relic of the Duke of Buckingham's York House that stood here) near Charing Cross, seems to have several ghosts. There are reports of a ghostly, smiling girl at Number 14, where William Etty, the artist, painted his nude studies. Perhaps one happy and carefree moment as one of the girls ran into the house has somehow become impinged on the atmosphere, for reports of the female phantom suggest a hurried and happy form, soundlessly running into the house.

Next door, at Number 12, Samuel Pepys lived for twelve years, while he was Member of Parliament for Harwich and publishing his *Memoirs of the Navy*. The staircase is probably original, and it is in the hall, facing the stairs, that the ghost of Pepys has reportedly been seen.

In 1953, the ghost was seen by Miss Gwyneth Bickford as she ran down the stairs. The stairs are wide and shallow and she was perhaps four steps from the bottom, alone in the lighted hallway, when she saw a figure standing against the wall between two doors. She stopped dead in her tracks, very frightened. She did not think of a ghost but was alarmed by the fact that someone

The house in Buckingham Street where Samuel Pepys lived for nine years, and where his stocky-looking ghost has been seen, smiling and happy, in the hallway at the foot of the stairs.

was there when she had thought the hall was deserted. Afterwards, out in the street, she began to realize everything she had seen.

The figure had appeared to be quite solid and he stood firm on his feet, which were placed a little way apart. He was stockily built and about five feet, five inches in height. The whole appearance was of a grey figure and the outline was slightly blurred, but what impressed Miss Bickford most of all was the expression on the man's face. His lips and eyes were smiling just as though he was tremendously pleased to see someone. Looking back, Miss Bickford cannot think why she was so startled as no one could have looked more friendly and kind.

The figure wore knee breeches and stockings. His coat was open, he was bareheaded and did not wear a full-bottomed wig, as in most of his portraits. Miss Bickford found that as far as she could establish, the clothes worn by the figure were the right period for Samuel Pepys, and she feels sure that the form she saw was indeed the great diarist, revisiting his beloved London: how different he must find it!

CHEYNE WALK, CHELSEA

A house in fashionable Cheyne Walk — that delightful riverside promenade bordering Chelsea Reach — has long been haunted by several ghosts. The occupant and others saw a phantom bear in the garden on several occasions and since the garden had, in Tudor times, formed part of a royal

estate it was thought that the ursine phantom dated from bear-baiting days, and that the ghost was the spectre of one of the maltreated animals. Once, several guests drew the attention of the occupant to a figure, something like a Dutch doll, that appeared to be leaning out of an upstairs window. A dog that belonged to one of the guests growled savagely and then showed terror, crouching low to the ground, shivering and whimpering. While they were still watching it, the figure suddenly disappeared.

Unexplained sounds were often heard in the house, especially the sound of some heavy object being dragged over bare boards. Once these sounds seemed to pass through the room in which a number of people were gathered. They all heard the sounds but nobody saw anything to account for the noise.

Once, the occupant of the house hurriedly left a visitor in the middle of a sentence and rushed out of the room. Afterwards he explained that he had seen a woman with her throat cut, lying on a chesterfield in the room. There are rumours of a murder having been committed in the house, long, long ago.

CHURCH STREET, CHELSEA

A house at the river end of Church Street, Chelsea, almost opposite old Chelsea Church, had a resident ghost that was seen by many people but never by the lady artist who lived there.

One morning, the artist was working with a woman model and, dissatisfied with the face she had painted, the artist replaced it with the face of a pretty young woman from her imagination. She was pleased with the result, for the face had a suggestion of sadness, which the artist felt added a dimension to the picture.

After the picture was finished a friend came to the studio and seemed to receive something of a shock when she looked at the recently completed painting. All the blood left her face and she turned to the artist. 'I thought you said you had never seen the ghost here?' she challenged. 'You must have — for you have painted the face of the ghost into this picture.'

Once, when the artist had a friend staying with her, the visitor heard footsteps tramping up the stairs at dead of night. They seemed to enter the drawing room and then retreat down the stairs and out into the yard. Next day, in broad daylight, the visitor saw the ghost of a pretty young woman standing by a window in the drawing room, looking out towards the river.

Several visitors asked about the loud raps and sound of heavy footsteps that seemed to climb the stairs in the early evening, from the direction of the Elizabethan cellars, remnants of a former house that once stood on the site. Once, during a party, six sceptical and mundane guests heard the sounds and, learning that they were of ghostly origin, diligently searched the whole house and every inch of the cellars but could find no cause for the noises.

Miss Geraldine Cummins, one of the world's leading 'automatic' writers, told me she believed that Black Magic had been practised in the old house and that earlier still the house had been used as a brothel. She wondered whether the ghost of the sad-faced young woman was one of the girls who had worked in the brothel.

Mrs Hester Dowden, a reputable and highly-respected medium, held an exorcism in the house and believed that she had succeeded in exorcising the ghost. Thereafter, the owner was dogged with bad luck, but she loved the house and fought to the last to retain a charming fragment of the old village of Chelsea, but eventually she had to go and the house was pulled down and an ugly modern villa built in its place. This in turn was destroyed during the Second World War.

The vicinity of Cleopatra's Needle holds a strange fascination for suicides and has a tall, nude ghost that disappears into the river without a ripple or splash.

Haunted London seen from Waterloo Bridge.

THE EMBANKMENT

The Embankment in the area of Cleopatra's Needle and Waterloo Bridge had, and perhaps still has, a strange fascination for suicides and I have been told that it is a fact known to the older members of the River Police that there are more suicides and attempts at suicide in the immediate vicinity of this granite obelisk, which was originally erected in Egypt about 1500 BC, than on any other particular stretch of the Thames. There have been reports of a strange and shadowy figure, tall and nude, that disappears over the protective wall into the river, although there is no sound of a splash. The sound of groans and mocking laughter have been heard here, for which no explanation has ever been discovered.

Waterloo Bridge was haunted for a time by the ghost of a headless man following the discovery of a bag containing a dismembered body near one of the abutments of the bridge. The ghost was reported to appear on several successive nights near the spot where the remains were found. The body was never identified and the ghost was only seen for a few weeks.

Elliott O'Donnell related at The Ghost Club the experience of one police officer who was crossing Waterloo Bridge at night when he heard someone running after him and, looking round

found himself face to face with a well-dressed young woman who appeared to be in a highly agitated and excited state. She implored him to go with her, as she had just left someone in great trouble. She led the officer, from whom O'Donnell had the story first-hand, back off the bridge and along the Embankment. As they approached Cleopatra's Needle he saw a young woman in the act of throwing herself into the river. He rushed forward and just succeeded in preventing the tragedy. After he had managed to bring her back to the safety of the pavement, imagine his surprise on looking at her, to see the exact counterpart of the young woman who had fetched him — in both features and dress! On turning to the latter for an explanation, he discovered that she had vanished. Subsequent questioning ascertained that the young woman he had rescued had no twin sister or indeed any close relative or friend and she had seen no woman of any description on the Embankment that night.

ISLE OF DOGS

A riverside district comprising Cubitt Town and Millwall, within the borough of Tower Hamlets, is known as the Isle of Dogs, although it is actually a peninsula and not an island. The basis from which both the Isle of Dogs and the neighbouring suburb of Barking take their name is reputed to lie in the legend of a ghostly hunt. In ancient times, the forest of Hainault covered this part of Essex, culminating in a swamp of Thames mud, and the legend tells of a handsome young huntsman and his bride who elected to spend their wedding day boar-hunting. The bride, eager to make a mark on her big day, outran the rest of the hunt and, forgetful of the dangerous ground, dashed wildly on until she found herself engulfed and sinking, slowly but surely, into the treacherous quagmire. Her husband, too late to rescue her but determined to try, plunged gallantly into the slushy wasteland and was also lost in his efforts to save his impetuous young bride. This sad wedding day is regarded as the origin of a skeleton horseman and hunting dogs that have been seen at nights in the locality, a story that is perpetuated in a very old poem:

> A hideous huntsman's seen to rise,
> With a lurid glare in his sunken eyes;
> Whose bony fingers point the track,
> Of a phantom prey to a skeleton pack,
> Whose frantic courser's trembling bones
> Pray a rattling theme to the hunter's groans;
> As he comes and goes in the fitful light,
> Of the clouded moon on a summer's night.
> Then, a furious blast from his ghostly horn
> Is over the forest of Hainault borne,
> And the wild refrain of the mourner's song
> Is heard by the boatmen all night long,
> That demon plaint on the still night air,
> With never an answering echo there.

The story of the wharfs of the Isle of Dogs is a long history of violence and sudden death and there are many stories of ghostly happenings in the area. One of the more persistent concerns a ghostly clergyman seen as recently as July 1971, as well as on many previous occasions, in the vicinity of Ratcliff Wharf.

Running east from Ratcliff Wharf is Ratcliff Highway, notorious for years as the wickedest thoroughfare in London, where prostitutes sold themselves for the price of a drink and murder was commonplace. Not a few of the hard-headed and down-to-earth dockworkers and lightermen have stories to tell of strange happenings, ghostly lights, sudden echoing laughter, hollow voices from places apparently deserted and an atmosphere that many men have found downright frightening.

Mark Kitchener, a young lighterman from Islington, recalls his grandfather talking to him about a former vicar of Ratcliff Cross who was said to run a lodging house for seamen 200 years ago when nearby Limehouse was the haunt of 'homeward-bounders' sailors and seamen of the roughest kind who came ashore to drink and brawl. The house run by the vicar of Ratcliff became known as a place to be avoided, even by the toughest sea-men, for there were stories of men being murdered for their money, and anyone that made trouble was likely never to be seen again.

John Denning is a master builder contractor and one Sunday morning in July 1971 he was busy mixing cement on the empty quay and looking forward to a break for a mug of tea. He remembers hearing a clock chime and checking his watch and then, as he bent down to continue his work, he became aware of an elderly man, dressed in black and leaning on a cane, standing about twenty yards away, looking at him. Denning leaned on his shovel and called out a greeting to the stranger but he received no reply. The old man just stood there, his long white hair moving slightly in the breeze; and then the builder realized that the visitor was not looking at him, as he had at first supposed, but at something behind him. John Denning turned round to see what had attracted the attention of the man. He could see nothing untoward or unusual on the deserted wharf, but when he turned back there was no sign of the old man!

Greatly puzzled, for there was simply nowhere that the old man could have hidden in a few seconds, Denning stopped work and looked about him at the locked warehouses on one side and eight feet below the empty quay, the equally empty dock. He could see around the quayside for a distance of several hundred yards, but there was no movement anywhere. He walked to the edge and looked down at the quiet and undisturbed water. He could find no answer to the mysterious disappearance of the old man. A little later, when two of his workmen arrived with some materials, John Denning told them of the curious experience, and although he was very white and trembling slightly, they laughed the matter off and told him to forget it and have a cup of tea. Then, at eleven o'clock the same morning, one of the men, Peter Kinsley, saw the same figure.

Peter Kinsley was busy with two buckets of water at the far end of the quay (where John Denning had seen the old man) when he suddenly noticed a figure standing at the angle of the docks, looking out over the water towards the lock gates. He appeared to be quite solid and normal in every way and, thinking to himself that this must be the man his friend had seen, Peter Kinsley quietly put down the buckets he was carrying and walked towards the man who was about ten yards away from him, on his left. As he approached the figure he realized that he did look rather odd. He was wearing gaiters buttoned up at the sides and a high and close-fitting neckband; his clothes were black and sombre and the straight cane did not appear to have a handle. 'I remember noticing the blue veins standing out on his wrinkled hand and the knuckles tightly clenching the stick,' Peter Kinsley said later, 'and then when I was about three yards from him, he just wasn't there! He didn't fade or become transparent or anything like that. He was there one second and gone the next.'

A week later, Terry Doyle, a newly-employed labourer who had been told nothing about the experiences of the previous Sunday, worked through the dinner hour to make up his time and when John Denning, John Clarke and Peter Kinsley returned to work he was still busy and said nothing, but a little later, when he and John Clarke met as they were filling their buckets, Terry

said suddenly, 'There was a funny old character hanging about here while you were away. He wore black clothes and looked like some sort of clergyman; an old fellow with a stick.'

After Terry had been told of the previous appearances of the 'vicar', he commented that the figure had not looked at all ghostly. Terry said he had gone out on to the dockside and saw the man, as he took him to be, standing some distance away, looking down at the water. He hadn't thought any more about the matter until a little later when he walked on to the dockside again and he saw that the man was still there, and this time he noticed that the figure did look rather odd, especially the old-fashioned clothes. However, he continued his work and when he looked again the man was gone. A week later, the same figure was seen yet again and this time by both John Denning and John Clarke at the same time. It was about ten o'clock in the morning and John Clarke saw the figure first. Although he had not previously seen the mysterious form, he immediately recognised the description of John Denning, Peter Kinsley and Terry Doyle. He called out to John Denning, 'Ha! There's your ghost!' John Denning looked up and saw the figure he had seen two weeks earlier. Both men turned to call their friends, but when they turned back the figure had disappeared.

During the weeks that followed John Denning and his companions continued to work at the same place, restoring a derelict warehouse, but they never saw the figure again. It is interesting to note that the figure never spoke or seemed aware of the human beings; it never looked directly at any of the witnesses; it appeared and disappeared suddenly and under seemingly impossible circumstances; and it was only seen on Sunday mornings. If we accept the evidence of the four men, the apparition of the vicar of Ratcliff Wharf is convincing and puzzling. John Denning is the son of a senior Foreign Office official, John Clarke is a former publishing assistant and Peter Kinsley used to be a journalist and is the author of three novels. The latter was filling in time before returning to his flat in Ibiza, working as an unpaid labourer to try to lose a bit of weight and toughen himself up. Terry Doyle is a devout Roman Catholic who had worked through his lunchtime to make up for the time he had taken off that morning to attend Mass. This entire account, I find, is entirely fictitious, and the creation of Frank Smythe (2010).

LAMBETH PALACE

One of the Thames ghosts is that of Queen Anne Boleyn making her last sad journey from Lambeth Palace in the barge with its shadowy oarsmen, carrying her to execution at the Tower. There is a strong tradition that Anne (whose ghost is also reputed to haunt Hever Castle in Kent, Bollin Hall in Cheshire, Blickling Hall in Norfolk, Marwell Hall in Hampshire, the church at Salle in Norfolk, the Tower of London and other places) was tried on the charge of adultery by Archbishop Cranmer in the undercroft of Lambeth Palace, on the banks of the Thames, and the sound of moaning, groans and occasionally Anne's voice pleading her innocence has been heard at times by people passing near the door of the undercroft. The sounds are distinct and clear when they are first heard, but fade and die away as the hearer stops to listen.

The crypt is a strange and atmospheric place where scores of skulls and human bones have been discovered between the five floors (probably built as successive attempts to keep out the river water) during excavation at different times, and it seems likely that the dark and sombre crypt has been used in the past as a secret burial place. It is the oldest and least restored part of the present palace.

After being found guilty of the charge on which she had been accused, tradition asserts that Anne was taken down the steps of the Water Tower to the boat and it is the stretch of the river by the Water Tower that is said to be the scene of this arresting and spectral reappearance.

Lambeth Palace from Lambeth Bridge. Here the figure of Anne Boleyn has been seen on her last sad journey, in a phantom barge rowed by shadowy oarsmen.

Lambeth Palace itself has several ghosts. There is the phantom presence on the winding staircase in the Lollards' Tower that sometimes manifests so strongly that visitors cannot proceed upwards and dogs can rarely be induced to pass the invisible influence. The stairs lead to the Lollards' Prison, with its ominous iron rings and sad writings on the walls, which were scratched by the wretches imprisoned there over the years, and there is a haunted door which sometimes opens without difficulty and at other times locks of its own accord.

During the Second World War, a member of the palace fire-fighting brigade always maintained that he owed his life to this door, for during an air-raid he hurried down the iron ladder from the roof but then found himself imprisoned by the door that had locked by itself. There he remained for over an hour until the door was forced open, but meanwhile the room to which it had been his intention to report received a direct hit and was entirely wrecked.

NATIONAL LIBERAL CLUB

In Whitehall Place, and facing the river across the public gardens, stands the white eminence of the National Liberal Club, founded in 1883 with W. E. Gladstone, the great Liberal leader, as President. The existing premises were opened in 1887, and the club's library, which now includes Gladstone's collection of 31,000 volumes and 33,000 pamphlets, was inaugurated by the former Prime Minister in 1888. Some years later, the club was the scene of apparent poltergeist activity.

Professor George John Romanes, a prominent Fellow of the Royal Society, a Professor of Physiology, a noted naturalist and a close friend of Charles Dickens, was also much interested in occult matters and he was one of the early students of psychic phenomena who strongly objected to the use of the word 'supernatural' since he believed that everything must have a place in nature. The correct term is now accepted to be 'supernormal'.

Professor Romanes was in Scotland, investigating a poltergeist case in Ross and Cromarty, when the secretary of the National Liberal Club wrote to him to ask whether there was any living creature which, while encased within a wall, could produce sounds like knocks and raps.

Professor Romanes was intrigued by the enquiry and in replying said that he did not believe such a creature existed, and inquired about the reason underlying the question. The secretary then

The clubs of Whitehall. At the National Liberal Club (extreme right) poltergeist phenomena were reported by the secretary.

explained that for some time past he and his wife and family had been disturbed by sounds which apparently emanated from the walls of the rooms they occupied at the club, sounds for which they had been unable to find any rational explanation. He described the noises in some detail and the professor promised to call at the club on his return to London, but by the time he did so the disturbances had ceased. However, the club secretary gave him a full and first-hand account of the well-authenticated sounds and added a peculiar answer to the mystery.

The secretary said that he had discovered that the noises always seemed to be heard in the vicinity of a young German maid who was employed at the club and, while it was certainly not suggested that she was in any way consciously responsible (indeed, this would not have been possible in the circumstances described), the noises had seemed to follow her and were heard to proceed from the walls of rooms when she was present, and (somewhat unfairly perhaps) she had been given notice in consequence. Since her departure the noises had ceased.

This case might well be described as a typical poltergeist infestation. The disturbances commence suddenly and inexplicably and in some way are associated with a young person, more often a girl than a boy, and when this person is no longer present the disturbances cease as inexplicably as they began. Professor Romanes endeavoured to trace the girl, who had gone back to Germany, but he was unsuccessful.

New Scotland Yard (old premises)

On the north bank of the river, near Westminster Bridge, stands the famous chequered tower block that marked for years the headquarters of New Scotland Yard, before new premises were erected in Victoria Street.

Before being moved to rooms in the new building the gruesome collection of criminal relics known as the Black Museum was housed in the basement of the Metropolitan Police Headquarters, and there the apparition of a headless lady was seen on many occasions.

These old police headquarters on the Thames Embankment are built upon a series of ancient vaults, and when the buildings were under construction, a carpenter, Fred Widborne, discovered

a bundle in one of the dark vaults — a bundle that contained parts of a human body. The surgeon of 'A' Division at the Yard at the time, Dr Thomas Bond, established that the remains were those of a woman of about five feet nine inches in height but apart from the fact that the woman had been well nourished when alive, very little could be gleaned from the remains.

In the subsequent search for the head of the body, a police dog located a foot and other parts of the same body and with the help of these Dr Bond concluded that the woman had lived in comfortable circumstances, but the head, so important to identification, was never traced. A small silver crucifix bearing the name of a French convent was found with the remains and it was thought that the victim might have been a nun, or rather a Sister of Charity, but the parts of the dead body were never identified and no information was ever discovered as to the crime itself or how the remains came to be in the vaults. However, it seems likely that she was the (appropriately!) headless figure that was seen years later inside the museum.

The Black Museum began as a collection of exhibits from famous trials that were stored in a room in the basement of the Yard, to which favoured visitors were taken by members of the CID by way of dark and dismal underground passages that added to the eerie atmosphere of the occasion. After the First World War, the collection was arranged in some order and exhibits were added to enable the museum to be used for instruction and educational purposes.

When I visited the Black Museum some years ago it contained a collection of death masks of prisoners hanged at Newgate Prison and a staggering collection of housebreaking instruments and weapons used by criminals, including the skeleton keys, rope ladder, dark glasses and false arm that had belonged to Charlie Peace; the equally ingenious equipment once owned by 'Flannelfoot', a housebreaker who successfully eluded the police for years; relics of Sir Roger Casement and examples of forgery; mock jewellery used by confidence tricksters; and gambling contrivances employed by swindlers, including a 'gold' brick used in the Gold Brick Fraud.

There too I saw the rolling-pin used by murderer Ronald True; the knife used by Bywaters when murdering Thompson; the medicine chest that had belonged to Neill Cream, the Lambeth murderer; and several items connected with the Crippen case, including part of his pyjamas that he had used as wrapping for parts of his wife's body, and the wireless telegram that led to his arrest — the first time wireless was used for such a purpose. More gruesome were the riding switch with which double-murderer Neville Heath had lashed Margery Gardner, and half a foot, gall-stones and false teeth of the last victim of John George Haigh, together with gloves and gas-mask that he had used for his own protection when destroying the bodies of his victims in baths of acid.

A few years ago, a janitor at the Yard saw a female figure standing near the door of the museum, which she proceeded to open, a figure which he took to be a nun, but when he went forward to see what she wanted the figure disappeared. As he reached the spot where the figure had been, he stopped in amazement and then, turning round, he saw the same form at the far end of the museum. This time the figure was facing him and he saw that the nun's hood was empty: the figure was headless!

The late Mr 'Gerry' Dawson, who became museum curator in 1957, following his retirement as a detective inspector after twenty-seven years' service in London, once told me that he had seen a dark figure in the museum several times but it always disappeared when he approached and he tended to think that it must have been a trick of the light, although it appeared in different parts of the museum. He also told me about a murderer's death-mask from which

mysterious hairs grew at one time, and although the curator cut the hairs short, they grew again slowly. The death mask was that of a murderer whose beard had been cut off before he was hanged as it might have hindered the hangman's work. Charles 'Gerry' Dawson died in 1970 on his way to the Black Museum.

SOMERSET HOUSE

Somerset House, a palace when the Strand was known as the King's Road, linking Westminster with the City of London, was later occupied by the Inland Revenue, Probate Registry and the Registrar General. The first government department to occupy Somerset House was the Admiralty, where Lord Nelson was a frequent visitor, and it is his ghost that has been seen within the precincts of this historic building, which was one of the first in this country to be designed in Italian Renaissance style. Canaletto knew Somerset House and painted several pictures from the terrace.

The present Somerset House has been in existence some two hundred years. The first Somerset House, a Tudor extravaganza, saw many a brutal death by dagger, sword or poison. That first house was built by the Duke of Somerset when he was Protector of all the Realms and Dominions of the King's Majesty and Governor of His Most Royal Person — the ten-year-old Edward VII — in 1547. To find room for the noble building he had in mind he demolished several bishop's houses, the old church of St Mary le Strand (rebuilt in the middle of the Strand in 1714-17) and a charnel house. It was said that more than a thousand cartloads of human bones were removed and buried in Finsbury Fields. There is some mystery about the architect of Somerset House, although it is generally thought to have been Sir John Thynne, who built haunted Longleat, a house that contains some of the features of old Somerset House.

In 1551, the Duke of Somerset was falsely accused of a plot against Warwick, whose eldest son had married Somerset's daughter Anne, and after practically every possible charge had been made against him he was found guilty of felony and died on Tower Hill, his great palace beside the Thames still unfinished. The Princess Elizabeth received Somerset House as a town residence, and when she became queen she retained possession and used the great house as a royal palace, a meeting place for her council and as a kind of grace-and-favour residence for friends and relatives. Some of these were of questionable character and substance, such as Cornelius de la Noye, who was provided with an apartment where he practised alchemy, having persuaded the queen that he could transmit base metals into gold, manufacture precious stones and produce a potion with powers of perpetual youth.

During the reign of James I, his queen, Anne of Denmark, preferred Somerset House to all her other palaces and there she smuggled Roman Catholic priests to celebrate Mass, beginning a trend of deceit and intrigue that culminated in the Great Popish Plot seventy-five years later — an affair that nearly destroyed the monarchy.

Queen Anne died suddenly at the court in 1619 and a week later her embalmed body was conveyed by river at night to Somerset House (then called Denmark House) to lay in state there for over two months. King James, having satisfied himself that his wife was recovering, had gone to Newmarket, and the end came quickly and unexpectedly. Yet the king had a morbid fear of death and if he could convince himself that he had some excuse for not being at her death-bed there can be no good reason for his absence at her funeral.

Six years later, the king's embalmed body lay in state at Denmark House for a month, after he had died at Theobalds of a fearful attack of dysentery that led to rumours of poison.

Charles I installed his fifteen-year-old bride Henrietta Maria in Denmark House and she began to bring back some of its frivolity and style until the King ordered her interfering mother, who stopped at nothing to further the Roman Catholic cause in England, to leave the country together with the whole of the queen's French suite. For a time after that the silent stones of Denmark House saw deep sadness as poor Henrietta, surrounded by the unresponsive English, and seeing little of her husband, wept in her loneliness. But soon the young couple were reconciled and gaiety returned to the house by the river.

Henrietta Maria had a passion for dwarfs and in 1627 she received an eighteen-inch-high, nine-year-old dwarf in a pie as a gift. She was much upset when one dwarf fell to his death from a window at Denmark House, and when a dwarf couple married, with the king giving the bride away, the pair lived at Denmark House as part of the royal suite.

During the violent storm that brought down trees in St James's Park on the night of 3 September 1658, Oliver Cromwell died and his embalmed body lay in state at Somerset House, by this time called again by its original name. However, visitors saw only a wax effigy clothed in royal purple and holding the sceptre and orb, for the body itself had not been properly embalmed and was quietly removed and buried in Westminster Abbey. A fortnight later, the crowned wax effigy was carried at the official funeral.

Before long the brother of King Charles II, Henry, Duke of Gloucester, died of the smallpox and his body lay for some weeks at Somerset House. While there for the funeral, the Princess of Orange died from the same disease and her body was carried in torchlight procession from Somerset House to Westminster Abbey. The body of the Queen of Bohemia lay in state at Somerset House, and that of the Duke of Albemarle, and also the body of the Earl of Sandwich who had brought the king back from Holland.

Apart from acting as a royal mortuary, Somerset House was the scene of many macabre incidents. Pepys relates that one Tom Woodall was killed in a drunken brawl at Somerset House, and in 1678, Sir Edmund Barry Godfrey, a highly respected magistrate, disappeared and his body, run through with his own sword, and with a livid mark around the neck, was found in a ditch. There is evidence to suggest that he was murdered at Somerset House, where he had been persuaded to come to meet some Catholic priests, and where he was probably murdered by the palace sentries and the body hidden in the vast mansion for some days and then taken to Primrose Hill where it was found. Some say his ghost walks at Somerset House. In 1720, Somerset House became the meeting place for some of London's Satanists or Hellfire Clubs and the following year a royal proclamation forbade such clubs, although twenty years later they were revived by Sir Francis Dashwood and his notorious Monks of Medmenham. On the lighter side, Elizabeth Chudleigh, maid of honour to Augusta, Princess of Wales, appeared at the Somerset House Ball in 1749 as Iphigenia — naked for the sacrifice! The princess pretended to be embarrassed and threw a veil over the girl.

A hundred years later, Somerset House first boasted a resident ghost. Out of all the gruesome happenings, violent deeds and associations with death, Somerset House is haunted by the quiet ghost of Horatio Nelson. The Admiralty was established at Somerset House in 1786 in premises later occupied by the Inland Revenue, and for years its museum and exhibition of model ships was a popular attraction. The great admiral spent some of his most poignant and happy hours within the region of Somerset House, and in 1806 his body was carried up the Thames past Somerset House to Whitehall in readiness for the last journey along the Strand and burial in St Paul's Cathedral. It does not seem unlikely that even in death Nelson found the atmosphere of Somerset House irresistible. His ghost, the thin and spare and frail-looking form with one arm missing, quite unmistakable, has

usually been seen on bright spring mornings, walking briskly across the rough stones of the quadrangle towards the old Admiralty Office. In most cases the figure is seen from a distance and invariably it disappears before it can be challenged. Some witnesses have detected a wispy and almost transparent cloud surrounding the figure that appears unusually sharp in the morning light.

When Charles Weld was librarian of the Royal Society, then occupying rooms in the north block of Somerset House, he learned about a curious story that was said to account for the watch-face inserted high up on the wall of the quadrangle. During the course of construction, a workman was said to have fallen from the scaffolding and was halted in his descent by his watch-chain catching on a portion of the wall. As a mark of his gratitude, he inserted his watch into the face of the wall, a memento of his lucky escape. Alas for legend, the watch-face was placed in its present position by the Royal Society as a meridian mark for a portable transit instrument in one of the windows of their rooms.

One little mystery before we leave Somerset House. In the basement, known as the West Search, there is a strange little self-contained snuggery, panelled in wood designed to look like stone and with dummy windows and dummy skylights. No one seems to know the original purpose or history of this pretence apartment.

THE TEMPLE

The Temple, on the Victoria Embankment, was originally the headquarters of the Knights Templars who came here in 1184. When the Order was dissolved in 1312 the property was acquired by the Crown and given to Aymerde de Valence, Earl of Pembroke. On his death in 1323 it passed into the possession of the Knights Hospitallers of St John who leased it to students of the Common Law. On the dissolution of the Knights of St John in 1539 the Societies of the Inner and Middle Temples leased the property to the Crown, and in 1608, James I granted the property to them and their successors forever.

Among the mysteries of the Temple there is the curious affair of the skeleton discovered when electricity was installed in the Middle Temple Hall. The skeleton, in a perfect state of preservation, was found in a box in a recess of the wall near the roof. It was judged that the skeleton must have remained hidden there for over 200 years. And among the tragedies there is the Brick Court murder by a Miss Brodrick who killed her lover, Mr Eddington, when he deserted her and the cruel murders in Tanfield Court of old Mrs Duncomb and her little maid, Annie Price, by a charwoman, Sarah Malcolm.

The Temple has seen much strife and suffered much damage over the years. Wat Tyler wrecked many of the buildings in 1381 and the Great Fire burnt most of the Inner Temple in 1661. There were other fires in succeeding years and the Second World War took its toll, yet there are still buildings, gateways, arches and cloisters that would be recognized by the scores of famous people who knew the Temple. Dr Johnson lived here, as did Oliver Goldsmith, Lamb and Thackeray. Elias Ashmole, friend of diarist John Evelyn, and founder of the Ashmolean Museum at Oxford, had chambers in Middle Temple Lane, and Sir Francis Drake knew this place, as did Queen Elizabeth I.

Others who had chambers at the Temple include Lloyd Kenyon, Chief Justice of the King's Bench, and Sir Alexander Cockburn, who achieved the same distinction; Sir Gordon Hewart, Lord Chief Justice; Sir Edward Carson and George Jeffreys. However, it is not the ghost of the infamous Judge Jeffreys of the Bloody Assizes that haunts these ancient precincts but that of

The archway at the Temple where the ghost of Sir Henry Hawkins has been seen as daylight fades, with a bundle of papers underneath his arm.

Sir Henry Hawkins, afterwards Lord Brampton, whose ghost has been seen many times, usually around midnight, clothed in wig and gown gliding noiselessly though the cloisters with a bundle of papers under his arm. Or sometimes in the fading hours of daylight, his hurrying form has been glimpsed in the vicinity of one of the fine archways that 'the hanging judge' must have known so well during his days at the Temple.

HAUNTED HAMPSTEAD, HIGHGATE AND NORTH LONDON

BRUCE CASTLE, TOTTENHAM

Bruce Castle, Tottenham (now part of the London Borough of Haringey), a former Elizabethan manor house, has been restored as a museum. The property was once owned by Rowland Hill, the originator of the penny postal system, and it is appropriate that the exhibits at Bruce Castle include a museum of British Post Office history. There is also a ghost that appears on 3 November every year. The haunting is said to date back to the seventeenth century when the beautiful Costania, Lady Coleraine, threw herself to her death in desperation at being kept locked in a tiny room over the central porch by her jealous husband, Henry, the second Baron Coleraine.

On 3 November 1680, she is reported to have made her way to the parapet outside, her baby in her arms, and there jumped to her death, screaming hysterically. The event is said to have been re-enacted for many years afterwards on each anniversary. As the years passed, the vision faded, but the sound of screams are said to have been heard within living memory and C. H. Rock, a museum curator, told me some years ago that he had heard from a seventy-six-year-old lady living in Essex, who resided opposite Bruce Castle as a child, who claimed to have heard the screams several times. After a parson held a prayer meeting the 'ghost' quieted down for a time, but a few years later, one 3 November, the screams were heard again.

Bruce Castle has an interesting history. The present building dates from the sixteenth century and there are records of the estate passing into the hands of Sir William Compton, a favourite of Henry VIII, in 1514, and in fact the king visited the house on more than one occasion. No one knows the purpose of the detached sixteenth-century tower. In the seventeenth century, when the property was owned by the Coleraines, the porch was heightened and contemporary dates and initials are still to be seen, carved into bricks on one side of the porch. About 1720, the present wooden staircase was erected and much of the north side of the block. In the eighteenth century, the Townsends added two wings and replaced the old gables with a brick parapet and dummy windows. Early in the nineteenth century, Sir Rowland Hill and his brother added a new block at the back of the building, and at the end of that century, the property was acquired by the then Urban District Council of Tottenham.

The manor of Tottenham at one time belonged to Robert Bruce and it is believed that Bruce's 'castle' was pulled down by the Comptons. Early foundations have been found nearby. Bruce himself is reputed to haunt the round tower, which is difficult to understand since the tower was not erected until two centuries after his death.

Some fifty years ago, thirteen watchers held an all-night vigil on the anniversary of Costania's fatal jump and, although no screams were reported, several of the watchers heard footsteps from

the direction of the deserted spiral stairs. Mr Rock told me that he joined the watchers and the thing that particularly interested him was the apparent failure of the clock (situated immediately above the haunted chamber) to strike one o'clock, although it struck the hours of midnight and later quite normally.

COLLINS' MUSIC HALL, ISLINGTON (DEMOLISHED)

The famous Collins' Music Hall (now alas no more), where old-time stars of the calibre of Marie Lloyd, Eugene Stratton, Little Tich and Harry Randall appeared, was long said to be haunted by Sam Collins, the singing Irish chimney-sweep who founded the theatre, and also by the ghost of Dan Leno.

Chris Rowlands, stage manager at Collins' for forty years, claimed that Dan Leno's ghost was often seen at rehearsals and auditions, invariably occupying one particular seat and occasionally showing his disapproval at a poor performance by snapping his fingers.

Mr Lew Lake, proprietor of Collins' in 1948, often complained that his office at the theatre seemed to be the centre of the manifestations. On many occasions, a single clear knock would sound on the office door when no one was near it. On one occasion, his table cigarette lighter, a tall, slender object, somewhat top-heavy, suddenly jumped into the air and then came to rest on the desk at an angle of forty-five degrees. Doors shut of their own accord so often that they had to be wedged open with a piece of iron, and even then the wedge was sometimes moved and the doors closed. One hot evening, Lake became so annoyed at the continual closing of the door, which he had wedged open, that he slammed it shut with a curse. A few moments later, it opened by itself. The disturbances usually occurred around nine o'clock in the evening, a time that approximately coincided with the interval during the second performance.

One night, a friend of Lew Lake said he would sleep in the office, a large and pleasant room with big windows looking out to Islington Green. Soon after settling down for the night he felt icy hands running over his face and then fingers clutched at his throat. Soon afterwards he gave up the idea of spending a night in the room and awakened his host who put him in another room!

HAMPSTEAD

Hampstead has several ghosts. An old house not far from the parish church was the scene of a murder and was reputed to be haunted for years afterwards. People who lived there and visitors who knew nothing of the story often heard a curious sound, half a sigh and half a shudder, that seemed to come from just behind them in the hall. Pattering footsteps, faint and yet distinct were also heard time after time in the house — running footsteps that put one in mind of a child running downstairs. Sometimes they would halt suddenly and then retreat at a slower pace, almost as if a child had unexpectedly found itself face to face with a stranger or someone of whom it was frightened.

Upstairs, too, strange noises were often heard from the stairway. They were sounds that suggested someone creeping stealthily up, a step at a time, as though anxious not to awaken or disturb anyone. A shuddering sigh would sometimes be heard in the upstairs rooms, especially at dead of night and most often during the month of September. And when the first rays of daylight began to light up the shadows of the old house, the figure of a charwoman with red hair and carrying a carpet bag would sometimes be seen, standing just inside the front door, apparently breathing heavily and much exhausted from some fatiguing labour. The crime at the unquiet

house had been committed by a woman with red hair. She had murdered a child of the household, dismembered the body and carried the remains out of the house in a carpet bag.

Hampstead Heath is reputed to be haunted by the ghost of Dick Turpin in the vicinity of the old-world atmosphere of the Vale of Health. Mrs Helena Steibel said she was walking near the Vale of Health when she saw a man on horseback riding straight towards her. She thought he must run her down and, although getting on in years, she tried to get out of the way, but it was no use and she prepared herself for the inevitable collision, but both the black horse and its black-clad rider just vanished! There was no doubt in her mind but that she had seen the figure and she described the black coat 'and funny hat... the kind that comes over the forehead in a point — a tri-corn'. A few months before Mrs Steibel's experience a running enthusiast had reported seeing a man on horseback near the Vale of Health, when he had been doing a practice run across the heath. The rider looked like Dick Turpin riding a black horse.

A basement flat in Adamson Road, Hampstead, seemed to be haunted a few years ago by a hundred-year-old dwarf who came to be known as 'Little Charlie'. At first the disturbances seemed to be of a typical poltergeist character with knives and forks, scissors and even a plate of fish and chips vanishing without trace. Books were said to fly through the air, strange marks appeared on doors, and none of the residents' pets would go near the basement. Then one night the young son of a tenant was found almost hysterical with terror. He said he had opened a cupboard to put some toys away and inside he saw the figure of a small crippled man. The boy's mother maintained that she had also seen 'Little Charlie' once: he was so small and ugly that she took him for a monkey and was about to telephone the zoo to say that she had an escaped animal in the house, when the apparition suddenly vanished. A previous occupant of the flat was traced who also stated that the place was haunted, but after new tenants occupied the premises no further disturbances were reported.

Something of a similar character seems to have infested a shoe shop in Kilburn High Road, a branch of the Anglo-American Shoe Stores. It caused shoes to move of their own accord, hammers and chisels to fly through the air, locked doors to open, candles to move and light by themselves, and tappings to sound on solid walls.

Jim Best, a thirty-eight-year-old crippled shoe-repairer, had worked contentedly in the shop for twenty years until tappings sounded on the wall, and then he found brown shoes dyed black. Other shoes were found out in the street, tools started to fly about and the workbench was smashed. Jim reported the matter to his manager, Charles Fishburn, who was sceptical until a chisel suddenly whizzed past his ear and thudded into the wall behind him.

Two shop assistants tried to help and were greeted by a shower of tin tacks and a book which was thrown with such force that its cover was broken. One girl felt somebody was behind her but before she could turn round a soldering iron hit her on the elbow. Once Jim Best decided to make sure the door stayed shut and he and the manager put four locks and a bolt on the shop door and locked up. As they walked away they heard a 'click' and when they touched the door it swung open.

I was in touch with Charles Fishburn at the time of the disturbances and was interested to learn that nobody had ever seen an object begin to move. It seemed that each time the articles commenced their movement out of sight and then flew past the occupants. All the disturbances were confined to the small workroom used by Jim Best, and it was invariably left-hand shoes that were moved, never right-hand ones. For a while, Jim Best worked in another part of the shop. His old room was redecorated and then after three weeks of puzzling and unsettling happenings, the disturbances ceased completely.

HIGHGATE CEMETERY

Highgate Cemetery, with its 45,000 graves, is best known for the tomb of Karl Marx, but those buried in the older part of the cemetery, where graves have repeatedly been disturbed in recent years, include the parents of Charles Dickens, Sir Rowland Hill, who introduced the penny post, Tom Sayers, the old-time prize fighter, and Michael Faraday, the distinguished scientist.

It is this older part of the vast cemetery that has long been reputed to be the haunt of a vampire. Graves have certainly been disturbed and it is not difficult to imagine a vampire lurking among the forsaken tombs, many overgrown with the ever-increasing tangle of weeds, bushes and trees. At one time it was a chilling scene of utter ruin and decay where vaults yawned in the shadows and gravestones crumbled beneath one's feet.

In 1969, a man was discovered at dusk, armed with a pointed stake and a crucifix, waiting for the vampire that he is still convinced walks in Highgate Cemetery. In 1970, a grave was rifled and its corpse, a woman, removed and burnt. The head was missing and has never been recovered. Almost certainly some kind of sacrificial rite had taken place and the head removed for further rites. The human skull has long been regarded as the centre of psychic power and skulls play a big part in the rituals of modem black magicians. The 'catacombs' at Highgate Cemetery, with their rows of huge tombs and stacks of coffins, attract vampire-hunters and sensation-seekers who have been observed at night, entering the vaults, opening the coffins and daubing the walls with symbols.

In the newer portion of the cemetery where, among many others, George Eliot and Herbert Spencer are buried, two ghosts of the more traditional kind are said to walk. One is a solitary spectre with bony fingers that is reported to linger in the vicinity of the huge iron entrance gates. The white shrouded figure seems to gaze pensively into space and is oblivious to human beings until they approach too close and then it suddenly disappears, only to reappear a short distance away, adopting the same listless stance. There are those who claim to have communicated with this passive phantom.

The other ghost is that of an old woman, her thin hair streaming behind her as she passes swiftly among the mouldering tombs and disappears into the almost impenetrable thickets and decaying vaults. I have talked with two people who claim to have seen this ghost from different viewpoints at the same time, but always the fast-moving figure disappears from view before it can be closely studied and it always eludes those who try to follow it. The ghost is thought to be that of an old and mad woman whose children were buried here after she had murdered them, and now her sad and restless spirit seeks the graves of those she harmed but really loved.

HILLDROP CRESENT, KENTISH TOWN

Hawley Harvey Crippen, an American doctor, was hanged in 1910 for the murder of his wife Cora (alias Bella Elmore, etc.) with whom he had lived in disharmony at 39 Hilldrop Crescent, not far from Kentish Town Station. There is a piece of waste ground nearby where Crippen would often stroll at night, perhaps in the early days of 1910, dreaming about Ethel Le Neve and scheming how best to rid himself of his wife. Whatever the attraction, 'Peter' Crippen (as he was known) spent many night-time hours there, deep in concentration and thought, permeating the darkness with his tremendous vitality, and completely self-sufficient in his awareness of supernormal powers. I have talked with Fred Cavell who was the jailer in charge of Crippen at Bow Street for six or

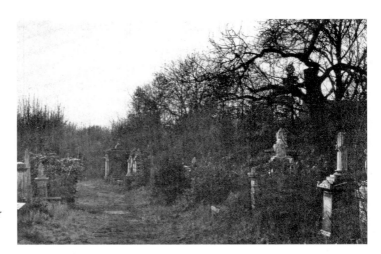

Highgate Cemetery has long been reputed to harbour a vampire, a stationary spectre in a white shroud and the fast-moving phantom of a mad old woman, searching for the graves of the children she murdered.

seven weeks. Crippen would be brought up from Brixton jail every morning and taken back at night. He was described to me as a quiet, monkey-faced little man who never spoke except to ask the time, which he did twenty times a day. He always seemed quite content with his two slices of bread-and-butter and a cup of tea twice a day. He never had any food brought in and nobody ever came to see him. He didn't seem to have a friend in the world, and he didn't give a moment's trouble. But what about after his death?

One man was sufficiently interested in the possible return of Crippen, in one form or another, to spend several nights at the dark, open piece of waste ground, following the hanging of Crippen on 23 November 1910. The execution was carried out at six o'clock in the morning and that night our investigator arrived to carry out the first of his nocturnal vigils. Just before midnight he felt a sudden and intense coldness all about him, and a scratching sound alerted him for what might follow.

Shortly afterwards he became aware of an indistinct and vague form watching him from the direction of a high brick wall — a short man with a drooping moustache and staring eyes behind metal-rimmed spectacles. After a moment, the figure noiselessly stepped out of the shadow of the wall and the watcher saw that the figure carried a large paper parcel under one arm. The form disappeared in the dim moonlight, going in the direction of an almost forgotten and litter-filled pond. After a few moments, the same figure returned but without the parcel, and this time the watcher realized with a start that he could see the trees and bushes through the form that was slowly walking towards him, slump-shouldered and with an appearance of sadness. Still the watcher stood his ground, and then, when the form was perhaps a dozen yards away, it suddenly disappeared.

Subsequently, the investigator spent the best part of several cold nights at the same spot and, although once or twice he thought he saw the same figure (and once saw a strange dog-like animal for a second) hidden in the deep shadow of the high wall, he never again saw the form clearly and he died before the plot of land was developed and built upon, perhaps laying for all time the ghost of Crippen. For a time, our watcher wondered about the big parcel that the figure had carried on the first occasion that he had seen it, and then he learned that only portions of the body of Cora Crippen had been unearthed at Hilldrop Crescent. The head, skeleton and limbs were never found.

THE MARLBOROUGH THEATRE, HOLLOWAY (REPLACED)

The Marlborough Theatre, Holloway, later a cinema, was reputed to harbour the ghost of an irritable ex-thespian in astrakhan collar that used to be seen in the vicinity of the manager's office. In 1947, the manager, Mr Billy Quest, told me that he had no doubt that the place was haunted and although he had never seen the ghost himself, he had talked to patrons and a previous manager who had seen the apparition.

THE OLD QUEEN'S HEAD, ISLINGTON

The Old Queen's Head at Islington is haunted by a female ghost. This is perhaps one of Sir Walter Raleigh's ladies, for he built the old pub that formerly stood here; or perhaps Queen Elizabeth I herself, for she stopped here occasionally when the Earl of Essex lived here; or possibly, as the landlord's wife thinks, it is the ghost of a younger girl. Mrs Arthur Potter says she has often heard the ghost run upstairs ahead of her, the little feet tap-tapping away along the passage, accompanied by the swish and rustle of a long dress. Mrs Potter's daughter once heard 'someone' coming along a passage at the Old Queen's Head when no one was there and once Arthur Potter walked into the ghost!

He was walking carefully downstairs in the dark one evening when the light-switch had broken and about half-way down he felt 'a body or a thing' press against him. He pushed it away and rushed down the rest of the stairs to switch on the light. The stairway was quite deserted and to this day Arthur Potter does not know what he encountered but he was very careful never again to walk downstairs in darkness.

POND SQUARE, HIGHGATE

The old and elegant Pond Square at Highgate has long been haunted by a ghostly chicken, a frightened, squawking featherless creature that has been seen many times over the years. This ghost has its origin in a far-reaching experiment conducted by statesman and philosopher Francis Bacon, Viscount St Albans — an experiment that cost him his life.

In 1626, Bacon, one-time Lord Chancellor of England, the highest office in the state, was sixty-five. He had enjoyed a brilliant political career before being found guilty of bribery and corruption and sentenced to a fine of £40,000, imprisonment in the Tower and prohibition from ever again holding office or sitting in Parliament. His work in philosophy and science was far in advance of his time and he had recently turned his attention to natural history, which he studied by following the Baconian Method: to discover the hidden, simple laws of the universe by gathering scientific data and laboriously eliminating all incidental attributes of those data to arrive at its essential causes.

In March that year, Bacon was riding in his carriage through the snow-covered streets of Highgate. Scientific problems were never far from his mind, and as he travelled along on that cold and icy day he suddenly wondered why the grass exposed beneath the snow by the wheels of his carriage was so green and fresh. Could snow be a preservative of some kind? He resolved to try an experiment immediately and called to his coachman to stop by the village pond and to purchase a chicken from a nearby farm.

Wrapping his cloak about him, Bacon stepped down into Pond Square and there and then ordered the coachman to kill the bird, partially pluck it and clean it. When this was done, Bacon,

Haunted Pond Square, Highgate, where a spectral chicken has been seen and heard for many years, perhaps dating from 1626 when Francis Bacon used snow to stuff the first frozen chicken; a far-reaching experiment that cost him his life.

to the wonder and surprise of a few locals who had gathered round, took the warm carcass and stuffed it with snow. He then placed it in a bag and packed more snow tightly round it. It was the first frozen chicken.

In his enthusiasm to conduct the experiment without delay, Bacon had overlooked the extreme weather, and he was not a young man. He suddenly found himself shivering violently, then coughed heavily and collapsed in the snow. He was hastily carried to the house of his friend Lord Arundel at the corner of Pond Square and there, a few days later, he died.

There is no record of the ghostly appearance of Sir Francis Bacon, or of a phantom coach and horses in Pond Square, but there have been many reports of a spectral chicken, half-running and half-flying in circles, and almost denuded of feathers. It is seen near a brick wall at dead of night, always in the winter months. In recent years, the shivering chicken has been seen at least fifteen times, and no one keeps chickens these days in Pond Square.

Mr and Mrs John Greenhill lived in Pond Square during the Second World War and they saw the ghost chicken many times. 'It was a big, whitish bird,' Mrs Greenhill reported. 'Many members of my family saw it on moonlit nights. Sometimes it would perch on the lower boughs of the tree opposite our house.' During the war too, in December 1943, there is a report that a certain Aircraftman Terence Long was walking through Pond Square late at night when he heard what sounded like horses' hooves and the grind of carriage wheels, followed by a frightful shriek. He peered about him but could see no horse or anything that could have made the noises he heard although they seemed so close at hand, and then he saw a chicken dashing about in frenzied circles, half-bald, flapping its wings and squawking and seemingly shivering with cold.

Long looked about him to see where the bird might have come from, and when he looked back the bird had disappeared. A few moments later the aircraftman met an ARP fire-watcher who told him that the bird had been seen around the square for years, and that a month or two previously a man had tried to catch it but it had vanished into a brick wall.

Another witness is a motorist who had a breakdown in South Grove and he walked into Pond Square late one January night in 1969 to ask for help at a house where a light was still burning downstairs. As he crossed the square his attention was attracted by a movement, and looking towards a wall he saw a large white bird flapping its wings and running round in circles. At first he thought it was hurt and he walked towards it, but as he drew nearer he saw that it was a chicken with nearly all the feathers plucked from its body. A few feet from the frenzied creature he stopped and looked about him to see whether there were any young hooligans who might have been cruel enough to pluck the feathers from the live bird for fun. The square seemed totally deserted however, and, as he turned back, he found that the bird had disappeared. He heard no sound at any time.

It has been observed that some hauntings run down, almost like a battery, and it may be that after nearly four hundred years the phantom chicken of Pond Square is gradually fading, since no sound accompanied the 1969 appearance. In February 1970, a young couple were startled when a big white bird, nearly naked, dropped to the ground nearby, as they were saying good night. It made no sound and, after flapping around in a circle a couple of times disappeared into the darkness.

THE ROYAL NATIONAL ORTHOPAEDIC HOSPITAL, STANMORE

A Grey Lady is reputed to haunt the wards of the Royal National Orthopaedic Hospital at Stanmore each November 13. She is generally regarded as the ghost of a nun, for the hospital is built on part of the grounds of a former nursery.

One nurse told me that there had been a ghostly Grey Lady at every hospital she had ever worked at! Some of the stories may be invented as a joke to scare new recruits when they were preparing for night duty for the first time, but the reluctance on the part of the hospital authorities to discuss and investigate alleged hauntings at hospitals suggests that there are genuine haunted hospitals in London as there are in the provinces.

SADLER'S WELLS THEATRE, FINSBURY

A theatre that took its name from the medicinal springs discovered in 1683 in the grounds of the Music House (formerly occupying the site) belonging to Thomas Sadler. Sadler's Wells Theatre is where the ghost of Joe Grimaldi has been seen, his glassy eyes staring from outlandish clown make-up at the dead of night in one of the boxes. It is only right that Grimaldi should return to this theatre for Joe Grimaldi, his son and his grandson were all famous clowns here.

THE SPANIARDS, HAMPSTEAD HEATH

The Spaniards, on Hampstead Heath, has associations with Dick Turpin and I have been shown three curious knives and forks with bent handles that are said to have been in use by the highwayman and his associates on one occasion when the word came that King George's men were in sight. Here too can be seen the room that Turpin engaged for the night, and the stable

The Spaniards Inn, Hampstead Heath, where the hoofbeats of highwaymen have been heard on still nights.

across the yard where Black Bess was lodged, and the tiny, foot-square, window cut in the stairway wall so that supplies could be handed out to highwaymen already saddled and anxious to be away.

Appropriately enough, Turpin himself is said to haunt the inn as well as the nearby heath and over the years not a few landlords of The Spaniards have heard the clatter of horses' hoofbeats, sharp and sudden in the stillness of the night, followed by total silence. No cause has ever been discovered for the sound of hoofbeats in a place where no horses have been stabled for years.

STOKE NEWINGTON

An interesting example of a mixed case of haunting and poltergeist manifestation took place at Stoke Newington in 1968-9, at a 150-year-old terrace house now demolished. The case involved the then Lord Chief Justice, Lord Parker.

The affected household consisted of the tenants, Mr and Mrs Richard McGhee, their unmarried twenty-one-year-old daughter Valerie, another daughter, Sally, her husband, Richard Strachan, and their two small children, Danny (four years old) and Elaine (three years old). The case was brought to my attention by the Rev. John Robbins, the Unitarian Minister, chairman of the Unitarian Society for Psychical Studies and a member of The Ghost Club.

There were stories of a 'white lady', of loud and frequent footsteps, a groaning noise, knocks, fires and unexplained smoke-like apparitions. The troubles seemed to increase during the five years that the family lived there. I visited the house on two occasions.

A 'woman in white' was seen by Mrs June Rose (another daughter of the McGhees) in 1964 and the same figure was frequently seen (it was claimed) during 1968 and 1969 by the little girl Elaine, usually emerging from a wardrobe in the corner of the bedroom. The child maintained that the 'white lady' lived in the wardrobe, always wore a white dress and had only one leg. In September 1967, Elaine's mother, Mrs Sally Strachan, saw the figure herself. That particular evening a lampshade caught fire inexplicably and a wardrobe fell over. About midnight Mrs Strachan went upstairs to bed and as she opened the bedroom door she immediately saw what looked like a Victorian woman in a white dress standing in the middle of the room, one arm crossed in front of her. She wore a white handkerchief or close-fitting bonnet on her head. Her long dress had a row of buttons all the way down the front, fastened by loops, and there were frills at the cuffs. The face of the figure was frightening in the extreme with enormous black eyes that seemed to fill the eye-sockets. The whole form seemed to radiate hatred and Sally Strachan was petrified with fright. She felt herself go suddenly icy cold and then she fainted.

Her sister, Mrs June Rose, who lived nearby and happened to be visiting her parents, hurried to the room and also saw the figure, which seemed to have turned in the meantime, since the apparition was now viewed from the side. June Rose described the figure as wearing a plain white 'Victorian' dress. She did not notice the buttons down the front as the figure was not facing her, and she did not notice the position of the arms. She did notice some dark hair straying down under the head covering. She thought the bonnet was tied underneath the chin and she too remarked on the big, black, menacing eyes. June took one look at the figure and ran out of the room in hysterics.

Mr Richard McGhee, the sixty-year-old father of Sally and June, told me that when he reached the bedroom he saw 'smoke' drifting towards the ceiling, as though the 'white lady' had dematerialized. The following night, Sally saw the figure again. This time it was in the act of kneeling and bending over the sleeping child, Elaine. The back of the figure was towards the bedroom door and this time both Sally and her husband, and also Mr McGhee, saw 'drifting smoke' as the figure disappeared.

The Strachan bedroom originally contained three wardrobes, one double-size and two single-size. Whenever a wardrobe was placed in one particular corner of the bedroom it was noticed that knocking sounds were heard and sometimes also the sound of groaning.

A few days before Sally saw the 'white lady', she was talking to her sister Valerie in the bedroom when to their amazement what looked like smoke began to issue from one of the wardrobes standing in the room. The smoke twisted and turned, forming spiral patterns and then disappeared. Before they could recover from the shock the heavy wardrobe in the room rose about a foot into the air and seemed to do a little jig before coming to rest facing the door of the bedroom! Alerted by the screams of the girls, Mr McGhee hurried upstairs and was in time to see the wardrobe in mid-air, quite clear of the floor. The wardrobe seemed to be coming towards him and he tried to push it down, but found that he was no match for the force that was propelling it along. As the wardrobe came to rest, the door opened and Mr McGhee, in trying to push the door shut, put his hand inside the wardrobe. He told me that it was as cold as if he had put his hand inside a refrigerator.

A month later, the same wardrobe caught fire and was reduced to ashes and a mattress was destroyed at the same time. The disturbances so dismayed the family that on at least one occasion all the occupants of the house spent the night in the garden, being too afraid to re-enter the house.

During the course of my visits, when I was accompanied by my wife, and W. G. T. Perrott, the chairman of The Ghost Club, we heard the stories of the happenings first-hand from the people concerned and during a tour of the house I was shown a fixed cupboard where, I was told, raps

had apparently emanated on several occasions. As we left the room I suggested that we might try to tempt the entity and I tapped twice on the cupboard shelf, closed the door and we all left the room and began to descend the stairs. As we did so two clear and distinct knocks sounded from the direction of the room we had just left, raps that were heard by all four of us, the Rev. John Robbins also being present.

The whole affair came before Lord Parker, the Lord Chief Justice, during the course of a High Court action over the rent of the alleged haunted house and the rent was reduced from £4 a week to 25p a week. The disturbances, which included four inexplicable fires, caused Mr McGhee and his family to leave the house — because of the ghosts. A rent assessment committee suggested that Mr McGhee was negligent and that ghosts had nothing to do with the fires. The Queen's Bench division decided that the committee was wrong. There was no evidence whatever that Mr McGhee was in any way to blame and Lord Parker observed that 'Some manifestations took the form of what was thought to be poltergeists causing havoc with the furniture and noises in the night.' The mystery of who or what caused the movement of furniture, the noises and the fires was never solved — but the sober statement in my records that two clear taps were heard in the quiet house, from a room devoid of human beings, reminds me that personal experience always outweighs other people's testimony.

Tollington Park, Islington

When I called at 63 Tollington Park, Islington, I was told about phantom footsteps that have been heard at this house where Frederick Seddon poisoned his lodger, a prostitute, for £200, in 1911. The house was badly bombed during the Second World War, but rebuilding the property seems to have retained the strange and hurrying footsteps that Mrs Munton told me she and her family had heard many times. The sounds seemed to fade almost as soon as one became aware of them, so that the hearer was inclined to dismiss the sounds as imagination. However, they have been heard so many times over the years and by so many people that it seems likely that something of Seddon's horrible, quick and anxious movements at the time of the murder remained at the house forty or more years afterwards.

Winchmore Hill Postal Sorting Office

In 1971, inexplicable footsteps in deserted corridors of the new Postal Sorting Office at Station Road, Winchmore Hill, prompted an official investigation. A correspondent told me that workmen in the building at night paused in their work, time and again, listening to the approaching footsteps and waited for someone to enter the room they were occupying. As the sounds became louder they sometimes threw open the door, but the sounds ceased as they did so and there was never anyone in the building other than themselves.

The modern, matter-of-fact office was built on the site of a former church hall, but the vicar of St Paul's church knows of no tragic happening that might have triggered off a haunting. The church hall was opened in 1903 and remained in use until 1965. Before 1903, the site had been an open field.

Other disturbances reported in the modern building included inexplicable opening of doors and windows. One night, all doors in the place were carefully closed and locked, yet in the morning every one was found open. Windows, carefully closed and latched, were found

unlatched. Nothing had been disturbed or removed and there was no evidence of a break-in. The disturbances ceased when the building came into use and as far as I am aware no mysterious footsteps or doors and windows opening by themselves now disturb the postal workers as they sort the mail.

YE OLDE GATE HOUSE, HIGHGATE

Ye Olde Gate House, Highgate, dates back to the fourteenth century and obtained its name by being conveniently situated for graziers and drovers to rest for the night before the cattlemen continued down the hill to Smithfield (formerly Smoothfield). The fine old hostelry was built beside the former toll-gate on Highgate Hill, on the fringe of the estate of the Bishop of London who granted the original licence to the inn. There is a dummy cupboard here from which Dick Turpin is said to have made an escape. It was here that Henning drew the very first cartoon for *Punch*, and regular visitors have included Lord Byron, Charles Dickens and George du Maurier.

Such an inn deserves a ghost and Mother Marnes, a widow who was murdered here for her money, haunts the gallery, the oldest part of the premises. However, the ghost is rarely seen since the black-robed figure only puts in an appearance when there are no children or animals in the building. Yet one landlord claimed to see the ghost and the old woman's cat that was killed with her, and he never really recovered from the shock, giving up the pub on the advice of his doctors.

Others say the ghost is that of a white-haired smuggler who was murdered for his money. A more recent mystery surrounds the story of some members of the staff who cannot see their reflections in a certain mirror, but only a blurred and cloudy image that might be anything.

CHAPTER SIX

SOME GHOSTS OF WEST LONDON, NORTH OF THE RIVER

BEAVOR LANE, HAMMERSMITH

Beavor Lodge, Beavor Lane, Hammersmith, was demolished in the 1920s, but in 1883 Mrs W. B. Richmond wrote of the haunting associated with the house and in 1961 her son, Sir Arthur Richmond, CBE, described the experiences in his book *Twenty-six Years, 1879-1905*. The figure of a tall lady dressed in grey was seen not only during the hours of darkness but also during daylight. The sound of someone weeping sorrowfully was heard night after night and the sounds of some thick material being sewn. There was a story that at one time a gang of coiners occupied the house after being caught and serving their sentence on 'information received'. They were convinced that the informant was a woman and they sought her out, lured her to Beavor Lodge and forced her to sew a sack in which she was drowned in the Thames.

Among the incidents recorded by Sir Arthur in his memoirs there is the testimony of a parlour maid who fainted and dropped a tray in the hall because, she said, she had met a strange lady dressed in grey who disappeared. There was the appearance of a figure similar to Sir Arthur's mother, and another figure that resembled his sister when she was a young girl. Mr George Richmond saw a grey lady sitting under a tree in the garden in an attitude of extreme grief, but when he looked again the figure had gone. Miss Perceval Clark, the daughter of a QC, saw a female figure in light grey standing in profile against some armour in a small room near the studio, and a few nights later she saw the same figure in the drawing room. Miss Clark's sister saw the outline of a woman's figure, dressed in pale grey, in her bedroom, and it is related that when old Sir William Richmond lay dying in Beavor Lodge his last action and words were to point to one corner of the room and say, 'There stands the Grey Lady.' Today, a factory occupies the site of haunted Beavor Lodge.

CHISWICK POLICE STATION

In Chiswick High Road the ultra-modern police station is built on the site of an old fire station that was haunted by the ghost of a woman who was murdered in the basement, originally the cellar of Linden House where, in 1792, a Mrs Abercrombie is said to have been killed by her son-in-law, Thomas Wainwright, a psychopath, with a meat cleaver.

Suggestions that the ghost of Mrs Abercrombie still haunted the building came to a head some years ago when a fireman who had moved to the new Brentford and Chiswick Fire Station maintained that the sounds of a woman walking around the basement were often heard late at night. 'Whenever the door was opened', he said, 'the sounds stopped, and there was never any sign

of anything or anyone around. I never went down there on my own at night — and neither did any of the other firemen.'

A senior police sergeant was reported at the time as saying that after working in the Chiswick area for many years, he was interested in the story and anxious to see whether there were any signs of a ghost in the new building. He had established that the new basement storeroom was on exactly the same site as the old Linden House cellar, 'so if there is a ghost it could well operate there too'. I have received no reports of supernormal activity at the police station, but the police are notoriously sensitive about such matters.

EATON PLACE, BELGRAVIA

One of London's best-authenticated ghost stories is associated with fashionable Eaton Place where, on 22 June 1893, Lady Tryon was giving one of her 'at home' parties. The cream of Edwardian high society chatted and circulated amid the elegant furniture. The ladies were resplendent in their frills and laces and the gentlemen in tight-waisted frockcoats when there was a sudden hush in the conversation.

A commanding figure in full naval uniform had entered the room without being announced. Glancing neither to the left nor to the right, he strode straight across the room. The guests drew aside to let him pass, for they all recognized Sir George Tryon. Next moment he had vanished.

At that very moment, the body of Admiral Sir George Tryon was lying in the wreckage of his flagship HMS *Victoria* at the bottom of the Mediterranean Sea, the result of a collision that remains a mystery.

As Lady Tryon was welcoming her guests at Eaton Place the Mediterranean Fleet was on manoeuvres. Sir George's squadron was steaming along in two columns, the flagship *Victoria* leading one column and HMS *Camperdown*, commanded by Admiral Markham, leading the other column. For no reason that has ever been discovered Sir George Tryon suddenly signalled to the two columns of battleships to turn towards each other. The ships were now in grave danger of colliding, and in spite of frantic appeals Sir George kept the ships on their course, and only when it was too late for a tragedy to be averted did he give the order to steam astern. The *Camperdown* crashed into the *Victoria* with considerable loss of life.

Perhaps as he realized the awful mistake he had made, Sir George's thoughts turned to his home in Eaton Square, resulting in the appearance there of his form, which was recognized by everyone present. The form did not speak.

ESMOND ROAD, CHISWICK

A council house in Esmond Road, Chiswick, was the centre of apparent poltergeist activity in July, 1956, culminating in the occupants, Mr and Mrs Joseph Pearcey, and their thirteen-year-old son being driven out of the house. Pennies, razorblades and clothes-pegs were reported to fly about the house and a spanner tore a curtain and smashed a window when it flew the length of a deserted room.

Young David Pearcey was playing in the garden, a week after the family had moved to the house from a prefabricated house at Acton, when he was struck on the face by a penny. Thinking that a friend was having a joke with him, he looked around the deserted garden when another penny flew through the air and landed near him. And then another, and another and yet another.

Later that evening, the Pearceys were busy with some home decoration when they heard the sound of pennies falling in the room beneath them. They took little notice, thinking that their

Everyone present at Lady Tryon's party at Eaton Place on June 22, 1893 saw the unmistakable figure of Sir George Tryon, in full naval uniform, suddenly stride unannounced through the room. At that moment Sir George lay dead at the bottom of the Mediterranean.

cleaning had dislodged coins that the previous tenant's children had pushed into gaps in the floorboards. Then a penny hit Mrs May Pearcey hard enough to cause a bruise and neighbours complained about the noise caused by coins falling in the stone-floored hall. As soon as one penny was picked up, another appeared in its place.

Joseph Pearcey decided to call the police and using torches the police searched the front garden and found several pennies. David was inside the house, answering questions put to him by a kind but suspicious officer, when one of the constables who had been searching the garden came in to announce that he had been hit by a flying penny.

The family passed a restless night. Wherever David went metal objects flew about. 'It was as if the boy was magnetized,' his mother told me. Next day, the spanner broke the glass of the front window. David was outside at the time but the spanner came from indoors.

It was decided that David should spend a few days with his uncle at Basildon and Mr and Mrs Pearcey moved in with relatives who lived nearby. The house, or the poltergeist, or the occupants, benefited from the 'cooling-down' period and I heard no more reports of disturbances at the house in Esmond Road.

HAMMERSMITH CHURCHYARD

Many years ago, a haunting that obtained much notoriety and became known as the 'Hammersmith ghost' was associated with the churchyard of that borough. A tall white apparition was frequently

seen and on one occasion a woman crossing the churchyard at night claimed that she saw a white figure rise from among the tombstones and glide towards her. When she fled the figure chased her and, as she was caught by the 'apparition', she fainted and was subsequently found by a passer-by. Tragically, she later died of shock. Some time later, a man was equally terrified as he walked through the churchyard and fled from 'a tall, white figure' that suddenly appeared before him. Apparently he was faster on his feet than the unlucky woman, for there is no report of the 'apparition' catching up with him! The spectre was commonly believed to be that of a local man who had committed suicide by cutting his throat.

At length, a number of Hammersmith residents kept watch in an attempt to solve the mystery but this well-intentioned vigil ended in tragedy when one of the watchers mistook a man wearing a white overall for the ghost and opened up with a shotgun, killing the unfortunate man. Sentence of death was passed on the responsible party, but perhaps mindful that a death had already resulted from the mysterious figure in the churchyard, this sentence was commuted to one year's imprisonment. There are certainly grounds for suspecting the paranormal origin of the Hammersmith 'ghost', although the affair was never completely explained. I was shown a coloured print of the 'Hammersmith ghost' dated 1825 some years ago.

HOLLAND HOUSE, KENSINGTON (REBUILT)

Holland House in Holland Park, Kensington, was badly bombed in 1940; the central block, including the haunted Gilt Room, being almost totally destroyed. After the war it was rebuilt as a youth hostel and today there are few reports of any ghostly activities in the successor to the fine Jacobean structure where James I stayed in 1612, where William Penn lived for a time, a place that was once the chief salon of Lord Byron and was known by Sir Walter Scott, Thomas Moore and Lord Macaulay, who wrote tenderly but sadly in 1841 of the 'favourite resort of wits and beauties, of painters and poets, of scholars, philosophers and statesmen... the avenue and the terrace, the busts and the paintings, the carving, the grotesque gilding, and the enigmatical mottoes ...'

Holland House was built for Sir Walter Cope in 1607 and called Cope Castle. The upper apartments were on a level with the stone gallery of the dome of St Paul's Cathedral, the front windows commanded a view of the Surrey hills and those at the back of Harrow, Hampstead and Highgate. After becoming the property of Sir Henry Rich, first Earl of Holland, who married Sir Walter Cope's daughter and heiress Isabel, the house was renamed and it was the ghost of Sir Henry himself that walked at midnight at Holland House, entering the Gilt Room through a secret door, with his head in his hand.

The Royalist Earl had been executed in 1649 at Palace Yard, causing something of a sensation on the scaffold. He was a handsome man and dressed for his death in a white satin waistcoat and white satin cap, laced with silver. Handing the executioner £10, he instructed him to be careful of his clothes, adding, 'And when you take up my head do not take off my cap!' Whether the ghost's head was seen wearing a white satin cap or not I do not know, but there were said to be three spots of blood on the side of the recess for the secret door from which the ghost emerged to walk slowly through the scenes of former triumphs — three spots of blood that nothing would ever efface.

The best-known ghost story associated with old Holland House, however, was related to John Aubrey, the antiquarian, in his *Miscellanies* published in 1696. He relates that the beautiful Lady Diana Rich, daughter of the Earl of Holland, walking in the fresh air of her father's garden before dinner, 'being then very well', met with an apparition of herself, identically dressed, as if she were facing a looking-glass. About a month later, Aubrey says, the Lady Diana died of smallpox. And

furthermore, he adds, that "tis said that her sister, the Lady Isabella Thynne, saw the like of herself also before she died'. Aubrey states that he had these accounts from a 'Person of Honour', but he was a credulous man and his appetite for folklore and gossip make his miscellaneous writings somewhat unreliable. Yet in her history of Holland House, published in 1875, the Princess Marie Liechenstein adds that a third sister, Mary, married to the first Earl of Breadalbane, not long after her wedding, had a similar warning of her approaching death and that it was an accepted fact that whenever a mistress of Holland House met herself, death hovered about her.

KENSINGTON PALACE, KENSINGTON

Kensington Palace, so-named from the adjoining district, was purchased by King William III in 1689 for £18,000 from Daniel Finch, second Earl of Nottingham, and the king often held councils at the palace. It was the birthplace of Queen Victoria who was living there when she succeeded to the throne. Her nursery is amongst the rooms now open to the public. Queen Mary, consort of George V, was also born at Kensington Palace and it was the residence of Queen Anne, George I and George II. It was at this palace that King William III (1702) and his consort Queen Mary (1694), Queen Anne (1714) and George II (1760) all died.

George II and his consort Caroline of Anspach were devoted to the palace and the ailing king would often raise himself to gaze from the window of his room at the curious old weathervane with its conjoined cyphers of William and Mary, high up over the main entrance to the palace. Especially during his last illness in October 1760, the irritable and choleric king (who like the other exiled monarch at Kensington Palace, William III, preferred his native country to the one over which he was called to rule) would look towards the weather-vane, hoping for winds from the right quarter to speed the ships conveying long-overdue despatches from his beloved Hanover.

The despatches arrived at last, but too late for the king, who died on 25 October 1760, still struggling to watch the weathervane, and when there are strong winds blowing the ashen face of the king is still said to be seen gazing up at the weathervane as he did over 200 years ago. There lingers still an air of sadness about the old palace and it was not difficult to imagine that the ghost of the old king returns from time to time to the room in which he died.

Kensington Palace was later the residence of Princess Margaret and the Earl of Snowdon and their family and also Prince Michael of Kent. When Princess Margaret was once asked whether she had ever seen the ghost of George II she replied, 'I'm afraid not, but I live in hope.'

NORTH KENSINGTON

Many people have said to me that they can accept the possibility of ghosts (although the clothes ghosts wear are sometimes a problem) and stretching credence to the limit, most people accept the possibility (however remote) of animal ghosts, but ghosts of inanimate objects seem beyond possibility. Yet there is evidence for ghostly objects that bears examination and a case in point is the ghost bus of North Kensington.

The junction of St Mark's Road and Cambridge Gardens, near Ladbroke Grove Station, was a dangerous one and the scene of many fatal accidents. It was here that the Number 7 buses turned quickly into Cambridge Gardens and many motorists not familiar with the area were forced to brake sharply and not a few had minor accidents until the borough council arranged for the removal of part of the garden of a corner house to facilitate safer driving.

Before this was done there were many reports of a strange bus, with the lights on but with no visible driver or passengers, which raced down St Mark's Road in the middle of the night when no scheduled bus was running. There was more than one case of a car crashing at this corner, the driver complaining bitterly that he was avoiding a bus that he found had disappeared when he turned to see what had become of it.

A member of the staff of a nearby garage reported that several motorists had remarked on how late the buses ran and told him that they had seen one after midnight in St Mark's Road, and once he had been surprised to see a bus pull up at the garage late at night but when he looked again it was nowhere in sight. He had neither heard it arrive nor heard it depart.

Following one fatal accident, a Paddington inquest heard evidence for the phantom bus and discovered that dozens of residents claimed to have seen it and hundreds more believed in the startling apparition.

One resident of St Mark's Road who lived near the junction told me that he and his wife had seen the bus at least half a dozen times and they often stayed awake at night till after one o'clock to see whether a crash or sudden screech of brakes would tell them that yet another night motorist had encountered the disappearing bus, where no real buses now run.

Another man told me that he had been crossing the road, his back to St Mark's Road, when a car approaching the deserted junction suddenly veered to the side of the road and mounted the pavement before coming to a jolting halt. Thinking that the driver must have been taken ill, my informant hurried to the car to find the white and shaken driver swearing and cursing about the driver of a bus that had come round the comer quickly and forced him on to the pavement. He asked what had happened to the bus, but my informant told him that he had seen no bus and certainly the roads were now totally deserted.

After the junction had been altered and made more safe, the phantom bus ceased to run, so perhaps this is an example of a ghost with a purpose and when the dangerous comer was rectified there was no need for the ghost bus to put in an appearance.

THE OLD BURLINGTON, CHISWICK

The Old Burlington, Church Street, Chiswick, was once an Elizabethan alehouse that was frequented by Dick Turpin. He is reputed to have leapt from an upstairs window straight on to the back of faithful Black Bess and so evaded once again the Bow Street Runners, those forerunners of the Metropolitan Police. The ghost at the Old Burlington is called 'Percy' and he appears in a wide-brimmed black hat and long cloak. Previous occupants of the inn described him as 'good-humoured and harmless' and although there are occasional reports that he has been seen in the bar and at the back of the inn, no one seems afraid of this harmless shape from the past.

WALPOLE HOUSE, CHISWICK

Walpole House in Chiswick Mall has long been reputed to be haunted by the ghost of Barbara Villiers, Duchess of Cleveland, who died here from dropsy in her sixty-ninth year. She lived at the fine seventeenth-century house during the latter part of her life, in the company of her grandson Charles Hamilton, the son of one of her daughters by the Duke of Hamilton (whose father was killed in a duel by the 'wicked' Lord Mohun). Barbara Villiers married Roger Palmer in 1659 when she was eighteen and he was made Earl of Castlemaine two years later. She became mistress of

Charles II within a year of her marriage and she had great influence with the king for about ten years — until he met pretty Nell Gwynne.

Created Duchess of Cleveland in 1670, Barbara Villiers' influence faded with her beauty and her last years, during which she swelled gradually to 'a monstrous bulk' were full of sadness as she spent more and more time remembering the gaiety and immorality of her youth. Five of her numerous children were acknowledged by Charles II and the sons became the dukes of Cleveland, Grafton and Northumberland.

She always wore high heels and the sound of her steps have been heard many times on the stairway where she would walk, gazing wistfully out of the tall windows of the drawing room. Sometimes she would raise her hands to the wide sky and beg for the return of her beauty. For two and a half centuries, that tap-tap of her heels and the appearance of her form have been reported from time to time at Chiswick House. These phenomena occur particularly on stormy, moonlit nights when the sad and bloated face has been seen pressed against the window, and the hands, clasped in despair, epitomize the forlorn plea that she repeated so often. After a while, the face is withdrawn from the window, the click of fading footsteps is heard for a moment amid the rain and wind and then silence reigns again over this house of memories.

WESTMINSTER CATHEDRAL, VICTORIA

In July 1966, the cathedral official in charge of sacred vessels and vestments of this English Roman Catholic Metropolitan church, reported seeing a 'black-robed figure', which disappeared near the high altar as the sacristan approached. It actually disappeared before his eyes, seeming to melt into nothingness. A spokesman at Cardinal Heenan's London residence said afterwards that 'an extensive search of the cathedral, both inside and outside, failed to yield any clue and police dogs failed to pick up any scent.' 'Officially' the statement continued, 'we do not support the theory that it was a ghost but that possibility has been mentioned.' After including this report in my *Gazetteer of British Ghosts*, published in 1971, I received a letter from a reader who stated that she personally knew four people who had seen unexplained figures in Westminster Cathedral, but the subject was frowned upon by the cathedral officials.

CHAPTER SEVEN

LONDON GHOSTS, SOUTH OF THE RIVER

THE ANCHOR TAP, BERMONDSEY

An elusive ghost haunts The Anchor Tap, Bermondsey, where successive licensees have reported objects disappearing and reappearing in the oddest places. The ghost is called 'Charlie', a name that has no more reason than the ghost's actions.

BATTERSEA

In 1956, fifteen-year-old Shirley Hitchins of Battersea was plagued by poltergeist phenomena for about a month. The disturbances began when a key (which did not fit any of the locks in the house in Wycliffe Road) suddenly appeared on Shirley's bed.

Soon afterwards she was reporting that her bedclothes were being tugged from her as she lay in bed; knockings were heard; rappings and tappings sounded about the house and furniture moved of its own accord.

One night, in an effort to obtain a good night's rest, Shirley slept with a neighbour, Mrs Lily Love, who said afterwards, 'She spent a night with us but none of us got any sleep because of the noise. We were all very scared.'

Alarm clocks and china ornaments moved without being touched by human hand; a poker flew across a room; Shirley's wrist watch was pulled off her arm and fell to the floor. One night, her father, Walter Hitchins, a London Transport motorman, decided to sit up with his brother and watch for developments. After Shirley had gone to bed in her mother's room all was quiet for a while and then came the tapping that seemed to originate from the bed that Shirley was occupying. The rappings went on for a long time. Then Shirley, who was still awake, said that the bedclothes were being pulled from her, and her father and his brother took hold of the clothes and felt them being tugged with considerable force. Shirley's hands were outside the bedclothes.

While this was going on both men and Shirley's mother saw that the girl was being lifted bodily out of the bed. She was rigid and about six inches above the bed. They lifted her out and stood her on the floor. Shirley explained that she felt a powerful force pushing into the centre of her back and lifting her up. She did not know that her body was rigid. This levitation occurred only once.

The mysterious rapping even followed Shirley on buses when she went to her work at a West End store and, distressed by lack of sleep, she was sent to the firm's doctor who was sceptical — until he too heard the raps. As with most poltergeist cases, the disturbances abated and then ceased, without anyone being able to explain what had caused them.

BETHLEHEM HOSPITAL, LAMBETH (DEMOLISHED)

The old Bethlehem Hospital was haunted when it stood at the comer of St George's Road and Lambeth Road, having been moved there from Moorfields in 1815 where it had stood since 1675. Before then it had stood on the present site of Liverpool Street Station — the hated 'Bedlam', a home for the mentally afflicted and one of the 'sights of London', open to anyone who cared to promenade and poke fun at the unfortunate inmates. Edward Oxford was confined to Bedlam for trying to shoot Queen Victoria in 1840; Jonathan Martin, who set fire to York Minster in 1829; Margaret Nicholson, who tried to stab George III (she died at the institution after forty-two years' confinement); James Hadfield died there after being confined for thirty-nine years for shooting at George III at Drury Lane Theatre; all were restricted behind gates decorated with figures of Raving and Melancholy Madness. Today, the Imperial War Museum occupies the site, and parts of the building date back to 'Bedlam' as the shape of some of the rooms reveal, and it is not difficult to imagine the shackled and chained patients groaning and screaming in their agony of despair. During the Second World War, a detachment of the Women's Auxiliary Air Force was stationed in Harmsworth Park with barrage balloons. An officer has recounted that the crews — girls from different parts of the country who knew nothing of the history of the building where they had sleeping quarters — were so frightened and complained so bitterly and repeatedly about groaning noises, shrieks and the sound of rattling chains, that in the end they were taken out of the building and the few men then working there were put inside. However, the same thing happened, and eventually, as no one would sleep near the building because of the noises, Nissen huts were put up in the grounds.

In the latter part of the eighteenth century, a handsome young Indian lodged for a time at the house of a merchant near London Bridge, where a pretty young girl named Rebecca fell head over heels in love with him, fondly thinking that he felt the same way about her.

She was sadly shocked one day when her 'prince' packed up his things and prepared to leave. Although no word had ever been spoken on either side Rebecca couldn't believe that he was really going away or that he didn't really love her as much as she felt she loved him.

She helped with the luggage and then stood on the threshold of the house, hoping and longing for some sign of affection. Instead, she felt a sovereign slipped into her hand and the light of her life disappeared for ever. Reality was such a shock that her brain gave way and she was committed to Bedlam where the harsh treatment of those days soon killed the body that had no will to live.

Ever since she had been given the sovereign, she had never again opened the hand that held it and when she died it was still clutched fast in her dead fingers, a fact that did not escape the keen eye of a keeper who managed to prise open the cold fingers and steal the golden coin. Consequently, Rebecca was buried without the one thing that she prized above everything, the thing that had belonged to the person she really loved.

Soon after her death the form of a wan and miserable ghost began to haunt the old hospital, seemingly looking for the stolen coin. For years afterwards keepers, inmates and visitors would catch an occasional glimpse of the pathetic Rebecca, silently searching and fading into oblivion whenever she was approached.

THE BISHOP'S HOUSE, SOUTHWARK

Dr Mervyn Stockwood, Bishop of Southwark, twice saw the ghost that haunts, or haunted, the Bishop's House. This is an elderly woman, sad-looking and silent, who is always seen in one

particular part of the house. The bishop, who was sensitive in a psychic sense, not infrequently knew the main contents of a letter before he opened the envelope and sometimes found that he knew what a person was going to say to him before the visitor spoke. Dr Stockwood was interested in psychical phenomena for over twenty years and regularly practised silent meditation. He wrote articles about the subject in *The Times* and addressed the Society for Psychical Research. He once told me that he believed the 'ghost' at his house to be the tangible expression of a memory that became identified with a particular place. An interesting theory that could account for a number of similar 'hauntings'.

The bishop discovered that an old Polish woman had died in the Bishop's House. She had fled from her native land and had always been most unhappy in England. He feels that it might be the 'memory' of this sad old lady who walked along a corridor and appeared in one room, which she had occupied during her unhappy sojourn in Southwark. Dr Stockwood was quite happy with his ghost. She did no harm, but his cook became very worried about the apparition and — deciding that it would be easier to get a new ghost than a new cook — he performed a service of exorcism, and did not see the ghost again.

CENTURY CINEMA, CHEAM

There is, or was, a haunted cinema in South London: the Century at Cheam where members of the staff and visitors have heard noises that they could not account for. When the cinema was built in the 1930s a workman disappeared mysteriously without collecting his wages. His lunch-bag and hat and coat were found hanging on a nail near the part of the building that became the stage. He seems to have disappeared without trace and there was speculation as to whether something happened to him that never came to light.

At all accounts shuffling footsteps were heard from the direction of the empty stage late at night by several members of the staff, including the manager, Mr Lilley. The noises were heard so frequently that the cinema personnel would take little notice of them, merely remarking, 'There goes Charlie again.'

Mr Lilley is reported as saying at the time, 'There is no earthly explanation for the noises. I have heard them on several occasions while working late. It sounds as though someone is shuffling about, either under or across the stage. The first time I heard them I thought a burglar had entered the building, or someone had remained in the theatre after closing-time, but I always found all the doors and windows securely fastened, so no one could have got in or out without being noticed.'

Three reporters from the *Epsom Herald* spent a night at the cinema in 1955 and reported afterwards that they had heard the shuffling noises. The complete silence of the night was disturbed by the sound of heavy, shuffling footsteps from the right-hand side of the stage. After the noise had been heard three times one of the reporters switched on a torch to reveal an utterly empty theatre. An immediate and minute search of the whole cinema failed to reveal any explanation for the noises.

COVENTRY HALL, STREATHAM

Coventry Hall, Hopton Road, Streatham, a building that used to be a convent, has, appropriately, the ghost of a nun. Mrs Evelyn Sayers, a young housewife, saw the form floating above a table on the stair landing. 'It was the head and shoulders of a nun with a young and pleasant face', she said

at the time. And she seemed to hear a voice which said, 'Don't be frightened, you must say "God be with you".' As the words trailed away, the apparition vanished.

Frank Cunningham, who lived in the same block but on a different floor, found himself awakened one night by a nun in a white habit. He said she stroked his brow and he heard a voice say, 'God bless you, my son.' Two nights later, Mr Cunningham saw two figures of white-robed nuns bending over the beds occupied by his children.

Neither Mrs Sayers nor Mr Cunningham believed in ghosts until they saw the nun apparitions, which were probably a remnant of concentrated thought that lingered on in the building after it was altered for secular use.

ELEPHANT AND CASTLE STATION

The Elephant and Castle Railway Station used to be haunted by mysterious running footsteps, knockings, tappings and a self-opening door. Mrs G. C. Watson of Herne Hill was travelling home from the station late one night. In fact, she was the only passenger on the platform and she was struck by the silence and the eeriness of the station. She mentioned the atmosphere to a passing porter who replied that they had several ghosts!

At first, Mrs Watson thought he was not being serious but she continued to talk to him and discovered that he was quite sincere. He told her that when he was on night duty at the station he spent most of the time in the porters' room and on several occasions the door of this little room, normally kept fastened, had opened wide of its own accord. Whenever he had looked out there had never been anyone in sight.

He had often heard tapping on the door, as if someone was looking for him, but when he opened the door, the platform was deserted. Furthermore, Mr Sargant, the night-duty porter, later stated that sometimes he heard someone running up the platform, but when he looked out the place was deserted. He had heard the running footsteps scores of times and each time he told himself that this time it really was someone, but he never saw a human being who could have been responsible for the footsteps which, he had noticed, were most common on wintry evenings.

Unexplained footsteps were also heard by Mr Sargant and others on the stairway leading from the platform to the booking office, and once he actually stood near the top flight and peered over at the deserted stairs as footsteps seemed to run down them.

A night-duty porter at Blackfriars, Mr Horton, refused night work at the Elephant and Castle after hearing the mysterious footsteps, tapping and knocking noises while he was in the porters' room. Once he heard footsteps approach the room along the platform. The footsteps stopped outside and two taps sounded on the door. When Mr Horton opened the door the platform was empty.

On Saturday nights the station used to be completely locked, as there was no night service, but even then the phantom footsteps were reported by staff.

GREENWICH

The provenance of photographs purporting to depict genuine spontaneous apparitions is often suspect and difficult to establish satisfactorily. An exception, it would seem, is the remarkable photograph obtained by the Rev. R. W. Hardy and his wife, while on holiday in England from

Canada in 1966, during a visit to the Queen's House at Greenwich. Certainly it is the most interesting photograph of a spontaneous ghost that I have seen in half a century of psychic investigation.

The retired clergyman and his wife visited many famous and historic houses in London and before returning home to White Rock they explored the National Maritime Museum and the beautiful Queen's House at Greenwich. This is a place best approached by water so that one can inspect on arrival the interesting boat preserved there in dry-dock: the tea-clipper *Cutty Sark*, built in 1869, that plied the China tea trade and afterwards the Australian wool commerce.

The old *Cutty Sark*, reminiscent of a picturesque but hard chapter in sea history, sports a fine figurehead, an attribute regarded as embodying the very spirit of the ship and an emblem to protect her and those aboard her from harm and the horrors of the deep.

There are several stories of sailors on the *Cutty Sark* seeing what they took to be phantom ships during her sea life of over fifty years and on these occasions the sailors would hurry towards the figurehead for protection. One account relates that a sailor on his first voyage on the *Cutty Sark* made a model of her in a bottle (objects universally considered unlucky by men of the sea) and exceptionally high seas and bad weather followed the completion of the model. During a storm a score of sailors saw an enormous, five-masted sailing-ship bearing down on them with incredible speed. They hurried to the prow and watched, awestruck and powerless to do anything, as the huge vessel raced towards them. A gigantic wave engulfed the ship when it was almost on top of the *Cutty Sark* and when the wave passed the ship and all trace of it had disappeared. It transpired that at the very moment the ship vanished the sailor who had constructed the model, tired of the pessimism of his companions, had thrown the model overboard.

Visitors today can stand where those frightened sailors stood waiting for the death that seemed inevitable. The phantom ship has been likened to the *Köbenhavn*, the world's biggest sailing ship, that disappeared on the Australian run in 1924 when the *Cutty Sark* was at Falmouth being used as a training ship.

Until recently, *Gipsy Moth* IV was alongside the *Cutty Sark*, the yacht in which Sir Francis Chichester made his famous single-handed voyage round the world. When I talked with Sir Francis at the Savage Club on one occasion I asked him whether he had encountered anything inexplicable or possibly paranormal during his incredible journey and he told me that he had had one terrifying experience that he had never told anyone about. It was an experience so strange and uncanny that it frightened him to think about it and no power on earth would persuade him to discuss it. I had to be satisfied with that for the time being, and Sir Francis died with his secret still untold.

The Royal Naval College at Greenwich stands on the site of an old royal palace built by Humphrey, Duke of Gloucester, youngest son of Henry IV. Here, Henry VIII was born, and Mary I and Elizabeth I. Edward VI died at Placentia, 'the House of Plaisance' as it was then known, and there 'bluff King Hal' married Catherine of Aragon and Anne of Cleves and signed the death-warrant of Anne Boleyn. Henry VIII was baptized in Greenwich parish church, the predecessor of the present church where the Danes murdered the venerable Alphege, Archbishop of Canterbury, in 1012, by splitting open his skull with a bone. The present church is dedicated to St Alphege.

Elizabeth I spent much of her time at Greenwich, sitting at the window or walking in the fresh air on the terrace and a contemporary description tells us that in her sixty-fifth year she was still very majestic, her face fair and unwrinkled, her lips narrow, her teeth black, wearing a red wig and the low-necked dress that was fashionable for unmarried ladies of that period. Such a figure, a

small crown on her head, has been seen to walk with stately air in the precincts of the Royal Naval College, but reports are fragmentary, rare and unsubstantiated.

Anne of Denmark, consort of James I, laid the foundation of the House of Delight, later called the King's House, the Ranger's Lodge and finally the Queen's House when it was completed by Inigo Jones for the unhappy Henrietta Maria, wife of Charles I. Today the house, beautiful in its elegant symmetry, is in a perfect state of preservation, including the haunted Tulip Staircase which leads from the ground floor to the upper floor and balcony, a staircase not open to the public who visit the Queen's House where Rubens, the Flemish painter, often stayed.

During the course of their visit the Hardys photographed the graceful Tulip Staircase. They had previously photographed a colonnade and subsequently some of the ships' figureheads in the museum. The Tulip Staircase was, of course, deserted when they took the photograph, which they did in the light that was available at about five o'clock on a Sunday afternoon, aided by the electric candelabra that lights the staircase. When the photograph was developed, after their return to Canada, there was a shrouded but distinct figure (possibly two figures) climbing the stairway, a ringed hand clearly clutching the stair rail.

When the affair was brought to the attention of The Ghost Club, an immediate and thorough investigation of the story and scientific examination of the photograph followed and when no logical explanation was forthcoming an all-night vigil was arranged at the Queen's House. A personal interview with the Hardys had established that the day on which the photograph had been taken was fine but cloudy and this was later verified by the Meteorological Office. The camera used was a Zeiss Ikon 'Contina' Prontor SVS Zavar Anastigmat lens I: 3.5f + 45 mm with 'skylight' auxiliary haze filter and a Kodachrome X, daylight, 35 mm colour film with speed at 64 was used. Although there is no possibility of double exposure on this camera, each picture being accounted for by number, nevertheless we submitted the photograph to Kodak and other photographic experts with the resulting unanimous decision that there was no trickery or manipulation whatsoever as far as the photograph itself was concerned. The only logical explanation from the photographic point of view was that there must have been someone on the staircase, and against this we have the evidence of the Rev. and Mrs Hardy (who are not and never have been interested in psychic phenomena), the fact that the staircase is not open to the public, and also the fact that the museum warders are very strict because the Queen's House houses many valuable paintings.

The Ghost Club contacted Commander W. E. May, then Deputy Director of the National Maritime Museum, and eventually we obtained permission for a limited number of members to spend a night at the Queen's House, after we had obtained authorization from the Ministry of Public Buildings and Works, which included agreeing to a number of conditions and the taking out of an insurance policy in the sum of £5,000 to cover loss or damage to the permanent collection of paintings. Permission was granted on the understanding that after admission in the evening we would be locked in and not allowed to leave until a set time in the morning; that smoking, alcohol, and the use of naked lights would be prohibited; that all our equipment was inspected and installed by the museum engineers; that two 'warders' would be present with us at all times, and that a not inconsiderable fee would be paid.

On first examination the photograph appears to show a figure with an exceptionally long right hand reaching ahead of the figure, but closer scrutiny establishes that both the hands on the stair rail are *left* hands and they both wear a ring on the marriage finger. The higher figure is oddly convincing, since the shadow falls directly across the light rays emitted by the electric chandelier. It is possible to see the shrouded figure leaning forward in a menacing position, apparently in pursuit of the 'shadow' figure as they ascend the stairs. Viewed in this light there is

an overwhelmingly malevolent air about the photograph. A plausible explanation would be that the left hands are both those of the same person who is photographed twice mounting the stairs, but the senior museum photographer used yards of film in a futile attempt to obtain a similar photograph by normal means.

The Hardys' story is simple and convincing; listen to Mrs Hardy on one point:

> My husband actually took the picture as his stronger and steadier hands are better than mine at holding a camera steady ... thus I was free to watch for any possible intrusion of anything visible during the exposure time. Actually a group of people who noticed our preparation apologized and stepped back although I explained that my husband was not quite ready. I mention all this to indicate that no person or visible object could have intervened without my noticing it. Also we had previously tried to ascend the staircase but were blocked by a 'No Admittance' sign and rope barrier at the foot of the stairs.

The party of Ghost Club members who spent the night at the Queen's House was joined by the senior museum photographer who took a number of photographs during the night, all of which turned out normally. During the night still and cine-photography was employed with special filters and infra-red film, sound recording apparatus was running continually; thermometers were checked regularly to discover any abnormal reading (easily detected where the temperature is kept constant to protect the paintings), and a dozen or so doors were sealed off with cotton to aid strict control of the rest of the building. The portion of the staircase rail which appeared in the photograph was coated with diluted petroleum jelly and at the end of the investigation checked for fingerprints; instruments were employed to detect draughts, vibration and other variations in the atmosphere; objects were distributed in the area of the Tulip Staircase at selected points (and ringed with chalk) to detect possible movement; and throughout the night attempts were made to tempt any unseen entities to communicate by means of various kinds of seances.

We did not succeed in scientifically proving that a ghost exists at the Queen's House, but a number of curious sounds were never satisfactorily explained and several members of the investigation team had distinct, definite and inexplicable impressions during the night. Footsteps which did not originate from any member of the party were heard on several occasions. They were heard during periods of otherwise complete silence and in total darkness, a strategy we employed at various times throughout the night, when those taking part were stationed at intervals up and down the Tulip Staircase—especially opened for us.

Efforts were also made by The Ghost Club to identify the ring which the figure in the photograph wears on the wedding finger, for it would have been extremely interesting if it could have been established that such a ring was associated with the unpopular Henrietta Maria, Queen of England and daughter of Henry IV of France, who certainly had ties with the Queen's House and must have known and used the Tulip Staircase. However, these enquiries, which included consultation with the National Portrait Gallery (where pictures not on public view were examined) and the Victoria and Albert Museum, proved unsuccessful.

No substantial ghostly associations or any reputed haunting was traced at the Queen's House, but among the unsubstantiated stories of possibly paranormal activity in the vicinity there is evidence of a former museum warder finding the doorway to the Tulip Staircase (where the Hardy picture was taken) uncomfortable and disturbing. Time and again, we were told, this man, an experienced and unimaginative attendant, found his attention being drawn in the direction of the little doorway whenever he was on duty and although he never

saw anything unusual, he always felt that there was something malevolent about that part of the building.

The same attendant claimed to have once seen an unexplained figure which vanished inexplicably in the tunnel which runs underneath the colonnade immediately outside the Queen's House, and he and other museum warders have heard footsteps which they have been unable to account for while on duty at the Queen's House.

There is also an odd and unsubstantiated story that many years ago a young married couple, living in first-floor rooms at the Queen's House, had a violent domestic quarrel and their baby son was dashed to his death from the balcony on to the mosaic floor below, where we held several seances during our all-night vigil. The facts of the story (if it has any basis in fact) now seem to be lost, but it appears unlikely that there is any connection with a sinister figure creeping up the Tulip Staircase.

After the photograph of the Tulip Staircase was published in my *Gazetteer of British Ghosts* my friend and well-known medium Trixie Allingham visited the Queen's House, and in a clairvoyant vision saw an insanely jealous woman conspiring with her confidant, identified as 'Viscount Kensington', in the hall below. They planned to lure the mistress of the woman's husband to the house and murder her on the stairs and Trixie described to me how she saw red blood flowing down those dark stairs.

On the other hand I am indebted to a correspondent, Miss Dorothy E. Warren of Chelsea, for pointing out to me that the figure or figures on the staircase look like monks or friars, possibly abbots or priors (though the rings should be on the right hand). Miss Warren informs me that recent archaeological finds at Greenwich show remains of an abbot's house, and when Baldwin II, Count of Flanders, died in 916, his widow, Elstrudis, youngest daughter of Alfred the Great, gave the manors of Greenwich, together with Woolwich and Lewisham, to the Abbey of Ghent as a memorial to her husband and for a long time the Abbots of Ghent received rents and tithes of the priory estates, before they were taken over by the Crown of England in the late fourteenth century. There seems to have been a large medieval house at Greenwich (according to Beryl Platts' *History of Greenwich*) which had an upstairs room grand enough for visiting prelates in the thirteenth century and Miss Warren suggests that this part of the great house may have stood on the site of the later Queen's House and well away from the enclosed parts of the priory. The figures in the photograph do seem to be mounting a staircase extraneous to the present one; a staircase that may have formerly been the stairway to the abbot's guest room. Beryl Platts mentions that in the fourteenth century the abbot let part of his domestic buildings, 'only holding back accommodation for his courts'; so the question of positively identifying the ghosts at this period of time looks like being very difficult indeed, unless more new evidence turns up.

It would be very interesting to discover any other photographs of the Queen's House that includes an unexplained figure, or one of the Tulip Staircase with a shrouded and cowled figure creeping up the stairs, its jewelled hand clasping the stair rail as so many hands must have done in the long history of this beautiful house.

In April, 1972, Edward C. Hull wrote to me from Lewisham, having read several of my books, and he was kind enough to relate a curious experience which befell him when he was an attendant at the Staff College at Greenwich, housed in the Queen Anne Block of the Royal Naval College. On January 1, 1962, Mr Hull and a colleague heard sounds and witnessed a door opening that they were told might be due to the ghost of the unfortunate Admiral Byng.

Admiral Byng was the son of Lord Torrington and due to his father's influence Byng received very rapid promotion in his chosen career in the Navy which he entered in 1718 at the age of

fourteen, becoming a captain at the age of twenty-three, a rear-admiral at forty-one, a vice-admiral two years later and an admiral at fifty-one. The following year, 1756, he was sent from Gibraltar to relieve a garrison in Minorca. He was defeated in a sea battle with the French, and this defeat was seized upon by the British Government who used Byng as a scapegoat to conceal their own negligence in maintaining the garrisons of Port Mahon and Gibraltar. Byng was brought home to face a court-martial at Greenwich, where he occupied rooms in the Queen Anne Block that are reputed to be haunted by his unquiet ghost. He was found guilty and executed by shooting on board HMS *Monarch*.

That January day Edward Hull and his colleague were sorting mail in the deserted Staff College (the students were on leave) when suddenly the handle of the door began to move, slowly and then violently, and then the door was thrown open with great force. Yet nothing could be found that might have caused such an occurrence. Both men rushed immediately to the door but no one was in sight. As they looked at each other in the now silent corridor, they both heard faint footsteps. They closed the door and returned to their work. A few seconds later, no more, the entire proceedings were repeated and this time the door was thrown open with even greater force. Again the puzzled men tried to discover any possible cause but they were unsuccessful. On again returning to their work they heard sounds resembling grit dropping from the ceiling, or very light taps. Nothing was found on the floor or anywhere else and after a while the light tapping noise ceased.

Discussing the matter afterwards both men discovered that they had on occasions seen 'filmy figures' that appeared to float about the corridors, appearing and disappearing in a flash, and on one occasion Edward Hull saw a shrouded figure in one of the rooms at the Naval College. Thinking that it was a real person, he called out a greeting but received no reply and when he approached it the figure faded away into nothingness.

Edward Hull himself feels that Admiral Byng was innocent of the charges for which he was executed and that his ghost returns to the college in an attempt to make known the injustice that he suffered. Certainly there has been considerable controversy surrounding the case which has been a puzzling naval story for over two hundred years. It may be that his 'ardent rappings' and violent entry into rooms that he knew may yet redress an injustice.

GUY'S HOSPITAL, SOUTHWARK

Guy's Hospital was built in 1722-4 at the sole expense of Thomas Guy, a bookseller in Lombard Street who made a fortune by printing and selling Bibles. The hospital has always had a ghost, a nursing sister who appears in various wards and who has been known to rest her hands on patients' shoulders.

In 1969 ghostly footsteps echoed through Addison Ward, on the first floor, and the hospital chaplain was asked to conduct a service of exorcism. Staff, including two senior nurses and a houseman, as well as patients, heard the footsteps on this occasion.

The three staff members were sitting at a table in the centre of the long ward with the lights on. The houseman had been called to the ward because an elderly woman patient was thought to be dying. Two other patients in the ward were awake at the time.

Suddenly heavy footsteps sounded along the centre of the ward. They approached the middle of the ward, apparently walking straight through the door, and stopped near the bed of the woman who was dying. Several other patients woke up, two of them in time to hear the footsteps approach the bed. The two patients who were lying awake also heard the sounds.

After a few moments the footsteps, heavy and squeaking, went back the way they had come—through a closed door, and in the few moments of quiet between the two journeys, the woman patient died.

THE HORN INN, BERMONDSEY

The Horn Inn, Crucifix Lane, SEI, has only a ghost voice, that of a female child crying and calling for its mother. There seems no doubt that the cries, perhaps of a child of eight- or nine-years-old, are objective for they were heard over a period of seven years by many different people and once by two people at the same time. Following a visit by a medium the little girl ghost seems to have gone, but a new ghost was discovered. A very old lady who banged on walls and floors and moved furniture around and even slept in other people's beds when they were vacant. The tenancy of the inn changed in 1970 and I have not heard of any disturbances since then.

KENNINGTON

A curious type of ghost seems to have disturbed the Rt. Hon. John Stonehouse, MP, and his family during their occupancy of a flat in Kennington in 1969. The former Minister of Post and Telecommunications firmly denied that he left the flat in the October because of ghosts, but his son Matthew complained of hearing inexplicable noises, and two previous tenants of the flat maintained that there was a poltergeist active on the property.

Restaurant owner Peter Norwood left the flat in March, 1969, and stated that several strange things happened in the first few months that he was there. In particular he recalls a wicker basket that 'floated' on several occasions and doors that opened for no apparent reason. He never discovered any logical explanation for the happenings.

Public relations man Peter Earl shared the flat with Peter Norwood and one night he was playing bridge with three friends when they all saw a 'grey figure' pass one of the open windows. He too recounts movement of wicker baskets which seemed to be 'picked up and hurled across the room', although no one was ever near them at the time.

THE KING'S ARMS, PECKHAM RYE, SE15

The present King's Arms, Peckham Rye, replaced the old pub of the same name that was destroyed by a direct hit from a bomb in 1940. The bomb killed eleven people in the pub at the time and injured many more. Ever since it has been built the present King's Arms has been haunted, not by a tangible, single-purpose ghost, but by scores of curious and quite inexplicable happenings, insignificant in themselves but collectively overwhelming evidence that some unknown force is present.

More than one barmaid has reported peculiar experiences that have nothing to do with any person and one landlord and his wife heard footsteps that could not have been produced by a human being. Once they sounded from a locked and empty room and another time from the direction of a deserted passage. These and other sounds were heard by more than one person. Objects were moved and domestic animals behaved hysterically for no apparent reason. Previously sceptical of such things, Mr and Mrs Anthony King admitted in 1968 that they were having second thoughts.

LANGMEAD STREET, WEST NORWOOD

Strange happenings took place at Langmead Street, West Norwood, lasted several years and affected all eight occupants. Soon after they moved into the six-roomed house in 1947 the Greenfield family were puzzled by tapping noises which began in the empty loft and gradually grew louder until they sounded like stones being broken and heavy furniture being dropped. At first birds or rodents were suspected but the deserted loft showed no trace of either and before long the noises were far too loud to have been made by such creatures.

Time passed but the noises continued, often very loud and always frightening. Then there would be a few weeks of silence before they started up again. In July, 1951, Cecil, the twenty-six-year-old son, found himself awakened one night by the sound of movement outside his bedroom door. Thinking that one of the family must be unwell he opened the bedroom door, but all was quiet and the landing was deserted—and then he saw something rounding the bend in the stairway, a tall, grey-white shape that seemed to have no face. As the form advanced towards him Cecil felt himself becoming increasingly cold with terror and only when the shape was almost within touching distance did he find his voice. As he screamed, the form vanished. His parents, young sister Pat, brother Dennis and his wife and her parents all found Cecil white and shaken. He had obviously seen something that had frightened him badly.

A few nights later Dennis and his wife returned home late and when they opened the front door they saw the same grey-white, faceless figure, standing motionless in the narrow hallway. Very frightened, they ran to a neighbour's house but when they returned with the neighbours, the figure had disappeared. Later the figure was seen one afternoon by Pat.

Alarmed by the sudden appearance of the frightening figure and puzzled by what was happening, the Greenfields called in the police. When the police were unable to explain the happenings, the family sought shelter at night with friends and the police maintained constant vigil at the house. One night when nine police officers were in the house, they all heard raps and thumps from the direction of the loft. Investigation of the empty loft produced no explanation. An eiderdown was found to have been moved from a bed and a picture crashed to the floor, the cord unbroken, and the hook still secure in the wall.

The police investigation was under the direction of Inspector Sidney Candler who is reported to have stated, 'I was sceptical at first but now I am convinced something strange is happening here.' Unable to help or prevent the mysterious disturbances, the police left and still inexplicable things occurred. Inside a closed cupboard a spoon rattled in a sugar basin; a large photograph fell out of its frame, leaving the glass front and backing undisturbed; a shopping basket moved from one side of an unoccupied room to the other. Afraid to go upstairs, the family moved their beds to the ground floor but still they did not sleep.

Once a married daughter and a newspaperman waited on the doorstep for the return of Mrs Greenfield. They told her they had heard heavy thumps from within the locked and empty house. When Mrs Greenfield opened the door she found that heavy furniture had been moved and a hanging mirror had been turned to face the wall.

Brilliant luminous flashes were seen in the living room by all the members of the family; a radio would be switched on or off; a mattress lifted itself and curled up in mid-air; vegetables and cooking utensils from the kitchen were found littering a bedroom; books were thrown about and torn; and then, quite suddenly, everything stopped. But the Greenfields were glad to have the opportunity of moving house and after they left the next occupants, Mr and Mrs E. Hewitt and their four young children, were not troubled by any poltergeist activity—or whatever it was that plagued the Greenfields for over four years.

THE OLD VIC, WATERLOO ROAD

The Old Vic in Waterloo Road, once famous for its blood-and-thunder productions, has appropriately a frightful spectre: a distraught woman wringing her bloody hands. No one knows who she is but it is thought that she might be some player from the past re-enacting the part of Lady Macbeth.

THE PLOUGH INN, CLAPHAM COMMON

In the autumn of 1970 psychic happenings resulted in the dismissal of the landlord of The Plough Inn, Clapham Common. Landlord Felwyn Williams and his wife were only at The Plough a few weeks when odd happenings on the attic floor worried them and soon the eight residential staff were afraid to venture upstairs alone. They insisted on going in pairs when they retired to their rooms at night.

The two top floors of the old and historic inn have long been reputed to be haunted, and curious happenings and even the appearance of the ghost, known as Sarah, were reported by previous publicans and occupants of The Plough. One resident barman woke up in the middle of the night and saw the form of a woman in white standing by the window of his room, staring silently into space, her long black hair unruffled by the breeze that billowed the curtains out from the open window. He jumped out of bed, woke the landlord, told him his story and left the pub the next day.

A correspondent who knew Felwyn Williams contacted me after strange noises were heard at night and several of the staff believed that they sensed the presence of Sarah. Mr Williams, thirty years old and described to me as very level-headed and sensible, formed a 'ghost squad' and held amateur seances in the haunted rooms. At one seance the name Sarah was spelt out and the date: September 11. As that date approached the staff of The Plough waited for some kind of manifestation but nothing happened.

Mr Williams had worked in four public houses before coming to The Plough and he never even thought about ghosts before taking over at Clapham, yet within a few weeks he had left The Plough. He said he had an 'acute awareness of Sarah' and he often felt certain that she was standing over him whenever he ventured upstairs. Her presence certainly had an alarming effect on the staff 'who had all experienced Sarah's approach' which the landlord described as 'like a mild electric shock and lasting on occasions for half a minute or a minute'.

Rex, the publican's dog, seemed to have a fear of the undecorated rooms on the top floor and always kept very close to his master or mistress whenever he was upstairs. There is something of a mystery about the number of rooms on the top floor. From the outside three windows are visible but inspection from inside reveals only two windows.

Following reports of a ghost voice and unexplained knockings on a window at the haunted inn I made arrangements to carry out an investigation, but I was then advised that Mr Williams had been sacked. The 'ghost' publicity was bad for business and the owners were quoted as saying that everything had been imagined.

ST THOMAS'S HOSPITAL, LAMBETH

London's best-known hospital ghost is probably the Grey Lady of St Thomas's, the old building on the Albert Embankment that was founded in the thirteenth century by the canons of St

Mary Overy's Priory and dedicated to Thomas à Becket. The hospital survived the Black Death, the Plague, the Great Fire of London and the Blitz, and was the establishment that Florence Nightingale used as a base to revolutionize world nursing. It has a ghost that is kind and helpful; yet its appearance often heralds the death of the person who sees her.

The ghost is usually described as a very nice, middle-aged lady dressed in grey nurse's uniform. The figure has been reported in various wards of a particular unit that used to specialize in the treatment of malignant disease, Block 8.

One cold November morning in 1943, Mr Charles Bide, a member of the hospital staff, told me he was at the top of Block 8. The night before a German bomb had damaged the hospital. Windows had been blown in and there was dust and debris everywhere. Mr Bide looked after the 180 clocks at St Thomas's and he was wondering how many clocks and other articles were lost. He noticed an oil painting, hanging askew, and a large mirror, the glass miraculously undamaged. Having lifted down the picture, he turned towards the mirror and saw, reflected in the glass, a woman of about thirty-five. 'She had a good head of hair and her dress was old-fashioned and grey in colour. It looked ruffled'; and Charles Bide thought to himself that she had probably been lying down, resting, after a busy night.

As he looked at the figure, he suddenly felt very cold—although he had the distinct impression that she meant no harm—but the coldness grew rapidly, it became intense and penetrating, and Charles Bide felt frightened. The thought came to him that he was alone at the top of the building, at least he should be alone. Everything seemed quiet all of a sudden and he hurriedly left. He has always regretted that moment of panic. He feels that the ghost may have had some message for him. She seemed to be making an effort to communicate and he thinks that if he had stood his ground, she might have been released from her torment.

Mrs Bide has never forgotten how shaken and subdued her husband was that day. She knew him as a sensible and down-to-earth man, not at all the type to have hallucinations or see something that was not really there. It was some time before he would tell her of his experience and she believes that the expression he saw on the face of the ghost troubled him ever after. With the demolition of St Thomas's imminent, Mr Bide thought the Grey Lady may well appear again.

A former superintendent at St Thomas's, Edwin Frewer (now retired) encountered a similar figure soon after his arrival at the hospital in 1929. He was walking along the main corridor in the company of his chief, a Mr French, on their way to Block 9 when the new superintendent suddenly experienced a feeling of extreme coldness and he came to a sudden stop in the open section between Blocks 7 and 8 as he saw a nurse approaching from the direction of Block 8. He saw, with some surprise, that she was dressed in an old-fashioned uniform with a long skirt. She looked very worried and after hurrying towards the two men she suddenly disappeared. The only places of exit from that particular part of the corridor were a door to a sleeping block (which was tried and found locked) and the ward devoted to male venereal disease, where female nurses were not allowed. Mr French was more than a little puzzled when Mr Frewer stopped dead in his tracks since he did not see the figure. Long afterwards Mr Frewer commented, 'The memory of her face, with its look of anguish, remains with me after all these years.'

Some years after his sighting of the Grey Lady, Edwin Frewer was approached by one of the hospital physicians, Dr Anwyl-Davis, who had had an almost identical experience one day in April, 1937. It was in the same corridor of the hospital and the figure seems to have disappeared at almost exactly the same spot. Dr Anwyl-Davis never forgot the encounter and often described the experience. As the lifelike apparition approached him, he raised his hat and bid her good morning.

The figure made no reply but continued on her course, seemingly oblivious to the presence of Dr Anwyl-Davis. A moment later the figure had vanished.

Although the appearance of the ghost nurse frightened them, it did not foretell the death of either Charles Bide, Edwin Frewer or Dr Anwyl-Davis, but there is evidence that the form was seen by five patients shortly before they died, and it was probably seen by many others.

One evening in September, 1956, a nurse was filling the water jugs in the ward at about 8.30 pm, and when she came to the bedside of an elderly man suffering from cancer of the lung he told her there was no need to fill his water jug as he had already been given a glass of water. Since no other nurse was on the ward at the time, the night nurse was somewhat puzzled and asked the patient who had given him the water. He replied that the very nice lady dressed in grey who was standing at the foot of the bed had done so. The nurse looked in the direction of the old man's smiling gaze but she could see nothing and certainly there was no 'lady in grey' anywhere in the ward. Two days later the old man died.

Two months later another nurse in the same unit, but a different ward, was washing the back of a man of seventy who had widespread malignant disease, but who was, however, expected to recover sufficiently for him to go home. Suddenly the patient asked the nurse whether she always worked with 'that other nurse'. No other nurse being present at the time, the patient was asked which other nurse he meant and he pointed in a certain direction where the nurse could see no real person. The patient said the 'other nurse' was dressed differently and she often came to see him. He died shortly afterwards.

Thirteen months later in December, 1957, the figure was seen again in the ward where the patient had been given a glass of water in September, 1956. During the night a man of thirty-seven, suffering from widespread cancer, asked the nurse about a lady warming her hands by the fire. No one was in fact by the fire and when he was asked to describe the figure, he said, 'The person in the grey uniform.' He died a couple of days later.

Two months later in February, 1958, a similar figure was seen yet again in another ward in the same unit. This time the patient was a woman suffering from a malignant disease. One morning she told the night nurse that during the night she had been visited by a lady dressed in grey who had been very kind to her and had given her a cup of tea. She died next day.

A year later in February, 1959, another female patient, a young pregnant woman of twenty-eight with multiple myelomatosis, had a very similar experience in the same ward. During the night, she said, a nice woman, sympathetic and kind, stood at the foot of the bed. She did not find the figure at all frightening, but she too died a few days later.

These five first-hand examples of a 'grey lady' in one unit were collected by a doctor at the hospital who became interested in the long-standing legend that in the wards of that particular unit a lady in grey has sometimes been seen by patients who died shortly afterwards. His findings were subsequently published in the *Journal* of the Society for Psychical Research.

The fact that the figure has invariably been described as wearing grey is extremely interesting in view of the fact that the present sisters' uniform of Oxford blue dress with white apron and collar, only came into use in the early 1920's. Previously a grey dress had been worn. In addition to these experiences, which were all written and signed by the nurses voluntarily, a number of other reliable accounts of the Grey Lady appearing to patients who died soon afterwards were obtained by word of mouth but dates, names and other details are no longer available.

There is written evidence however for one other appearance that took place in a different ward of the same unit some years ago, and vouched for by a state registered nurse. While she was on night duty she was called, as night sister, to supervise the giving of a dangerous drug to a patient known to be dying from malignant disease. She asked the patient whether she could make her

more comfortable in bed, whereupon the patient replied that the other sister had just done so. There was no other sister on duty at the time and neither the night nurse nor any other nurse had recently attended to the patient, who died the following day.

The sceptical will point to the fact that patients in hospital wards specializing in the treatment of malignant disease are likely to be under the influence of pain-killing drugs and therefore in a state of delirium and likely to experience hallucinations, and this is true to the extent that all the patients in the six accounts described would have had analgesic drugs at the ward sister's discretion; these drugs have opium derivatives or synthetic analogues of morphia, and the hallucinogenic properties of these drugs have not been fully explored, yet the fact that six quite separate reports are so similar would seem to outweigh objections on this score. It is extremely interesting to notice that more than a dozen dying patients in one unit of a massive hospital had almost identical 'hallucinations'. These 'hallucinations' had all the impressions of reality to the person concerned who was able to reconcile the apparition with specific articles and particular parts of the ward, and was able to describe, soberly and sensibly, the experience to the nurse concerned.

The Chaplain of St Thomas's, the Rev. Kingsley R. Fleming, respects the integrity of those who have seen the ghost. 'I'm convinced that it is possible to be aware of such manifestations,' he told me when I was at St Thomas's in April, 1973; 'Obviously there must always be in these cases a spiritual awareness in the person and a willingness to accept what is happening to them ... Hospitals are places of constant crisis ... There is a terrific super-charge of emotion and feeling and people who die are not always able to come to terms with their anguish or remorse.'

The legend of the Grey Lady is known widely throughout the staff of the hospital, although it is obviously guarded from the patients and no factual basis has been discovered for the legend. There is a story that a nursing sister fell to her death down a lift shaft at the turn of the century; another story says the ghost is that of an administrative sister who committed suicide in her office on the top floor of the haunted unit; a third rumour tells of a nurse throwing herself off the balcony because she was responsible for the death of a patient, and a fourth says the ghost is that of a sister who died in Block 8 from smallpox. (This block, prior to demolition, was a maternity unit.) It has not been found possible to obtain confirmatory evidence for any of these deaths. Some of the nurses maintain that the Grey Lady is only visible from mid-calf upwards, due to the fact that she appears on the floor level of the wards as they were before the present block was rebuilt.

THE THOMAS À BECKET, BERMONDSEY

The Thomas à Becket in the Old Kent Road is built on the site of an eighteenth-century gallows and strange happenings have been reported at times from the pub that used to be known as the 'Boxers' Pub', for the first floor constituted a gymnasium where at least one contender for a world title fight did his training.

At one time, when Arthur Ward had been landlord for five years, he found the disturbances so bad that he would not sleep alone at the pub. At this time the pub's cat and dog would not go upstairs to the top floor; bedroom doors were impossible to open and police and firemen had to break them down. Although no coal was then used at the pub, only coke, fires were found on several occasions to be made up, ready for lighting—with coal!

Once a customer, scoffing at the idea of ghosts, found his glass of beer shattered in his hand. Another customer, Albert Williams, a hearty butcher, declared that he had no fear of ghosts and accepted a bet of £5 that he would stay half an hour alone in the top-floor room in broad daylight—within two minutes he came running down and paid over his £5!

TOWER CINEMA, PECKHAM

The old Tower Cinema at Peckham was at one time reported to be haunted, and both the chief projectionist and the assistant manager stated that they saw the figure of a man walking in mid-air in the auditorium at midnight, one Saturday in 1955.

The apparition was seen ten feet above the auditorium and it was later discovered that this was the approximate ground level before the theatre was built on what was once consecrated ground. An 1819 map shows that a chapel once stood on the site or very nearby.

Mr Jerry Adams (the projectionist) and Mr Bernard Mattimore (the assistant manager) were on their way towards the rear exit when half-way down the darkened auditorium they both saw simultaneously the form which seemed to glow with a light of its own.

They stopped in their tracks and watched the figure walk slowly across the stage in front of the closed curtains and vanish into a bricked-up organ recess. They described the figure as dressed in clothes of 'an early period', and they agreed that the man appeared to be middle-aged.

A year previously a builder's labourer had reported seeing the same figure in the same position, and in 1953 two upholsterers stated that they saw a ghost in the cinema when they were working there late one evening. One of them was so frightened that he refused to return to do any more work there.

A number of other incidents were recalled by various people that were never satisfactorily explained. Workmen reported that bags of cement were split open and thousands of cigarettes ruined by water that dropped from a ceiling where there was no hole or waterpipe, and when it was not raining. The same men were startled when scaffolding that had been erected by experts collapsed when they started work.

TRAFALGAR AVENUE, CAMBERWELL

Something very strange seems to have troubled the Stringer family when they lived at Trafalgar Avenue, Camberwell, and their chief fear was fire. The family had so many inexplicable fires that they told me no company would insure them against fire.

I talked for several hours with Graham and Vera Stringer who occupied the double flat with their four-year-old son Steven. They told me that in the four years they had been at Trafalgar Avenue they had been worried by something that had practically destroyed their home with unaccountable fires. Most of the fires took place around Easter time.

A few weeks before Easter, 1958, Mrs Vera Stringer went to bed early as she was not feeling well. She left her husband in the living room doing some typing. He went up to bed at about 10.30, with a cup of tea. As their bedside clock was stopped, Graham Stringer went downstairs to check the time. He hurried back to say that the living room was on fire. Together Vera and Graham threw water over a chair on which all little Steven's toys had been placed in a plastic bag. They succeeded in quenching the fire but the toys were destroyed.

On Good Friday morning, 1959, Mrs Vera Stringer told me she popped down the road to buy some hot-cross buns, having unpacked a parcel from her mother-in-law which contained some knitted clothes for Steven, a tie for Graham and some nylon stockings for herself. As she returned to the house she saw smoke coming from the living room window. Indoors she discovered that her husband, finding the contents of the parcel alight, had thrown water all over the woollies and other things. He had put the fire out but all the gifts were ruined.

On Easter Monday, 1960, Mrs Stringer was in the kitchen when she smelt burning. She hurried into the living room and then into Steven's bedroom, but everything appeared to be all right, until

she went into her own bedroom where her husband had left a pullover, shirt and vest on a chest of drawers. The clothes were blazing. Once again the fire was extinguished but the clothes were ruined and the chest of drawers badly scorched.

Around Easter, 1961, there were no fires, but a mysterious and vague 'grey column of fluorescent light' was seen twice, once in Graham Stringer's darkroom and once in the living room where it floated from one corner of the room to disappear in the opposite corner. Footsteps were often heard, the sound of doors opening and closing, and one morning the Stringers found the big window-pane in the kitchen smashed. It looked as though a fist had been put through it and glass was scattered all over the garden, although nobody had heard a sound.

Around Easter, 1962, *two* rooms were found alight. On the first occasion Mrs Stringer was in bed and her husband had just left for work. Suddenly she noticed the smell of burning and she was terrified to find smoke on the stairs and flames three feet high in the living room. She raced down to the basement to telephone the fire brigade. They soon had the blaze under control and Graham Stringer came home from work to help clear up the mess. In the afternoon Vera Stringer was at the launderette, leaving her husband in the garden trying to salvage what he could of the living room carpet, when she heard fire-engines and a neighbour ran in to her and said, 'Go home at once—you've got another fire!' This time it was Steven's room—Graham Stringer had looked up from the garden and seen the bedroom curtains alight. There was no form of heating in the room and it is difficult to suggest how the fire could have started—excluding human intervention. After 1962 the fire-raising 'phantom' seems to have ceased activity.

WIMBLEDON COMMON

An unusual ghost in south London is an eighteenth century spectral highwayman, 'Jerry' Abershaw, who is reputed to gallop his steed across Wimbledon Common at night—a habit that could cause complications since a revision of local bye-laws in 1971 prohibits 'unauthorised' horse-riding between half an hour after sunset and half an hour before sunrise! Abershaw paid the penalty for his crimes and in 1795 his body swung from the gibbet that used to stand at Wimbledon Hill.

THE GHOSTS AT THE TOWER OF LONDON

The Tower of London—the name still causes a shudder, as well it might, since for nearly a thousand years prisoners of the state have been confined, tortured and executed in this sombre collection of ancient and massive buildings. Some say there have been murders within the confines of these stout and high walls and certainly there have been suicides. If violent happenings and tragic deaths can cause hauntings, then surely the Tower should be more ghost-ridden than most places, and so it is.

From the well-documented apparition seen by a Keeper of the Crown Jewels and his wife two hundred and fifty years ago, to the ghost of a 'long-haired lady' seen in the Bloody Tower in 1970, stories of ghosts and ghostly happenings at the Tower are legion. There is no doubt that there are convincing reports, extending over many years, of very curious occurrences, including appearances of Anne Boleyn, the Countess of Salisbury, Sir Walter Raleigh and the murdered boy princes.

Julius Caesar has been credited with establishing the White Tower, the oldest building and the original tower from which the present collection of buildings takes its name. Shakespeare supports this assumption in his *Richard* II and *Richard* III but John Stow, the Elizabethan antiquarian, expresses scepticism, pointing out that Caesar came only to conquer 'this barbarous country' and none of the Roman writers 'make mention of any such buildings created by him here'.

It seems likely that William the Conqueror, in 1078, began to build the great keep (known as the White Tower because white Caen stone was used) on the base of a Roman bastion, a work later supervised by Gundulf, Bishop of Rochester and Grand Master of the Freemasons. Some authorities have suggested that the name is derived from the Bryn Gwyn or White Hill upon which the tower was erected, white being a Celtic synonym for 'holy'; whilst others believe that it was so-called on account of the whitewashing it received in the reign of Henry III.

Ralph Flambard, chief adviser to King William II, was imprisoned in the White Tower in 1100 after the king, as every schoolboy knows, was killed by an arrow while hunting in the New Forest. In one attempt to escape, Flambard, his bishop's staff in his hand, fell from a window to the ground sixty-five feet below and was picked up unhurt. He lived for many years and was later successful in escaping from the dreaded Tower, received a pardon, regained his bishopric and was responsible for the completion of the nave of Durham Cathedral. Griffin, son of Llewellyn, Prince of Wales, was less successful when he tried to imitate Flamhard in his method of escape, and was found by the guards with his neck broken.

The perfect little Chapel of St John in the White Tower is the earliest Norman building in London. Here rested Richard II's body in 1400 after he had been murdered in Pontefract Castle; here too the body of Elizabeth of York, Consort of Henry VII in 1503, lay in state after she had died in the Tower in childbirth. Five hundred tapers and candlesticks surrounded her bier. Here, while

praying before the altar in 1483, Sir Thomas Brackenbury received instructions to put to death his nephews, the young princes, and the pathetic ghosts of these young brothers have long been reputed to haunt the vicinity of the White Tower, where their bodies were buried at the foot of the staircase, although they were murdered by Sir James Tyrell and two assistants in the Bloody Tower.

It may be that this murder gave the tower its name—it was originally called the Garden Tower as its upper storey opens on to that part of the parade ground which was formerly the Constable's garden. At all events the silent ghosts of Edward V and Richard, Duke of York, have also been seen here, hand in hand, in white nightgowns, at the angle of a wall, outside the gate to the right, where the little bodies were hastily buried by their murderers. In 1674 excavation revealed the bones of two young boys. Charles II believed them to be the royal remains and they were buried in Westminster Abbey.

There is a story that the ghost of Thomas à Becket (murdered in 1170) was seen in 1241 when Henry III was strengthening the fortress. In these building operations he was delayed by two serious reverses. On the night of St George's Day, 1240, when the work was nearly finished, the foundations suddenly gave way and the new structure fell apart as it might have done from an earthquake. The work was restarted and in twelve months was almost complete again. On the same night, St George's Day, 1241, according to Matthew Paris (the outstanding Latin chronicler of the thirteenth century, a valuable historian and a monk) a priest saw a stem-faced, venerable figure in archbishop's robes walk towards the newly-erected building and strike the walls with a cross which he carried—whereupon the building fell down. In the vision the priest enquired of an attendant nearby who the figure might be and received the answer, 'The blessed martyr, St Thomas Becket.'

Whatever the explanation of the 'apparition', it is an historical fact that the building collapsed a second time. King Henry III seems to have believed that his grandfather's crime in being responsible for the murder of Becket was unforgiven and on another occasion Matthew Paris records that when someone died, the king complained, 'Is not the blood of the blessed martyr Thomas fully avenged yet?'

On the main floor of the White Tower, below St John's Chapel, there is a stone crypt containing a block specially made for the execution of the Scottish lords and cuts from the axe are still clearly visible. Here too are some of the instruments of torture, for most of the torturing in the Tower took place in the White Tower. Thumbscrews, the crushing scavenger's daughter, a spiked collar, bilboes for securing captives' feet and a large gibbet bear witness to the ingenuity and cruelty of man.

Anne Askew was tortured on the rack here in 1546 and Lord Chancellor Wriothesley became so interested in the proceedings that he took off his coat and laboured at the levers himself until he had almost torn her body apart. Perhaps it is her agonized screams and groans that have occasionally been heard issuing from these impregnated walls rather than those of Guido Fawkes who was 'examined' in the Council Room at the Queen's House, built in Henry VIII's time for the Lieutenant of the Tower and still used as the residence of the Governor.

Anne Boleyn spent her last night on earth at the Queen's House (then known as the Lieutenant's Lodgings), and her ghost has been seen to emerge from a doorway under her room and to glide towards Tower Green where she was executed on May 19, 1536.

One evening in 1864 a guardsman of the 60th Rifles saw the white figure materialize in the dark doorway and float silently towards him. When his challenge was ignored he stabbed at the figure with his bayonet. He found no resistance and his bayonet went clean through the figure which still advanced towards him! He realized that he was face to face with a ghost and he collapsed in a faint. The Captain of the Guard found him unconscious on the ground and put him on a charge. At the subsequent court-martial for sleeping on duty (or being drunk) several other guardsmen

Tower of London. The Wakefield Tower, where the ghost of the murdered king, Henry VI, has been seen outside the chamber where he was stabbed as he knelt at prayer.

swore that they had seen a similar figure at the same spot while on guard duty themselves, and furthermore two witnesses appeared and maintained that they had seen the same figure at the same time as the accused. They had seen him thrust his bayonet through the figure and had heard his scream of terror before he collapsed. In the circumstances the court took a lenient view and the prisoner was acquitted.

Another sentry saw a woman in white appear from the direction of the Queen's House one evening a little after midnight. He could not see her head in the darkness but he distinctly heard the clicking of her heels on the hard ground. Puzzled, he watched the figure move towards Tower Green and then, when the form entered a patch of moonlight, he saw to his horror that she was headless. He fled his post but again the authorities were lenient.

Yet another guardsman on night duty near the Bloody Tower was standing motionless in the dim shadows when, with startling suddenness, he saw a white form appear before him. It seemed to rise out of the ground almost at his feet. Although shadowy and indistinct, he had no doubt that it was a headless woman. After challenging the strange appearance, he thrust his bayonet towards the form, whereupon it vanished.

Henry Percy, Earl of Northumberland, 'committed suicide' in the Bloody Tower and his ghost is reputed to have walked nightly afterwards along a narrow rampart. When sentries saw the ghost they were reluctant to do night duty in that part of the Tower and Sir George Younghusband, a Keeper of the Crown Jewels, has stated that the sentries were doubled. The ghost of the Earl of Northumberland may have had a reason to walk. Although a verdict of suicide was decided at the inquest, the Earl, a sympathizer with Mary Queen of Scots, was three times sent to the Tower on the orders of Queen Elizabeth I and was finally found there, shot dead through the heart in his bed, on June 21, 1595. It was widely believed that he had been murdered, especially as Sir Christopher Hatton, only a day before the death, ordered the Lieutenant of the Tower to place a

new warder in charge of the prisoner. Some witnesses maintain that the ghost of Northumberland walks in the vicinity of the Martin Tower where a later Henry Percy, Earl of Northumberland, was imprisoned for thirteen years. There the ghost is said to walk along a narrow path running along the edges of the ramparts each side of the Martin Tower, a path known as Northumberland's Walk.

Years ago the Crown Jewels were housed at the Jewel House situated on the west side of the Martin Tower and it was there that the most famous of all Tower ghost stories originated.

The singular, impersonal and quite unexplained manifestation occurred in 1817 and is vouched for by no less an authority than Edmund Lenthal Swifte, the Keeper of the Crown Jewels, who lived with his family at the Jewel House, then in the Martin Tower. Swifte (who courageously saved the Regalia during the great fire at the Tower in 1841) was appointed Keeper in 1814 and he retained the appointment until 1852.

That October night he was at supper in the sitting room with his wife and their eldest child, a boy of seven. His wife's sister was also present. The doors of the room were shut fast as the night was cold, and heavy, dark curtains were drawn across the two closed windows.

Swifte was on the point of offering his wife a glass of wine when she suddenly exclaimed, 'Good God! What is that?' pointing above her husband's head. He looked up and saw a cylindrical object, like a glass tube and about the thickness of his arm, hovering between the ceiling and the table. It appeared to contain a dense fluid, white and pale blue, and the two incessantly mixed and separated within the cylinder. Swifte and his wife watched the curious object for perhaps two minutes, and then it began to move slowly round the table, following an oblong path and passing in front of Swifte's sister-in-law, his son and himself but pausing *behind* Mrs Swifte, near her right shoulder. Suddenly Mrs Swifte crouched down, covered her shoulder with both her hands and shrieked, 'Oh Christ! It has seized me.' Swifte quickly picked up his chair and struck out with it, whereupon the figure seems to have vanished. It later transpired that neither Swifte's sister-in-law nor the little boy had seen anything unusual. Mr Swifte, in common with many people who have apparently paranormal experiences, had to face considerable scepticism from friends and other people but he adhered steadily to the belief that the phenomenon was supernormal in origin and related an identical account of the experience forty-three years later; a factual, unembroidered and convincing account that has puzzled investigators of psychic phenomena ever since.

Martin Tower, which is not open to the public, was for a time the 'doleful' prison of Anne Boleyn and she slept in the little upper room where her ghost has been seen on occasions, seated in a dark corner. It is a sad and silent ghost that appears and disappears for a few moments at a time, quite unexpectedly and usually on autumn evenings.

Sir Walter Raleigh too was lodged in the Martin Tower (then known as the Brick Tower) during one of his three imprisonments in the Tower of London. After falling into disgrace with Queen Elizabeth I following his intrigue with beautiful Elizabeth Throgmorton, one of the queen's 'maids of honour', both Raleigh and Elizabeth were sent to the Tower in 1592. After eight weeks Raleigh and his lady were released and they were married shortly afterwards. With King James I, Raleigh again found himself unpopular and after being summarily dismissed from Durham House in the Strand, where he had long lived, he was sent to the Tower in 1604, charged with treason, and lodged in Beauchamp Tower. There, in a frenzy of despair he attempted to stab himself to the heart but was unsuccessful. However, ghostly gasps, perhaps those of Raleigh thinking that he was near death, have been heard in certain apartments of Beauchamp Tower, while in the area where a passage formerly led to the Bell Tower an unidentified male figure in Elizabethan costume was seen one afternoon by a Tower guide. The passage was used as a promenade for prisoners.

Raleigh was tried at Winchester and convicted but the death sentence was commuted and he was returned to the Tower and imprisoned in the Bloody Tower where George, Duke of Clarence

is supposed to have been drowned in a butt of malmsey wine in 1478 in the dark and windowless room in which one of the portcullises was worked. In an adjacent chamber the two little princes are said to have been smothered to death in 1483. These deeds may have given the tower its name, unless the name derives from the fact that the mortar used in the building was tempered with the blood of beasts.

Raleigh is thought to have been lodged in a cell ten feet by eight feet, in the thickness of the wall of the Bloody Tower, but his wife and son were allowed to live with him there from 1603 to 1615 and their second son, Carew, was born in the Tower in 1605. During this imprisonment of nearly thirteen years Raleigh frequently dined with the Lieutenants of the Tower and he was given the freedom of the garden. His principal walk was on the ramparts between the Bloody Tower and the timber-built Lieutenant's Lodgings (now the Queen's House) where he would show himself and converse with people passing by—a path still known as Raleigh's Walk and haunted by his ghost on moonlit nights.

The Queen's House where, in the Council Chamber, the Commissioners 'examined' Guido Fawkes and his accomplices, is said to be haunted by inexplicable groans and the eerie screech and grind of instruments of torture that were used there long ago. The room with wall paintings depicting men inflicting and suffering torture has also long been reputed to be haunted but I have no precise details.

After his release Raleigh made one more sea voyage of exploration and on his return he was arrested at Plymouth and once more confined in the Tower. He spent his last night in Westminster Hall and was executed in Old Palace Yard, Westminster, on October 29, 1618, so it would seem that the ghost of the great courtier, soldier, explorer and author walks where he lived and not where he died.

'I have a long journey before me,' he said as he mounted the scaffold and gently touched the axe, adding, 'this is a sharp medicine but it will cure all ills.' Even the headsman shrank from beheading so illustrious and brave a man, until Raleigh made his last remark, 'What dost thou fear? Strike, man!' After his head was shown to the crowds it was placed in a red leather bag and conveyed in a mourning coach to his wife. His body was interred in the chancel of St Margaret's Church, Westminster, but his head was long preserved in a case by his widow who survived him for twenty-nine years, and after her death by his son Carew with whom it is said to have been buried at West Horsley in Surrey.

Raymond Lully, the alchemist, is reputed to have taken up residence at the Tower in the reign of Edward I, although Lully's biographers express doubt that he ever visited England. It is said, however, that he performed in the royal presence the experiment of transmuting some crystal into a mass of diamond or adamant and the king is said to have made little pillars of the transmuted precious stone. It is not impossible that an atmosphere of occult power exists, or once existed, in parts of the Tower for in the circular and vaulted dungeon of the Salt Tower (nearly as old as the White Tower and once known as Julius Caesar's Tower) there are a number of strange devices and inscriptions cut in the wall, including a circle with the signs of the zodiac for casting horoscopes. This was apparently drawn by Hew Draper, a wealthy tavern keeper in Bristol, who was committed to the Tower on an accusation of witchcraft against Sir William St Lowe and his lady, better known as Bess of Hardwick.. Draper 'so misliked his science' that he burned all his books but a distinct and disquieting atmosphere still lingers within these ancient walls.

West of the Salt Tower the thirteen-foot-thick walls of the Wakefield Tower harbour the ghost of King Henry VI, stabbed to death as he knelt at prayer. His wan form has been seen outside the chamber where the murder took place. Nearby hang portraits of past Keepers of the Record Room, some of whom reported seeing the ghost.

Tower of London. The Queen's House, where the ghost of Anne Boleyn walks, her heels clicking sharply on the hard ground.

A menagerie of wild beasts was kept at the Tower from a very early date, the last animals being removed to the Zoological Gardens in Regents Park in 1834. King Henry I kept lions and leopards and Henry III added to these. Edward III took much pride in the collection and successive monarchs attended combats of the wild beasts, including bear baiting. Perhaps a remnant of these cruel times survives in the form of a ghost bear that has been encountered within the Tower precincts from time to time.

One report states that a sentry saw the figure of a huge bear near a door in the Martin Tower. Marshalling his courage, the soldier promptly thrust at the enormous form with his bayonet, but the blade went clean through the phantom creature and struck the door. As the hairy form began to advance towards him, the sentry fainted. Another guard, hearing the sound of the bayonet against the door, hurried across and found the senseless body of his companion but of the mysterious bear there was no sign. The unfortunate man revived to some extent in the main guardroom, but his nerves were completely shattered and he died two days later. Over and over again he repeated the story of his terrible ordeal. A doctor verified that he was not under the influence of drink and only minutes before his experience, a fellow-guardsman had passed the sentry and exchanged a few words with him, so he was certainly not asleep. And for two days the bayonet remained embedded in the stout oaken door.

Most of the English kings from William the Conqueror to Charles II used the Tower as a palace. Henry VIII often held court there and, in great pomp, he received all his wives before the weddings. Two of them returned to the Tower to die on Tower Green, Anne Boleyn in 1536 and Catherine Howard in 1542.

There were two places of execution: Tower Hill (under the authority of the government of the city) and Tower Green, within the Tower walls. Today Tower Green is a spot of poignant and hallowed memory. The place of execution was marked off and railed by command of Queen Victoria. Those who were 'untopped' (as Anne Boleyn's daughter put it) included Lord Hastings in 1483; Jane, Countess Rochford (sister-in-law of Anne Boleyn) in 1542; Lady Jane Grey in 1554; Robert Devereux, Earl of Essex in 1601; and Margaret Pole, Countess of Salisbury, daughter of the Duke of Clarence, in 1541. It is the ghost of the latter that sometimes reappears in a spectacular way on the anniversary of her execution.

The Countess of Salisbury, beheaded on the orders of Henry VIII, was a reluctant victim. On the morning of the execution she was forcibly carried to the scaffold, screaming and fighting in a frenzy to escape and the fearful scene of the execution itself is said to be re-enacted in all its harrowing detail each anniversary. Then, according to reports, her ghost is seen, screaming with terror, running panic-stricken round and round the spot where the scaffold once stood, pursued by a ghostly masked executioner, heavy axe in hand, who finally overtakes the terrified woman and 'chuckling diabolically' slowly hacks off her head with repeated dreadful blows.

Lady Jane Grey entered the Tower as Queen of England but less than three weeks later she became a prisoner together with her young husband, and she saw his headless body carried past her on the morning that she knew she too must die—is it unlikely then that her ghost returns to this storehouse of memories? Her ghost was last seen as recently as 1957, on February 12 to be exact, the 403rd anniversary of her execution.

Guardsman Johns, a young Welshman on duty at the Tower stamped his feet that cold and wintry morning as a nearby clock chimed the hour of three. Suddenly a rattling noise alerted his attention and as he looked up towards the battlements of the Salt Tower, forty feet above him, he saw silhouetted against the dark sky, a 'white shapeless form' that moulded itself into the likeness of Lady Jane Grey. As the startled soldier shouted for assistance, another guardsman saw 'a strange white apparition' at the same spot, a hundred yards or so from the red-brick, seventeenth century Gentleman Jailer's House which stands on the site of a previous structure where Lady Jane Grey was imprisoned and where she saw her husband, Lord Guildford Dudley, go to his execution. 'The ghost stood between the battlements,' Guardsman Johns said afterwards. 'At first I thought I was seeing things, but when I told the other guard and pointed, the figure appeared again.' An officer of the regiment stated, 'Guardsman Johns is convinced that he saw a ghost. Speaking for the regiment our attitude is "All right, so you say you have seen a ghost. Let's leave it at that".'

Another guardsman on duty at the Tower saw a ghost in February, 1933. He said afterwards that he saw the white form of a headless woman near the Bloody Tower. The figure seemed to float towards him and then simply disappeared. Years afterwards, a Guards officer (who happened at the time to be training for the British Olympic Games) became aware, as he approached the Bloody Tower archway in Water Lane, that he was encountering a 'most queer and utterly distasteful atmosphere'. He saw nothing but was overcome with terror. The hair on the back of his neck stood on end and he could think of nothing except how to get away from the place as quickly as possible. Next moment (it seemed) he found himself on the steps of the officers' mess, three hundred yards away, bathed in perspiration and panting heavily. Yet he could recall nothing of his frantic sprint (probably in record time!), only the agony and terror of that moment near the Bloody Tower, which he had previously passed scores of times without any ill effects.

Anne Boleyn's ghost has been reported many times and in many different parts of the Tower. At a meeting of The Ghost Club in 1899, Lady Biddolph related that a phantom lady with a red carnation over her right ear had been observed looking out of a window at the Tower. She added that the description of the apparition tallied with that of Anne Boleyn herself and it was at the window of Anne's room at the Tower that the figure was seen. In 1972 a nine-year-old girl 'saw' the execution of Anne Boleyn on Tower Green. The girl visited the Tower for the first time with her parents when they were on holiday in London from their home in the north of England.

At Tower Green the guide recited the list of execution victims, including Anne Boleyn, when Joan suddenly whispered to her mother, 'They didn't chop her head off with an axe. They did it with a sword.' Later she described in detail the 1536 scene when a compassionate executioner removed his shoes, crept behind the queen and killed her with his sword. In fact that is exactly what happened, although very few people know it, and the entry in *Chambers's Encyclopaedia* states

that 'Anne submitted her slim neck to the headman's axe'. The *Encyclopaedia Britannica* however has it correct and the entry refers to Anne's head 'being struck off with a sword by the executioner of Calais, being brought to England for the purpose'. The nine-year-old girl had no interest in history and her father maintained that she had not read about Henry VIII's wives, nor had she seen any of the television programmes and in fact she knew nothing about the period.

The Tower Chapel of St Peter ad Vincula (Peter in Chains) dates from the time of Henry VIII, the earlier church having been destroyed by fire in 1512. It was largely rebuilt in 1305-6 and restored by Henry VIII. References to the church occur as early as 1210.

It has been said that no spot in England has sadder memories and perhaps no place has a more spectacular ghostly procession than this church. Here lie buried Queen Catherine Howard; Sir Thomas More; Thomas Cromwell, Earl of Essex; Margaret, Countess of Salisbury; Jane, Countess Rochford; Thomas, Lord Seymour of Sudeley; Edward Seymour, Duke of Somerset; John Dudley, Duke of Northumberland; Lady Jane Grey and her husband; Robert Devereux, Earl of Essex; James, Duke of Monmouth; Simon, Lord Fraser of Lovat; Sir Thomas Overbury (who was poisoned); Sir John Eliot; Arthur, Earl of Essex (who was found with his throat cut); and many more, including Queen Anne Boleyn, who, it would seem, returns to this melancholy chapel.

Anne's fall was rapid. On May Day, 1536, she accompanied Henry VIII as Queen of England to a tilting match at Greenwich. Next day she was arrested on a charge of high treason and seventeen days afterwards she was beheaded and her body thrown into a common chest of elm that had been fashioned to hold arrows. There is a tradition that her body was secretly removed to Salle Church in Norfolk where she was buried beneath a black marble slab without any inscription, and where her ghost is also said to walk, but when the black slab was lifted some years ago, no bones were found beneath it and it seems certain that in fact her remains rest in the crypt of the Chapel of St Peter.

An officer of the guard was making his rounds one evening accompanied by a sentry, when he noticed a light burning in the chapel. He pointed it out to the sentry and asked what it meant. The sentry replied that he did not know what it meant but he had often seen it there, and stranger things too. The officer procured a ladder, placed it against the chapel wall, climbed the ladder and looked into the still lighted-up window. He never forgot what he saw.

Walking slowly down the aisle moved a stately procession of knights and ladies in ancient costume and in front walked an elegant female whose face and dress resembled reputed portraits of Queen Anne Boleyn. After repeatedly pacing the chapel the entire procession vanished and with it the light that had first attracted the attention of the officer.

A rather different phantom procession at the Tower was witnessed by a sentry on duty near the Spur Tower during the First World War. It consisted of a party of men carrying a rough stretcher on which lay the body of a beheaded man, the decapitated head underneath his arm. It seems unlikely that the sentry would have known that the normal procedure, following an execution on Tower Hill, was for the headless body to be brought back to the Tower for burial, in procession, with the head placed under one arm.

Other ghosts at the Tower that have been identified include the apparition of Thomas Wentworth, Earl of Strafford, who appeared to William Laud, Archbishop of Canterbury, when he was a prisoner in the Tower from 1641 to 1645. Laud knew Strafford well and maintained that his old friend had comforted him by saying that he had nothing to fear. The ghost was ill-informed, however, for the Archbishop was beheaded in 1645.

Another man who saw the ghost of a friend at the Tower was an army general named Middleton. He and his friend, Lord Bocconi, had made a pact that whoever died first would endeavour to return and warn the other in the event of danger. Middleton was taken prisoner at

the Battle of Worcester and lodged in the Tower where one day his old friend appeared to him with an assurance that Middleton would be safely out of the Tower within three days and in fact Middleton did escape within the prescribed period.

After giving a lecture at the Society for Psychical Research a few years ago, Mrs Jerrard Tickell told me of the experience of an officer at the Tower; an experience which she would have dismissed as an hallucination or tall story had she not previously known the man concerned. In 1954, at a quarter to midnight, he saw what appeared to be a puff of smoke emerge from the mouth of one of the old cannons outside the White Tower. At a distance of about twenty-five yards he watched the puff of smoke hover for a moment, form into a cube and move along some railings towards him. As it did so it began to change shape again. The officer called a nearby sentry and they both watched the 'smoke' dangle on the side of some steps leading to the top of the wall. The alarm bell was sounded but by the time the guard turned out, there was nothing to be seen. The guns include an ancient one for stone shot; brass guns from the days of Henry VII and Henry VIII; French, Spanish and Chinese guns; guns from the wreck of the *Royal George*; and several mortars, including one used at the siege of Namur by William III. It is not clear from which gun the smoke issued.

The 'long-haired' lady in a black velvet dress and wearing a white cap and a large gold medallion that was reported by a visitor in August 1970, may well have been Lady Jane Grey. 'She' was seen standing by an open window in the Bloody Tower and when the visitor walked towards 'her', the figure vanished.

The ravens at the Tower have long had a sinister reputation, probably derived from their dark plumage, deep croak, and the ancient Romans' use of the bird in augury. When ravens fly and cry over a house containing a sick person, it has long been regarded as an omen of death; and if a sick man hears a raven croak, he is thought to be dying. With the age-old association of the bird with death and misfortune, the ravens at the Tower have long been regarded with superstitious awe and special arrangements are still made to feed and preserve them since it is believed that should the ravens ever leave, Britain will face disaster. As recently as the Second World War some Londoners were disquieted by the rumour that no Tower raven had been heard to croak for five whole days and it was feared that the ravens had deserted the Tower, with dire results for Britain.

Another tradition at the Tower is that the enormous shadow of an axe is sometimes seen spreading its form from Tower Green and appearing on the wall of the White Tower.

SELECT BIBLIOGRAPHY

Archer, Fred	*Ghost Writer* 1966
Aubrey, John	*Miscellanies* 1696
Bardens, Dennis	*Ghosts and Hauntings* 1965
Barton, Nicholas	*The Lost Rivers of London* 1962
Bates, L. M.	*Somerset House* 1967
Braddock, Joseph	*Haunted Houses* 1956
Cunningham, George H.	*London* 1927
Day, J. Wentworth	*Here Are Ghosts and Witches* 1954
	A Ghost Hunter's Game Book 1958
	In Search of Ghosts 1969
Dent, Alan	*My Covent Garden* 1973
Grant, Douglas	*The Cock Lane Ghost* 1965
Hallam, Jack	*The Haunted Inns of England* 1972
Harper, Charles G.	*Haunted Houses* 1907
Harries, John	*The Ghost Hunter's Road Book* 1968
Harrison, Michael	*London Beneath the Pavement* 1961
Hole, Christina	*Haunted England* 1940
Hopkins, R. Thurston	*Adventures with Phantoms* 1946
	Ghosts Over England 1953
	Cavalcade of Ghosts 1956
Hughes, M. V.	*The City Saints* 1932
Kent, William	*An Encyclopaedia of London* Revised 1970
	London for Everyman Revised 1969
Lang, Andrew	*Cock Lane and Common-Sense* 1894
Liechtenstein, Princess Marie	*Holland House* 1875
Ludlam, Harry	*The Mummy of Birchen Bower, etc.* 1966
	The Restless Ghosts of Ladye Place, etc. 1967
Macqueen Pope, W. J.	*Theatre Royal, Drury Lane* 1945
	Haymarket: Theatre of Perfection 1948
Mander, Raymond & Mitchenson, Joe	*The Theatres of London* 1961
Maple, Eric	*The Realm of Ghosts* 1964
Montizambert, E.	*Unnoticed London* 1922

Murray, Margaret	*My First Hundred Years* 1963
O'Donnell, Elliott	*Haunted Churches* 1939
	Haunted Britain 1949
	Phantoms of the Night 1956
	Haunted Waters 1957
Pearson, Margaret	*Bright Tapestry* 1956
Pendrill, Charles	*The Adelphi* 1934
Platts, Beryl	*History of Greenwich* 1972
Price, Harry	*Search for Truth* 1942
	Poltergeist Over England 1945
Richmond, Sir Arthur	*Twenty-six Years, 1879-1905* 1961
Sergeant, Philip W.	*Historic British Ghosts* (n.d.)
Squiers, Granville	*Secret Hiding Places* 1934
Stirling, A. M. W.	*Ghosts Vivisected* 1957
Stow, John	*The Survey of London* Everyman's Library Ed, 1956
Sutherland, Lord Ronald	*The Tower of London* 1901
Timbs, John	*Curiosities of London* 1867
Underwood, Peter	*A Gazetteer of British Ghosts* 1971
	Into the Occult 1972
	Horror Man – the Life of Boris Karloff 1972
Wheatley, Henry B.	*The Story of London* (Mediaeval Towns) 1904
Wilson, Colin & Pitman, Pat	*Encyclopaedia of Murder* 1961